ROMARE BEARDEN

ROMARE BEARDEN

Southern Recollections

Carla M. Hanzal
Glenda Elizabeth Gilmore
Jae Emerling
Leslie King-Hammond
Mary Lee Corlett

With a Preface by Ruth Fine and
an Afterword by Myron Schwartzman

The Mint Museum, Charlotte, North Carolina, in association with D Giles Limited, London

This book was published in conjunction with the exhibition *Romare Bearden: Southern Recollections*, organized by The Mint Museum, Charlotte, North Carolina.

2 September 2011–8 January 2012
Mint Museum Uptown at Levine Center for the Arts
500 South Tryon Street
Charlotte, North Carolina 28202
www.mintmuseum.org

28 January–6 May 2012
Tampa Museum of Art
Cornelia Corbett Center
120 West Gasparilla Plaza
Tampa, Florida 33602
www.tampamuseum.org

23 May–26 August 2012
Newark Museum
49 Washington Street
Newark, New Jersey 07102
www.newarkmuseum.org

Copyright © 2011 Mint Museum of Art, Inc.

First Published in 2011 by GILES
An imprint of D Giles Limited
4 Crescent Stables, 139 Upper Richmond Road
London SW15 2TN, UK
www.gilesltd.com

Library of Congress Cataloging-in-Publication Data

Bearden, Romare, 1911–1988.
Romare Bearden : Southern recollections / Carla M. Hanzal with contributions by Ruth Fine . . . [et al.].
 p. cm.
Published in conjunction with an exhibition held at the Mint Museum of Art, Charlotte, N.C., Sept. 2, 2011–Jan. 8, 2012, and other venues.
 Includes bibliographical references and index.
 ISBN-13: 978-1-904832-98-0 (hardcover : alk. paper)
 ISBN-10: 1-904832-98-9 (hardcover : alk. paper)
 ISBN-13: 978-0-9831942-2-4 (softcover: alk. paper)
 ISBN-10: 0-9831942-2-X (softcover: alk. paper) 1. Bearden, Romare, 1911–1988—Themes, motives—Exhibitions. 2. Southern States—In art—Exhibitions. I. Hanzal, Carla M. II. Fine, Ruth, 1941– III. Mint Museum (Charlotte, N.C.) IV. Title. V. Title: Southern recollections.

N6537.B4A4 2011
709.2—dc22
 2011015270

The Mint Museum is funded, in part, with operating support from the Arts & Science Council of Charlotte-Mecklenburg, Inc.; the North Carolina Arts Council, a division of the Department of Cultural Resources; the City of Charlotte; and its members.

Romare Bearden: Southern Recollections was made possible with generous support from Duke Energy and Wells Fargo. Additional funding was provided by an award from the National Endowment for the Arts.

Copyedited and proofread by Emily D. Shapiro
Designed by Alfonso Iacurci
Produced by GILES, an imprint of D Giles Limited, London
Printed and bound in Canada

Front cover:
Carolina Morning, 1974 (detail)
Mixed media collage on board, 30 × 22 inches

Back cover:
The Baptism, 1978
Watercolor, gouache, and graphite on paper, 21 × 26 inches

Frontispiece:
Frank Stewart
Romare Bearden, New York, 1979
Photography © Frank Stewart/Black Light Productions

Romare Bearden poem © Romare Bearden Foundation

CONTENTS

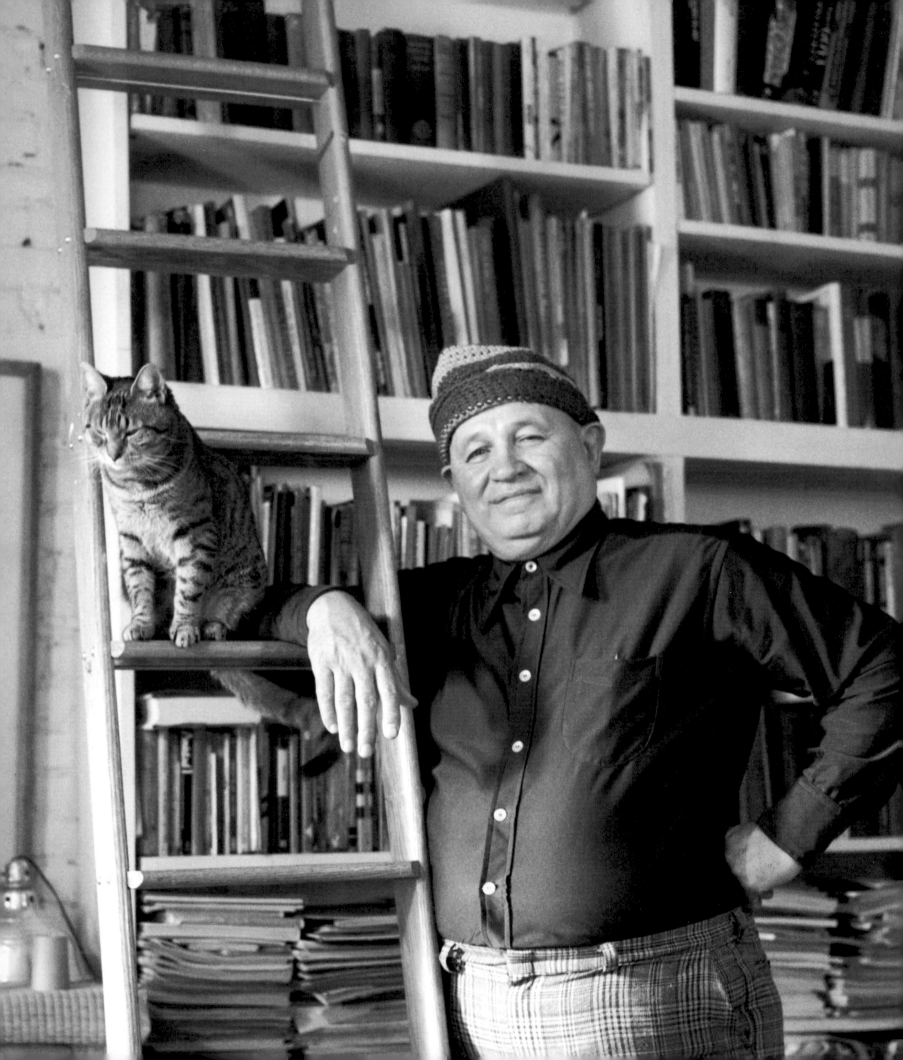

FOREWORD

Romare Bearden: Southern Recollections debuts on the centennial of the artist's birth, 2 September 2011, and with its presentation The Mint Museum celebrates Romare Bearden's enduring legacy. The works of art featured in this exhibition encompass more than five decades of Bearden's career and reveal his deep and abiding connection to his birthplace, Charlotte, North Carolina, and to the South.

Through visual recollections of the South—drawn both from his memories and the stories that were passed on from generation to generation—Bearden rendered with utmost care the experiences of his African American forebears. Like all great artists who forge enduring narratives, Bearden made statements that resonate universally by presenting the details of particular rites: baptisms, the cultivation of crops and gardens, and the rejoining of family and community. He meticulously recorded the rituals and collective beliefs that imbue his work with archetypal significance. Holding in perfect balance the literal and the symbolic, Bearden celebrated and eulogized a lost way of life, and illuminated the noble lives of his people—their longings, triumphs, and resiliency.

Bearden was an artist of great integrity. From the beginning, he sought to create art that would have lasting significance. Throughout his career he skillfully navigated the twentieth-century divide between abstraction and representation and managed to find both the philosophical grounding (creating works of art that use particular situations to illustrate the universal), and technical means (utilizing collage with its fragmentation, flattened space, and implications of making the past present) to successfully bridge the two. His collages and photomontages, for which he became known from the mid-1960s onward, remain strikingly modern in their rich colorations and structured compositions, even extending into a postmodern view of time and subjectivity.

The Mint Museum has embraced a thirty-one-year engagement with collecting and presenting the work of Romare Bearden, which has been an important part of this institution's seventy-five-year legacy. In 1980, the museum organized *Romare Bearden: 1970–1980*, which toured to four venues: the Mississippi Museum of Art, the Baltimore Museum of Art, the Virginia Museum of Fine Arts, and the Brooklyn Art Museum [now the Brooklyn Museum]. In 1998, the museum participated in the Whitney Museum of American Art's tour of *Romare Bearden in Black and White: The Photomontage Projections of 1964*, and in 2002, the Mint Museum of Art exhibition *Recollections of Charlotte's Own Romare Bearden* presented works assembled from local collections. Since 2003, the museum has had a gallery exclusively devoted to Bearden's work, and we remain committed to collecting, researching, and educating the public about Bearden's significant contribution to American and contemporary art. The present exhibition, *Romare Bearden: Southern Recollections*, provides an opportunity for the museum to make a new contribution to the literature on Bearden with the publication of this book.

Many individuals and institutions have worked together to bring this exhibition and publication to fruition. We are pleased to be able to share Romare Bearden's works of art with the Tampa Museum of Art in Tampa, Florida, and with the audiences of the Newark Museum in Newark, New Jersey. Executive Director Todd D. Smith has been a pleasure to work with at the former, as have Director Mary Sue Sweeney Price and Curator Beth Venn at the latter. On behalf of the museum's Board of Trustees, I extend my gratitude to the many lenders from across the country, some named and some anonymous, whose generosity secured the success of this undertaking. We thank sincerely Duke Energy and Wells Fargo, who supported this project, with additional funding from the National Endowment for the Arts. These generous contributions allowed this exhibition and catalogue to achieve the level of quality merited by this centennial exhibition. Finally, I would like to acknowledge and thank the entire staff of The Mint Museum for their devotion in making this extraordinary exhibition and publication a reality.

Kathleen V. Jameson, Ph.D.
President & CEO, The Mint Museum

Fig. 1
Blaine Waller
Bearden's studio on Canal Street, New York City, 23 October 1976 (detail)
Photography © Blaine Waller, 1976

ACKNOWLEDGMENTS

The creation of this exhibition and publication in honor of Romare Bearden's centennial has been a collaborative process since its inception, and could not have been accomplished without the support and generosity of museums, art galleries, foundations, corporations, and private collections. I also want to express my gratitude to Duke Energy, Wells Fargo, and the National Endowment for the Arts, whose sponsorship enabled the presentation of this exhibition at the Mint Museum of Art. For the thoughtful and illuminating writing on Romare Bearden, I sincerely thank the contributors to this publication: Ruth Fine, Glenda Elizabeth Gilmore, Jae Emerling, Leslie King-Hammond, Mary Lee Corlett, and Myron Schwartzman.

I am grateful to colleagues who have facilitated our loan requests. At public institutions—Albright-Knox Art Gallery, Buffalo: Louis Grachos, Douglas Dreishpoon, Laura Fleishman, and Kelly Carpenter; Asheville Art Museum: Pamela M. Myers, Frank E. Thomson, and Cole Hendrix; University of California, Berkeley Art Museum and Pacific Film Archive: Lawrence Rinder, Lucinda Barnes, Lisa Calden, and Genevieve Cottraux; Brooklyn Museum: Arnold Lehman, Kevin Stayton, Elisa Flynn, and Ruth Janson; Cameron Art Museum, Wilmington: Deborah Velders and Holly Tripman; Columbus Museum of Art: Nannette Maciejunes, Lisa Dent, Melinda Knapp, and Jennifer Seeds Martin; Dallas Museum of Art: Bonnie Pitman, Tamara Wootten-Bonner, Brent Mitchell, and Jeff Zilm; Georgia Museum of Art, University of Georgia: William U. Eiland, Paul Manoguerra, Christy Sinksen, and Sarina Rousso; Hickory Museum of Art: Lisë Swensson, Lauren Gallion, and Ronni Smith; Howard University Gallery of Art, Washington, DC: Tritobia Hayes Benjamin and Eileen Johnston; Kemper Museum of Contemporary Art, Kansas City: Rachel Blackburn Cozad, Barbara O'Brien, Amy Duke, and Robert Bingaman; The Metropolitan Museum of Art, New York: Thomas P. Campbell and Gary Tinterow; Montclair Art Museum: Lora Urbanelli, Gail Stavitsky, Renee Powley, Erica Jacob, Andrea Cerbie, and Michael Gillepsie; Munson-Williams-Proctor Arts Institute, Museum of Art, Utica: Paul D. Schewizer and Lori Eurto; National Gallery of Art, Washington: Earl A. Powell III, Ruth Fine, Mary Lee Corlett, Franklin Kelly, Lehua Fisher, and Barbara Wood; Neuberger Museum of Art, Purchase College: Lea Emery and Patricia Magnani; New Orleans Museum of Art: Susan Taylor, Miranda Lash, Paul Tarver, and Jennifer Ickes; North Carolina Museum of Art, Raleigh: Lawrence J. Wheeler, Linda Dougherty, Maggie Gregory, and Angela Bell-Morris; The David and Alfred Smart Museum of Art, The University of Chicago: Anthony G. Hirshel, Richard A. Born, Angela Steinmetz, and Sara Hindmarch; the Smithsonian American Art Museum, Washington, DC: Elizabeth Broun and Alison Fenn; Studio Museum in Harlem: Thelma Golden and Shelly Wilson; Tougaloo College Collections, Tougaloo College, Mississippi: Beverly W. Hogan and Johnnie Mae Maberry; Van Every/Smith Galleries, Davidson College: Brad Thomas and Tara Clayton; Virginia Museum of Fine Arts, Richmond: Alex Nyerges, John Ravenal, Mary Sullivan, and Howell W. Perkins; Wadsworth Atheneum Museum of Art, Hartford: Susan L. Talbot, Patricia Hickson, and Mary Busick; Weatherspoon Art Museum, Greensboro: Nancy Doll, Elaine D. Gustafson, and Heather Moore; Whitney Museum of American Art, New York: Adam Weinberg, Barbara Haskell, Barbi Speiler, and Kiowa Hammons. Additional contributors to the exhibition are: American Masters Collection I, Managed by The Collectors Fund, Kansas City, Missouri; *The Charlotte Observer*: Ann Caulkins, Gail Lenarcic, and Maria David; Manoogian Collection: Richard Manoogian and Cheryl Robledo; The Estate of Nanette Bearden and the Romare Bearden Foundation, New York: Diedra Harris-Kelley, Johanne Bryant-Reid, and Sheila Rohan.

Several galleries were helpful in identifying and making available works of art for the exhibition, and I am grateful for their support and assistance in securing loans. They are: ACA Galleries, New York: Dorian and Jeffrey Bergen, and Mikaela Lamarche; Curtis Galleries, Minneapolis: Myron Kunin, Jenny Sponberg, and Taylor J. Acosta; DC Moore Gallery, New York: Bridget Moore, Heidi Lange, and Sandra Paci; Hollis Taggart Galleries, New York: Hollis Taggart and Martin Friedrichs; June Kelly Gallery, New York: June Kelly and Bianca Dorsey;

Questroyal Fine Art, LLC, New York: Louis M. Salerno, Chloe Richfield Heins, and Jessica Waldman; and Michael Rosenfeld Gallery, LLC, New York: halley k. harrisburg, Michael Rosenfeld, and Marjorie Van Cura.

Numerous private collectors were willing to loan works to the exhibition, indicating their admiration for the artist. Many wish to remain anonymous. Others, I may thank by name: John Axelrod; Constance and Frederick Brown; Lucinda W. Bunnen and Kendrick N. Reusch Jr.; Dr. Raleigh and Thelmetia Bynum; Linda and Pearson C. Cummin III; Faye and Robert Davidson; Don and Patricia Deutsch; Judy and Patrick Diamond; Dr. Walter O. Evans and Linda J. Evans; Susan and David Goode; Lowrance and Brucie Harry; Earle Hyman; Paul and Karen Izenberg; Herb Jackson and Laura Grosch; David Lebenbom; Dr. and Mrs. Clinton N. Levin; Jancy and Gilbert Patrick; Emily and Zach Smith; Ute and Gerhard Stebich; Glen and Lynn Tobias; and T. Michael Todd.

Organizing and presenting an exhibition and catalogue of this scope calls on the expertise of every department in the museum. Amber Smith, adjunct project coordinator, provided invaluable contributions to the exhibition and publication at every stage with grace, competence, and good humor. Special thanks go to the museum staff who were instrumental in ensuring the success of the exhibition and publication: Martha Tonissen Mayberry, registrar, and her associates, Katherine Steiner, Eric Speer, and Andrea Collins; Kristen Watts, director of curatorial affairs; Rosemary Martin, publications editor and development officer; Joyce Weaver, librarian; Kurt Warnke, head of design and installation, and his associates, Leah Blackburn, Mitch Francis, and William Lipscomb; designers Emily Walker and Elyse Frederick; and public relations manager, Elizabeth Isenhour. Mike Smith, director of finance and administration, and accountants Hannah Pickering and Lois Schneider managed the finances, and Stacy Sumner Jesso, Betsy Gantt, and Regan Brown also helped secure funding. Rubie Britt-Height, director of community relations, and Cheryl Palmer, director of education, and her associates, Leslie Strauss, Rita Shumaker, Joel Smeltzer, Allison Taylor, and Karen Vidamo, as well as curatorial intern Francine Kola-Bankole, created engaging educational components to accompany the exhibition. I appreciate the collegiality and wise counsel of Jonathan Stuhlman, Brian Gallagher, Annie Carlano, Allie Farlowe, and Michelle Mickey. I thank Phil Kline, former president and chief executive officer; Charles L. Mo, director of fine arts; and Dr. Kathleen V. Jameson, president and chief executive officer, for their unwavering enthusiasm and support of this project.

It has been a pleasure working with D Giles Limited, London, to create this publication, and I thank Dan Giles, Sarah McLaughlin, and Allison Giles for their thoughtful, sensitive work.

Finally, I thank Faith Santo Hanzal for providing a sense of place, and D. David Childress and Helena Hanzal Childress for creating home with their presence.

Carla M. Hanzal
Curator of Contemporary Art, The Mint Museum

LENDERS TO THE EXHIBITION

Anonymous Private Collections

ACA Galleries, New York, New York

Albright-Knox Art Gallery, Buffalo, New York

American Masters Collection I, Managed by The Collectors Fund, Kansas City, Missouri

Asheville Art Museum, Asheville, North Carolina

John Axelrod

Estate of Nanette Bearden

University of California, Berkeley Art Museum and Pacific Film Archive, Berkeley, California

Brooklyn Museum, New York

Constance and Frederick Brown

Lucinda W. Bunnen and Kendrick N. Reusch Jr.

Dr. Raleigh and Thelmetia Bynum

Cameron Art Museum, Wilmington, North Carolina

The Charlotte Observer, North Carolina

Columbus Museum of Art, Ohio

Linda and Pearson C. Cummin III

Curtis Galleries, Minneapolis, Minnesota

Dallas Museum of Art, Texas

Faye and Robert Davidson

DC Moore Gallery, New York, New York

Don and Patricia Deutsch

Judy and Patrick Diamond

The Walter O. Evans Collection of African American Art

Georgia Museum of Art, University of Georgia, Athens, Georgia

Susan and David Goode

Lowrance and Brucie Harry

Hickory Museum of Art, Hickory, North Carolina

Howard University Gallery of Art, Washington, DC

Earle Hyman Collection

Paul and Karen Izenberg

Herb Jackson and Laura Grosch

Kemper Museum of Contemporary Art, Kansas City, Missouri

Dr. and Mrs. Clinton N. Levin

Manoogian Collection

The Metropolitan Museum of Art, New York, New York

The Mint Museum, Charlotte, North Carolina

Montclair Art Museum, Montclair, New Jersey

Munson-Williams-Proctor Arts Institute, Museum of Art, Utica, New York

Neuberger Museum of Art, Purchase College, State University of New York

New Orleans Museum of Art, Louisiana

North Carolina Museum of Art, Raleigh, North Carolina

Jancy and Gilbert Patrick

Questroyal Fine Art, LLC, New York, New York

Romare Bearden Foundation

Michael Rosenfeld Gallery, LLC, New York, New York

The David and Alfred Smart Museum of Art, The University of Chicago, Illinois

Emily and Zach Smith

Smithsonian American Art Museum, Washington, DC

Ute and Gerhard Stebich

Studio Museum in Harlem, New York

Glen and Lynn Tobias

T. Michael Todd

Tougaloo College Collections, Tougaloo College, Tougaloo, Mississippi

Van Every/Smith Galleries, Davidson College, Davidson, North Carolina

Virginia Museum of Fine Arts, Richmond, Virginia

Wadsworth Atheneum Museum of Art, Hartford, Connecticut

Weatherspoon Art Museum, The University of North Carolina at Greensboro

Whitney Museum of American Art, New York, New York

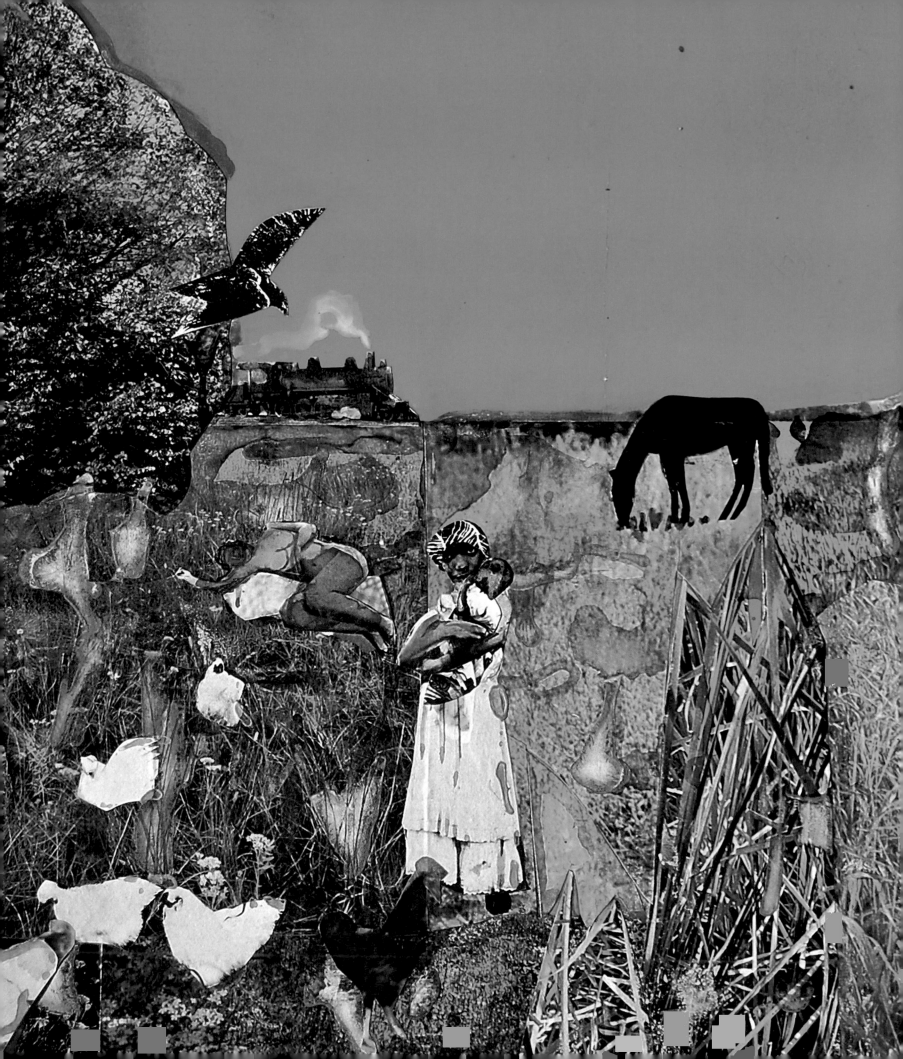

Sometimes I remember my grandfather's house
A garden with tiger lilies, my grandmother
Waving a white apron to passing trains
On that trestle across the clay road.

The house was even there when confederate
Cavalrymen came to conscript my grand-
 father
Now years have wrinkled the gray walls
An eagle on the weather vane has a missing
 wing
And spins unknowingly in all directions
The dignity of the magnolias is threatened
By ever changing winds that carry
Broken modes of the Eolian harp.
The calendar on the wall of my
 grandfather's
Room, points to a July many years
 ago
I am in the garden looking at the
Green stem of that tiger lily undulating
 like a small garter snake

Grandfather tells me my grandmother cut it
To wear to church on her white dress
"It will be here again when you return
 next year"
But the tiger lily's leaves faded the trains no
 longer pass by.
The house rocks back and forth, and I
 hear no sounds
Inside I search desperately for you
But neither you nor Liza are there and
The hum of the years calls my memory
There is laughter, the moans of women in
 childbirth,
Locked somewhere in the purple shaded rooms, but
What happened in the five months left
After that humid July?
I will wait here for you or for Liza
To take me where there are tiger lilies
And where I can hear the whistle of night trains
Not the cawing of this wounded,
 spinning eagle.

Romare Bearden

Fig. 2
*Profile/Part I, The Twenties: Mecklenburg
County, Sunset Limited*, 1978 (detail)
Collage on board, 15 ½ × 20 ¼ inches

PREFACE

Ruth Fine

The Mint Museum and Charlotte's revered native son, Romare Bearden (1911–1988), shared a slice of history that has been celebrated in several important exhibitions at the museum. The first of these, *Romare Bearden: 1970–1980* (figs. 3–4), continued the story begun in the retrospective exhibition at the Museum of Modern Art, New York, in 1971. Focusing on works dating from this one decade, the exhibition nevertheless suggested the many kinds of places that intrigued Bearden and inspired his art—Northern city streets, Southern farm life, homey interiors in both settings, and lush Caribbean landscapes. The present exhibition, *Romare Bearden: Southern Recollections*, by contrast, presents an array of work created over Bearden's entire career, spanning six decades; but all of them are associated with just one geographical region. The subjects and significance of Bearden's art seems available at a glance, but with extended looking his complex compositions reveal additional layers of meaning. *Romare Bearden: Southern Recollections* offers the possibility for this kind of serious, sustained viewing experience, demonstrating as well that Bearden's art continues to invigorate and inspire audiences, more than twenty years after the artist's death. It is the task of expansive exhibitions like this one to delight and educate museum audiences, to gather visitors into the show's orbit and set their imaginations to play, thereby giving reality to the notion that a viewer completes a work of art by investing his or her personal experience into its content.

A particular pleasure for museum staff, who have the opportunity to spend many hours in exhibitions, is the experience of watching and overhearing visitors as they express appreciative responses to an artist's work. This was our privilege in 2003, with *The Art of Romare Bearden* exhibition in Washington, D.C. Museum visitors of diverse ages, races, economic bases, and cultural and intellectual backgrounds carefully examined the artist's oils, collages, watercolors, and prints. Classes of school children responding to Bearden's gigantic imagination would sprawl across the gallery floors to make their own inventive drawings inspired by the work of the older master. Some of the youngsters focused on Bearden's abstract shapes; some attempted to grasp his sense of fractured figuration; some made loose interpretations that moved far afield from their source in Bearden's imagery. These promising artists invariably worked with quiet intensity, totally captivated by Bearden's colorful (in all senses of the word) world. Their adult counterparts were equally enthralled as they walked through the galleries, engaging in discussion about the work if they were with friends, or in quiet meditation if they were alone.

These Bearden enthusiasts included first-time museum visitors, veteran art junkies who never miss an exhibition, art historians who review and update our understanding of this visual world, and artists who engage a wide range of styles and materials. For all of them, Bearden's understanding of his world helped them to expand their own. His art conveyed something

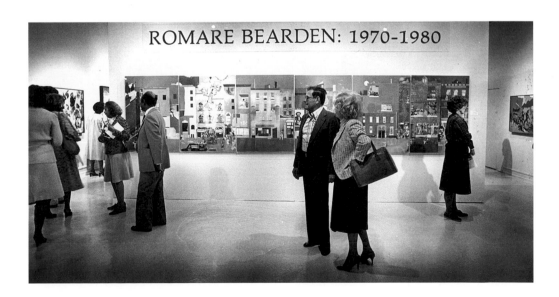

Fig. 3
Opening of Romare Bearden: 1970–1980 *at The Mint Museum*, October 1980
Photography courtesy of *The Charlotte Observer*

of importance to almost everyone who entered the exhibition, and the galleries tended to be crowded. Yet the atmosphere was never raucous. Bearden's highly dynamic and personal world commanded respect as well as enthusiasm. Rooted in Western art, literature, and philosophy, Bearden's oeuvre likewise embraces African and Asian cultures, creating that distinctive amalgam that is recognizably his, a celebration of the lives of African Americans within the universe of human experience as the artist understood it.

Initially inspired in the 1930s and 1940s by political cartoons, Mexican murals, and European Cubism, Bearden's early work was tempered in the 1950s by the artist's several-year commitment to songwriting; his introduction to Chinese calligraphy and scroll painting; and his brief foray into Abstract Expressionism. By the early 1960s, however, Bearden's course as an artist was set. His nominal subjects became focused on a group of places—Pittsburgh, New York, and Mecklenburg County, North Carolina; and his formal means were impacted by a commitment to collage, peppered by the inclusion of mid-twentieth century photo-based reproductive technologies such as Photostat and Xerox as part of his process. In later decades, a return to using watercolor extensively, a growing interest in printmaking (in editions and as unique objects), plus his extensive time in the Caribbean landscape extended both his medium and his subject base.

Highlighting Bearden's birthplace in Mecklenburg County, where he returned repeatedly as a child and sporadically as an adult, *Romare Bearden: Southern Recollections* reveals how the artist's imagination remained riveted on this milieu: the cotton pickers, melon season, and barns; the landscape and wildlife; the blues and sex. The exhibition also reveals that family and friendship were central to Bearden's world, and that his Southern recollections meshed with those of his other stomping grounds to function within the realms of myth, memory, and metaphor (to borrow and extend the title of Bearden's first major posthumous exhibition, at the Studio Museum in Harlem in 1991). Indeed, in many ways, Bearden's images of Mecklenburg County and other Southern sites stand as a microcosmic representation of the larger world that he portrays.

Bearden's titles tell us that both quotidian and religious rituals function to organize that cosmos: *Watching the Good Trains Go By* (see pl. 39), *Fish Fry* (see pl. 83), *Return of the Prodigal Son* (see pls. 43–44), *The Baptism* (see pl. 74). And titles as well reflect the importance to him of color and music, of time and place: *Autumn of the Red Hat* (pl. 1), *Evening of the Gray Cat* (see pl. 6), *Train Whistle Blues* (pls. 2–3), *Back Porch Serenade* (see pl. 56), *Evening Guitar* (see pl. 62), *Madeleine Jones' Wonderful Garden* (see pl. 46), *Mississippi Monday* (pl. 4), and *Mecklenburg County, Lamp at Midnight* (see pl. 21). The collage aesthetic that took root in Bearden's art in the early 1960s energized what was to become his expanding compendium of motifs—rainbows, lovers, couples in conflict, mothers with babies, and multiple generations of women supporting

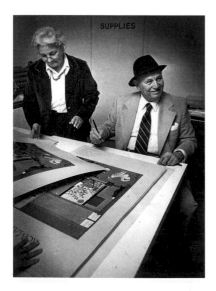

Fig. 4
Romare Bearden signs posters at The Mint Museum, October 1980
Photography courtesy of *The Charlotte Observer*

Pl. 1

Autumn of the Red Hat, 1982
Collage and watercolor on board,
30 ½ × 39 ⅝ inches
Virginia Museum of Fine
Arts, Richmond. The National
Endowment for the Arts Fund for
American Art. 95.17

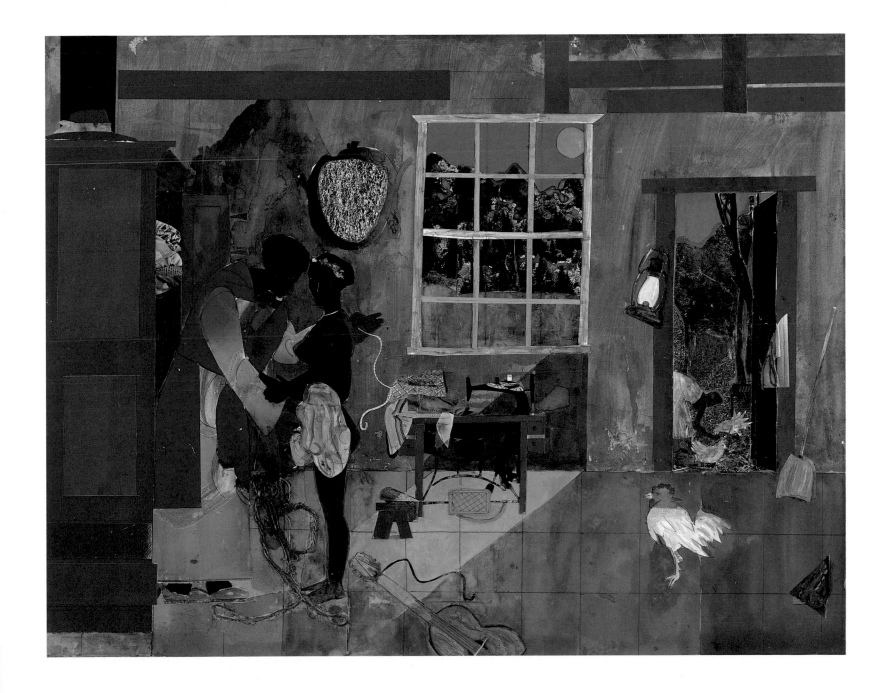

each other. The artist's rich compilation of collage layering parallels the complexity of human experience to project meaning beyond any ostensible subject.

In addition to the types of work exhibited here, Bearden's visual art includes posters, record album covers, and other functional designs. This work, and his songwriting and related poetry, are but two aspects of his vast cultural contributions, however. He also was a prolific documentary wordsmith throughout his life. Bearden's extensive writings about his own art began with a 1940 note that accompanied his first solo exhibition of oils, water-colors, gouaches, and drawings (in any given period he would work in several media) at 306 141st Street, a Harlem gathering place for artists and intellectuals. Among his best-known essays is "Rectangular Structure in My Montage Paintings," published in the art magazine *Leonardo* in 1969; and one of his last personal statements was for the catalogue accompanying *Riffs and Takes: Music in the Art of Romare Bearden*. This exhibition at the North Carolina Museum of Art, Raleigh, was on view at the time of the artist's death (12 March 1988). It was a fitting closure for a life in which music and music-related motifs played a seminal role, as evident throughout *Romare Bearden: Southern Recollections*.

Bearden's essays also addressed subjects well beyond his own art. In the 1930s, "The Negro Artist and Modern Art" and "The Negro in Little Steel" were published in *Opportunity: Journal of Negro Life*. His many subsequent texts—some broad in conception, others more personal—include "The Negro Artist's Dilemma," in *Critique: A Review of Contemporary Art* (1946) and "The Poetics of Collage," in *Art Now: New York* (1970). With his friend the painter Carl Holty, Bearden was co-author of *The Painter's Mind: A Study of the Relations of Structure and Space in Painting* (1969). Indeed, the Bearden bibliography includes dozens of listings, among them the many memorial tributes he composed to honor his distinguished roster of friends, including Charles Alston, Robert Blackburn, Aaron Douglas, Norman Lewis, and Hale Woodruff. Moreover, two important volumes have been issued since Bearden's passing. The first was a ground-breaking study that Bearden co-authored with another close friend, the journalist Harry Henderson, published in 1993—*A History of African-American Artists: From 1792 to the Present*. The second is Bearden's charming illustrated children's book, *Li'l Dan, the Drummer Boy: A Civil War Story*, with an introduction by Henry Louis Gates Jr., published ten years later.

Bearden was otherwise active in the art community as well, in particular by organizing many group exhibitions. They often were accompanied by publications to which he contributed, such as *Celebration: Eight Afro-American Artists Selected by Romare Bearden* (1984), which featured work by Emma Amos, Toyce Anderson, Ellsworth Ausby, Vivian Brown, Nanette Carter, Melvin Edwards, Sharon Sutton, and Richard Yarde. Bearden's inclusion of so many women artists at that moment in time is worth noting. Likewise, he was instrumental in establishing exhibition venues such as Cinque Gallery, and the Studio Museum in Harlem, which were supportive of artists in the African American community. He was, indeed, the larger-than-life character those who knew him describe.

These related artistic and community activities would have nourished Bearden's imagery, just as his travels elsewhere brought his attention back to his important roots in the South, and the depth of human experience they provided. *Romare Bearden: Southern Recollections* is based on this premise. When you go to see it, be sure to look for the school children sprawled on the floor of the galleries making drawings.

Pl. 2

Train Whistle Blues No. 1, 1964
Photostat on fiberboard,
29 × 37 ½ inches

Pl. 3

Train Whistle Blues: II, 1964
Collage of various papers with paint
and graphite on cardboard,
11 × 14 ⅜ inches

Pl. 4

Mississippi Monday, 1970
Mixed media collage on panel,
11 ½ × 14 ¾ inches

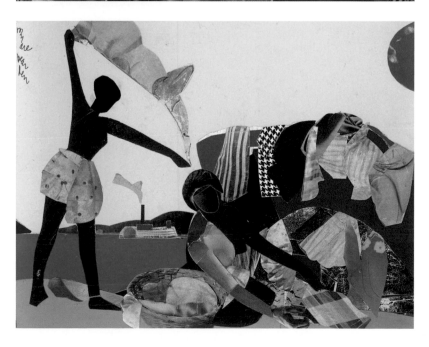

PREFACE – RUTH FINE

INTRODUCTION

Carla M. Hanzal

Most artists take some place, and like a flower, they sink roots, looking for universal implications. . . . My roots are in North Carolina.

Romare Bearden [1]

The master artist tends to forego surface refinements and to abjure all that is not of the deep wisdom of poetry. Secure in his space and structure, he is at one with the world he was born into and that world of difficulties he has overcome, and can now be seen for what he truly represents.

Romare Bearden [2]

Becoming "one with the world he was born into" was a process that took more than half a lifetime for Romare Bearden. With great clarity, Bearden sought from the beginning to make art that would be timeless and historically durable.[3] He succeeded in creating masterful works drawn in large part from the proverbial soil where he sunk his roots—Mecklenburg County, North Carolina—where he was born and lived as a young child, and which eventually served as the landscape of his imagination. Through accomplished acts of recollection and commemoration, Bearden forged rich narratives that convey universal statements.

Early in his career, when Bearden decided to abandon his work as a political cartoonist and pursue a career in the fine arts, he followed the advice of his mentor German émigré artist George Grosz, with whom he studied in the early 1930s at the Art Students League in New York. Grosz encouraged Bearden to reconstruct his own and his people's histories, as well as to study the Flemish and Dutch masters: Pieter Brueghel, Johannes Vermeer, and Pieter de Hooch. It was also likely Grosz who introduced Bearden to the photomontage techniques of the Dadaists, including, among others, Grosz, John Heartfield, and

Hannah Höch. Having experienced the ravaging aftermath of World War I, these artists responded by creating shocking, fragmented images that forced a glimpse at social ills, tricking people into seeing the disdainful and the grotesque.

Bearden spent nearly thirty years exploring a variety of styles—Social Realism, stylized figuration, and even Abstract Expressionism—trying to find his particular mode of expression. Unifying these diverse practices was Bearden's eschewal of linear perspective, his modernist focus on color and value, and his persistent quest to find the best means to arrange pictorial space. Throughout most of this time, Bearden was employed as a social worker in New York City, working with the Gypsy population. He read literature, mythology, and philosophy; exhibited in significant galleries in New York and Washington, D.C.; and was friends with some of the most important artists of the time—Stuart Davis, Jacob Lawrence, Norman Lewis, and William H. Johnson.[4]

In the early 1950s Bearden worked successfully as a composer, but shortly thereafter he experienced a crisis, a mental breakdown, perhaps the result of

deviating from what he could not escape. His unmistak-able mission was to reveal the unseen and to "work out of a response and need to redefine the image of man in terms of the Negro Experience I know best."[5] With nothing more left to lose, Bearden transformed him-self and devoted himself to painting. Another decisive juncture came in 1963 when Bearden helped to form Spiral, a group of African American artists who organ-ized in response to the Civil Rights movement. Bearden suggested that this group collaborate to create a collage. The idea did not adhere with the group, but for Bearden, this technique became his métier.

By combining fragmented imagery, Bearden devised a means of presenting the lives of African Americans with empathy and without sentimentality. Bearden's arma-mentarium had been building over time—his experience of social critique as a cartoonist, his empathy as a social worker, his collective memories of the South from his childhood, his migration North, and his rich urban experi-ences all coalesced as he mastered the possibilities of photomontage and collage. From the mid-1960s onward, Bearden's powerful collages confronted pervasive ster-eotypes about African American life and culture. He was able to claim these images as his own, to transform them into universal statements steeped in myth and ritual, revealing both the grotesque and the beautiful.

Bearden's work sheds light on the universal in the everyday: the rituals of connection to family and friends, the communal meal (greens, fish, and bread) that was the reward of toiling with the earth and coaxing its bounty. His art also celebrates spiritual practices—old rites of cleansing, rebirth, and renewal—through its depictions of baptisms and bathing. He used the particular details of the experiences he recollected from his rootedness in the South and his observations of the sounds and rituals around him.[6] Bearden's friend the writer Ralph Ellison, famed for penning The Invisible Man (1952), greatly admired the artist and wrote of the unique essence of his practice:

> Bearden seems to have told himself that in order
> to possess the meaning of his Southern childhood
> and Northern upbringing, that in order to keep his

memories, dreams and values whole, he would have to recreate them, humanize them by reducing them to artistic style. Thus in a poetic sense these works give plastic expression to a vision in which the socially grotesque conceals a tragic beauty, and they embody Bearden's interrogation of the empiri-cal values of a society which mocks its own ideals through a blindness induced by the myth of race.[7]

Moreover, Bearden believed an artist could be an "enchanter of time," devising new histories within the narrative space of a work of art or series of works.[8] The fragmented images Bearden painted, gleaned from mag-azines, and arranged to create a whole are as much a part of the content of his compositions as are the events and people they represent. His use of collage, which empha-sizes the coalescing of fragments, conveyed a dream-like quality, and was therefore a perfect vehicle for images of both his memories and his recollected perceptions of the landscape of his active imagination.

Among the abiding connections that Bearden cel-ebrated was the relationship between a mother and child. He often portrayed resilient, self-reliant women, like his grandmothers, his great-grandmother, and his mother Bessye Bearden, a formidable social force who passed away suddenly when Bearden was only thirty-two. The mother's face in Mother and Child, ca. 1976–77 (pl. 5), is signified by a regal Benin mask, which gives both poig-nancy as well as a pause—the familiar has become unfamiliar. Yet this uncanny mother remains central, the essential nurturer, taking her young daughter by the hand and literally overseeing the hearth and home. The moth-er's stately visage offered a new classicism rooted in both Africa and in the rural South. A colorful fire bursts from the cauldron, while a white cat—a lively curvilinear cut-out—rubs against the mother's feet. The cat, so pervasive in Bearden's work, is a symbol, although its meaning is not entirely clear. Perhaps it serves as a protector, as was the tradition in Egypt: known for its nine lives, the cat can endure many demises. Through stealth and agility it easily traverses borders, perhaps signifying memory itself.

The multigenerational family Bearden portrays in Evening of the Gray Cat, 1982 (pl. 6 and fig. 5), testifies to

Pl. 5

Mother and Child, circa 1976–77
Collage on canvas mounted on
Masonite, 48 × 36 inches

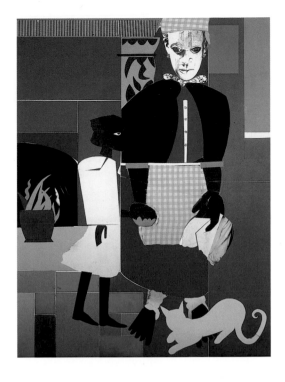

Pl. 6

Evening of the Gray Cat, 1982
Collage on board, 30 × 40 inches

the significant bonds and restorative sanctuary of home. Within this welcoming interior, lamps are lit as the evening sky darkens (from blue to violet, as viewed through the two windows). The musician is offered a cool drink, while an older woman slices a ripe melon at the kitchen table. The cat—barely perceptible, but emphasized by Bearden's tilted perspective—sleeps on the stool by the butter churn. A framed portrait of an ancestor oversees the peaceful scene of conviviality and connection.

More complex rituals are presented in *Evening: Off Shelby Road*, 1978 (pl. 7). In this scene, set in Mecklenburg County, the full moon streams light through the window, and an old woman appears to wind yarn into a skein, while a young woman bathes near the warmth of the stove. The theme of ritual bathing is prevalent in Bearden's oeuvre as a rite of purification. One source for this imagery is the Apocrypha story of Susanna, who was spied upon by lecherous elders as she bathed. When she refused their advances, they accused her of impropriety. However, Susanna ultimately triumphed; she succeeded in speaking truth to power, and therefore "embodies the deliverance of the righteous person from evil."[9] Bearden

frequently returned to this motif of a bathing woman, protected by an older relative, as is apparent in compositions including *Sunrise*, 1983 (pl. 8), and *Mecklenburg Early Evening*, 1982 (pl. 9). In all of these compositions, Bearden strategically leaves the viewer with the voyeuristic perspective.[10]

A suggestively draped woman dresses after a sponge bath in *Morning Train to Durham*, 1981 (pl. 10), while light streams through the open windows and doors. One important difference between this bathing scene and the others lies in the absence of the elder protector and the presence of a train, visible across the field at the horizon. Much has been surmised about Bearden's use of the train in his art, and it might certainly represent a mode of departure as well as a means of returning.

In Bearden's early childhood memories, his great-grandparents' comfortable, multigenerational home was the locus of family connection. Its solidity signified a strong foundation, hopes of continued upward momentum. Bearden's prosperous great-grandfather owned his own store; Bearden's college-educated father also worked there and played hymns at church every Sunday.

Fig. 5
Manu Sassoonian
Romare Bearden in studio with
Evening of the Gray Cat, circa 1982
Photography © Manu Sassoonian

Pl. 7

Evening: Off Shelby Road, 1978
Collage, watercolor, and ink on
board, 17 ½ × 13 ½ inches
Cameron Art Museum, Wilmington,
North Carolina: Purchased with
funds from the Claude Howell
Endowment for the Purchase of
North Carolina Art, 2002.8

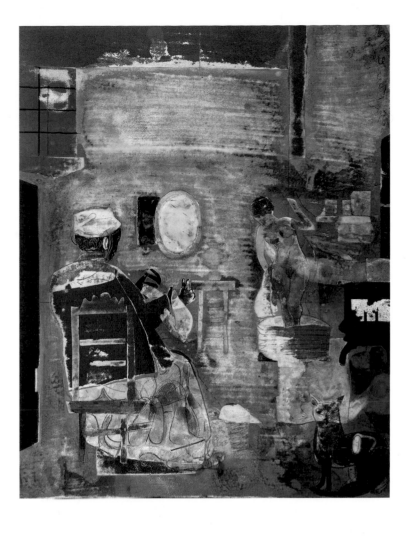

Pl. 8

Sunrise, 1983
Collage and watercolor on
board, 10 ¼ × 14 inches

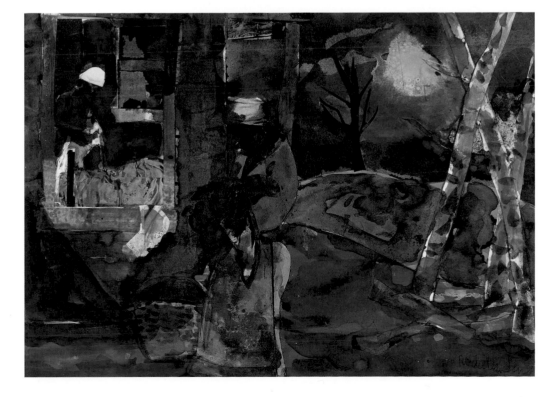

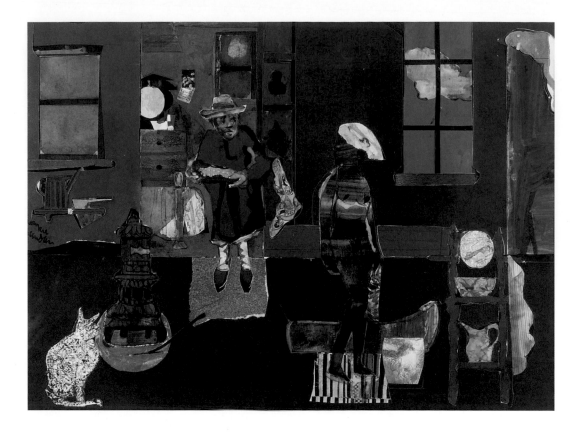

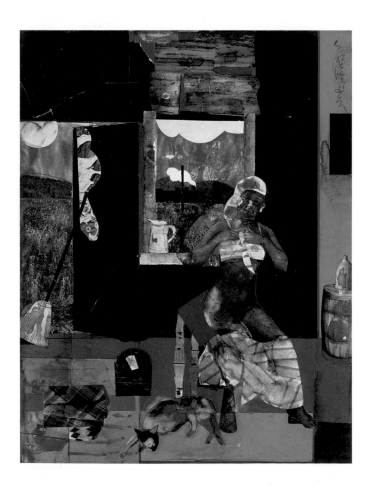

Pl. 11

*Profile/Part I, The Twenties:
Mecklenburg County, Railroad
Shack Sporting House*, 1978
Collage of various papers with
fabric, paint, ink, graphite, and
bleached areas on fiberboard,
11 ⅛ × 16 ½ inches

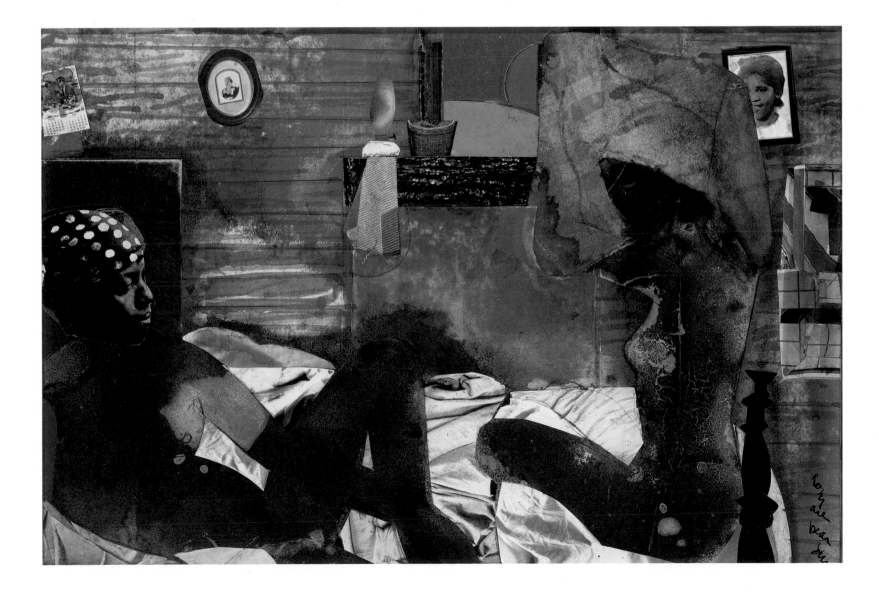

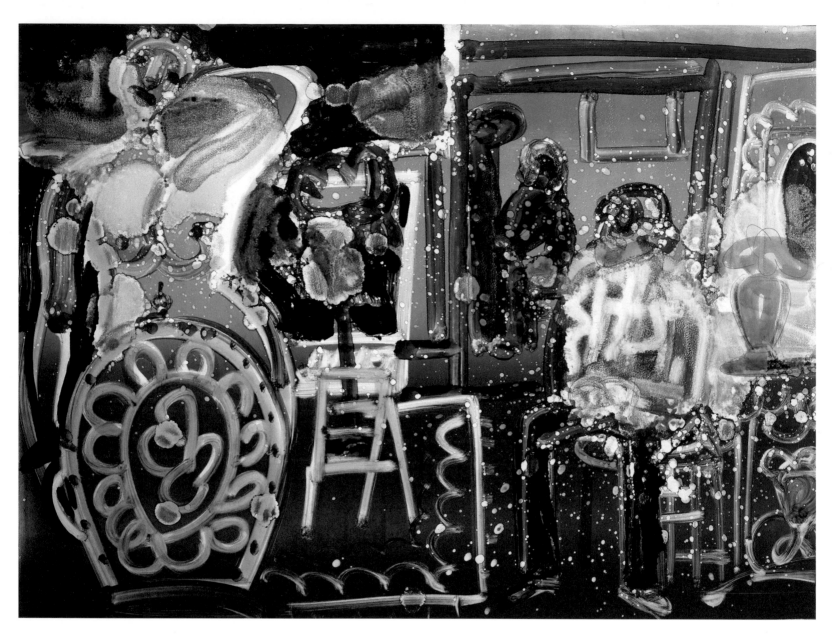

Pl. 12

New Orleans: Storyville Entrance, 1976
Monotype with graphite on paper,
29 ½ × 41 inches

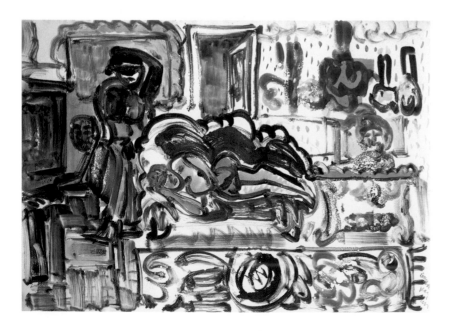

Pl. 13

New Orleans Joys (Storyville), 1977
Oil on paper, 29 ¼ × 40 ½ inches

Pl. 14

Of the Blues: New Orleans, Ragging Home, 1974
Collage of plain, printed, and painted papers, with acrylic, lacquer, graphite, and marker mounted on Masonite panel, 36 ⅛ × 48 inches

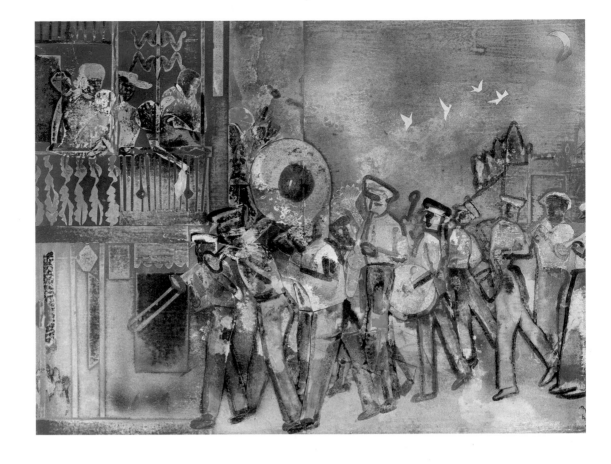

Pl. 15

Farewell in New Orleans, 1975
Cut paper, newsprint, and glossy magazine paper on board, 14 ¼ × 18 ¼ inches

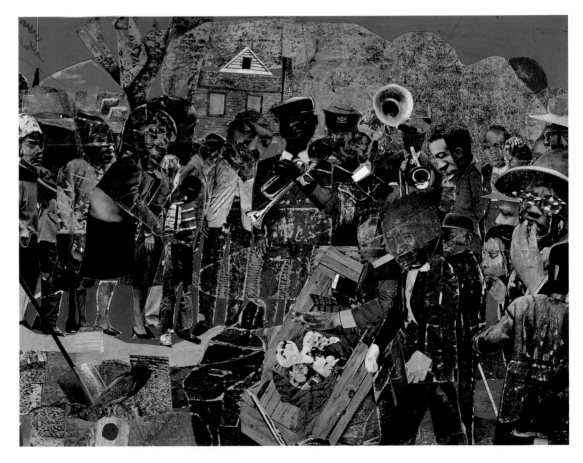

The train trestle directly beside this grand house made the trains virtually part of the domicile, their sounds announcing morning and evening destinations. For Bearden, the trains were an ever-present marker of time. Undoubtedly the rumbling of these locomotives also offered the sound of possibility, and heralded change. At age four, Bearden experienced a quick expulsion from this paradise of a secure home, when the oppression of the Jim Crow laws proved too much for his parents to bear and they migrated to the North. The powerful train on which they departed was like the *deus ex machina* (the god out of the machine) that delivered them from what was untenable. But it also plunged them into uncertainty, fracturing their family, so abruptly were they uprooted.[11]

The train, and the lives of the African Americans who worked for the railroad and lived nearby, were pervasive in Bearden's work about the South. Bearden portrayed the seedier side of life by the tracks in *Mecklenburg County, Railroad Shack Sporting House*, from the series *Profile/Part I, The Twenties*, 1978 (pl. 11), a frank portrayal of prostitutes. Bearden re-imagined history in his lyrical depictions of the famed brothels of turn-of-the-century New Orleans's Storyville district, such as *New Orleans: Storyville Entrance*, 1976 (pl. 12), and *New Orleans Joys (Storyville)*, 1977 (pl. 13). Bearden's images of Storyville can be linked to an exhibition of photographs by the early twentieth-century photographer E. J. Bellocq at New York's Museum of Modern Art. Bellocq's original glass negatives of Storyville scenes were restored, and new prints made and put on view, in 1970. Investigations into the history of this legalized red light district reveal that dark-skinned prostitutes frequently were forced to become women of the streets, while the more opulent parlors of Storyville, as portrayed in Bellocq's photographs, were populated by light-skinned women.[12] Ruth Fine surmises that Bearden used visual strategies to alter this history: "one wonders if Bearden's vision here was again specifically responsive to an exhibition and political, placing the black women he admired and loved in an elegant setting from which Bellocq erased them."[13] Bearden eulogized Storyville by rendering the parlors with loose lines that recall Henri Matisse's linear abstrac-

tions. Storyville, significantly, is also known as the district that was the birthplace of jazz.

New Orleans's rich jazz legacy is further addressed in *Of the Blues: New Orleans, Ragging Home,* 1974 (pl. 14), and *Farewell in New Orleans*, 1975 (pl. 15). As an indigenous art form, Bearden acknowledged "jazz's potency as a symbol of African American culture," and its layering of sound and syncopated rhythms as "a representation of modernity."[14] In these collages Bearden celebrates New Orleans, where music is part of the fabric of life and offers both jubilation and consolation.

Another recurrent motif, the harvest, reveals Bearden's reverence for those individuals who coax the earth's bounty. The two fishermen in *A Very Blue Fish Day on Mobile Bay*, 1971 (pl. 16), gather heavy nets filled with the catch of the day. The vibrant sky and bay seem to meld into one flat, yet infinite space. *House in Cotton Field*, 1968 (pl. 17), depicts a sharecropper's home at the edge of a field. The red sun is low on the horizon, while a cloudless blue sky intersects with what appears to be water at the field's edge. A father and daughter toil in the field as an older woman nears the house with a sack full of cotton. Bearden has collaged an image of a tape measure across the front of the house, as though these fleeing days are being quantified. A small child, too young to work the field, makes his way up the path leading home. Within the lamp-lit house, a younger woman, likely the mother, reveals her bare back as she quickly changes to prepare dinner. A golden light illuminates the roof of this humble dwelling, honoring its inhabitants' resilience.

Bearden celebrated the lives of his forebears, and the connection that they had to each other and to the land that provided them sustenance. In *Conversation Piece*, 1969 (pl. 18), three women have gathered in a field away from their homes and are engaged in an exchange. In *Eastern Barn*, 1968 (pl. 19), two men convene in the barn while a little girl sits quietly nearby with her basket of chicken eggs. *Evening Limited to Memphis*, 1987 (pl. 20), is another quiet evening scene depicting two men on a porch. A large moon looms overhead, visible simultaneously from the exterior—where a woman still works—and through the interior window. At the distant horizon, a train cuts through the landscape, punctuating the peace-

Pl. 16

*A Very Blue Fish Day on
Mobile Bay*, 1971
Mixed media collage on Masonite,
18 × 24 inches

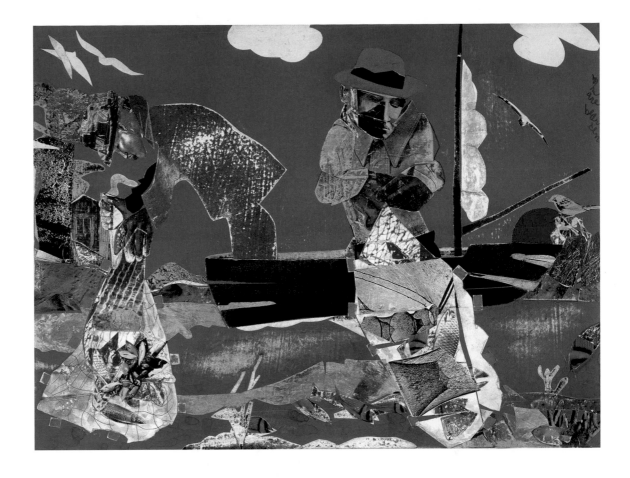

Pl. 17

House in Cotton Field, 1968
Collage of various papers on
fiberboard, 30 × 40 inches

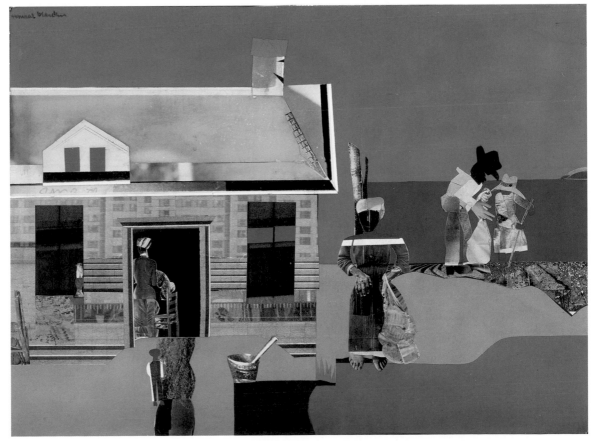

Pl. 18

Conversation Piece, 1969
Collage, fabric, and graphite on
paper, 17 ½ × 20 inches

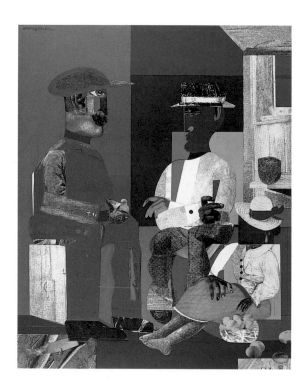

Pl. 19

Eastern Barn, 1968
Collage of paper on board,
55 ½ × 44 inches
Whitney Museum of American Art,
New York; Purchase 69.14

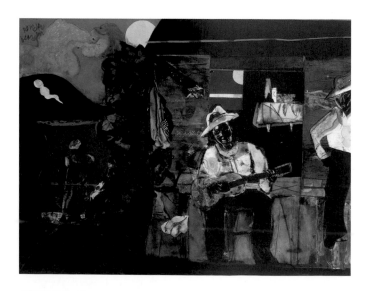

Pl. 20

Evening Limited to Memphis, 1987
Collage on board, 14 × 18 inches

Mecklenburg County,
Lamp at Midnight, circa 1979
Mixed media collage on board,
17 ¾ × 13 ½ inches
Georgia Museum of Art,
University of Georgia; museum
purchase with funds provided
by the Friends of the Museum
on the occasion of the
museum's 50th anniversary.
GMOA 1998.21

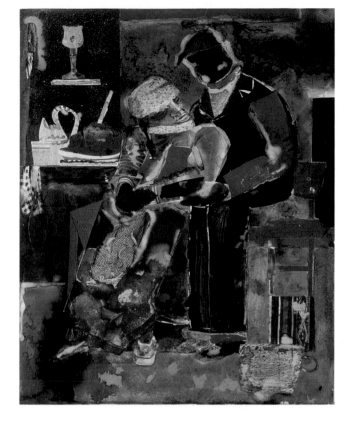

PI. 22

Carolina Reunion, 1975
Collage and watercolor on
paper, 21 ½ × 15 ¼ inches

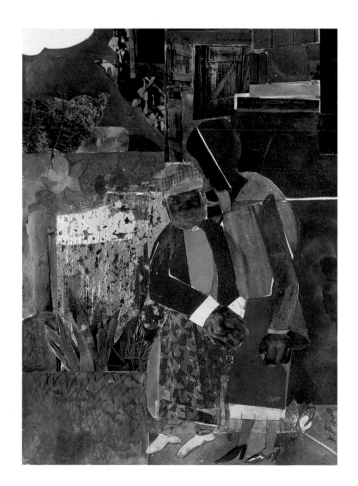

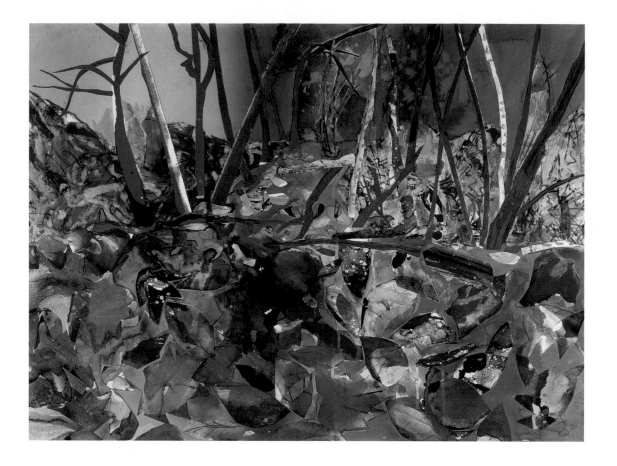

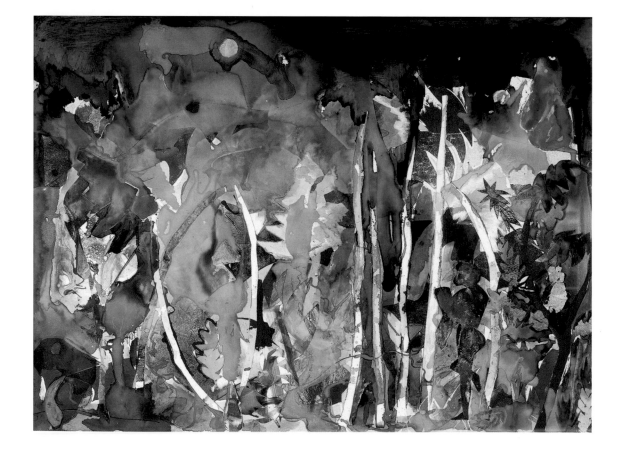

Pl. 25 35

Carolina Autumn, 1984
Collage on board, 12 × 16 inches

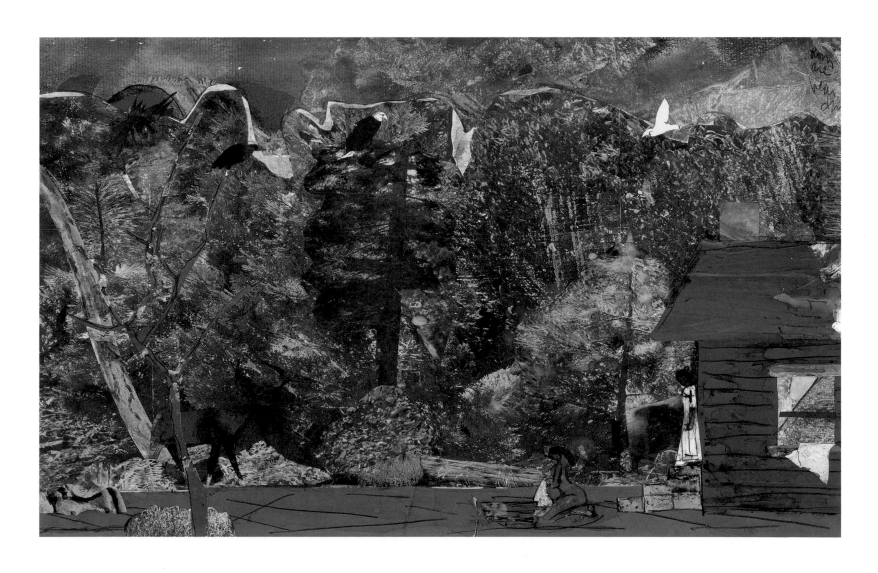

ful evening and signifying change. Yet even within these portents of change, Bearden finds continuity. Inviolable truths remain: sustaining love, as seen in the tender scene in *Mecklenburg County, Lamp at Midnight*, circa 1979 (pl. 21), which is bathed in radiant light; and the rootedness of family, as seen in *Carolina Reunion*, 1975 (pl. 22), where the citified daughter returns to the red clay patch of her ancestors.

In Bearden's last decade he found inspiration in the land itself. Two of his most beautiful depictions of place are *Mecklenburg Autumn: October—Toward Paw's Creek*, 1983 (pl. 23), and *Mecklenburg Autumn: September—Sky and Meadow*, 1983 (pl. 24). In both images, light permeates the land as though the passing of time has burned away the dross, and the darkness has been transformed and made palatable. In *Carolina Autumn*, 1984 (pl. 25), the bathing woman, no longer confined to the interior, seemingly becomes one with the landscape.

Created three years before Bearden's death, *Winter (Time of the Hawk)*, 1985 (pl. 26), a starkly beautiful landscape, could well represent the South's foothills. The ponds are frozen and the hills are covered with snow. In this scene there are no people; the landscape is made clear for the birds and animals. A red fox peers from behind a bare tree and two hawks circle high above, while two more perch on branches below. These birds are journeying things with powerful abilities: they can see from afar, and can fend for themselves, grasping what they need with their sharp talons. It is likely no coincidence that Bearden admired Brueghel's painting *Winter*, 1565 (fig. 6), which he writes about in his 1969 book *The Painter's Mind*: "Brueghel required a great sweep of pictorial space. . . . A marvelous bird, positioned perfectly in the painting, glides swiftly across the field."[15] Instead of using Brueghel's aerial perspective, Bearden created disparate spatial relationships so that the foreground appears to be viewed from above; the middle, as if viewed straight ahead; and the distant hills from the ground upward, a compositional technique often used in Chinese paintings. Bearden emphasized that the birds are survivors in the barren landscape, yet his winter scene is tinged in green, offering transformation and renewal. In this late landscape, Bearden, the soaring raptor, was perhaps able to return home.

Through his faith in the transformative powers of art, Bearden found the answer to what it means "to be at one with the world he was born into." Mecklenburg County provided a rich source of inspiration, imagery, and a sense of rootedness, all of which Bearden drew upon as he matured and his career flourished. Over the years he tapped both the dark shadows and the rich fertility of his first home, and through his skillful rites of recollection and eulogization, Bearden satisfied his search for self and place.

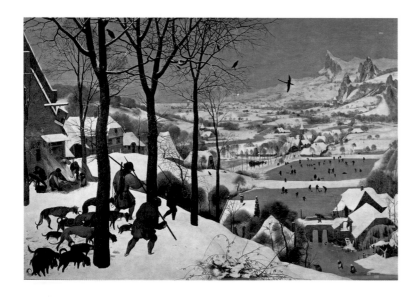

Fig. 6
Pieter Brueghel
Return of the Hunters (Winter), from the six-painting series *The Seasons*, 1565
Kunsthistorisches Museum, Vienna, Austria
Photography by Erich Lessing / Art Resource

Notes

1. "Most artists take some place, and like a flower, they sink roots, looking for universal implications, like James Joyce did in Dublin and the photographer Mathew Brady did for the Civil War. My roots are in North Carolina. I paint what people did when I was a little boy, like the way they got up in the morning. But I would like it to have more." Bearden, quoted in Myron Schwartzman, *Romare Bearden: His Life and Art* (New York: Harry N. Abrams, 1990), 256.

2. Bearden, quoted in Romare Bearden and Carl Holty, *The Painter's Mind: A Study of the Relations of Structure and Space in Painting* (New York, 1969; repr. New York: Garland Publishing, 1981), 218.

3. Mary Schmidt Campbell, "Romare Bearden: A Creative Mythology" (Ph.D. diss., Syracuse University, New York, 1982), 534.

4. Roberta Smith, "Visions of Life, Built From Bits and Pieces," *New York Times*, 2 April 2011, C1.

5. Bearden, quoted in M. Bunch Washington, *The Art of Romare Bearden: The Prevalence of Ritual* (New York: Harry N. Abrams, 1973), 9.

6. Bearden wrote that at the time it was his goal "to show that the myth and ritual of Negro life provide the same formal elements that appear in other art." Quoted in Grace Glueck, "A Bruegel from Harlem," *New York Times*, 22 February 1970, 29.

7. Ralph Ellison, in the introduction to Bearden and Holty, *The Painter's Mind*, xv.

8. Steve Crump, *Romare Bearden: Charlotte Collaborations* (documentary film) (Charlotte, NC: WTVI [PBS affiliate], 2003).

9. Gail Gelburd, "Romare Bearden in Black-and-White: The Photomontage Projections of 1964," in Gelburd and Thelma Golden, with Albert Murray, *Romare Bearden in Black-and-White: Photomontage Projections, 1964* (New York: Whitney Museum of American Art, 1997), 33. This theme is also apparent in *Conjur Woman as an Angel*, 1964 (see pl. 68).

10. Judith Wilson remarks that there were few images of the nude African American female prior to the 1960s, and observes that "Romare Bearden managed to transcend the widespread stigmatization of black sexuality . . . visualiz[ing] the historic conjunctions of black female beauty and eroticism with jazz, blues, African-American folklore and religion as well as African-derived visual practices." See Wilson, "Getting Down to Get Over: Romare Bearden's Use of Pornography and the Problem of the Black Female Body in Afro-U.S. Art," in *Black Popular Culture: A Project by Michelle Wallace*, ed. Gina Dent (New York: Dia Center for the Arts, 1970), 113.

11. "I use the train as a symbol of the other civilization—the white civilization, and its encroachment on the lives of the blacks. The train was always something that could take you away." See Bearden, quoted in Gelburd, "Romare Bearden in Black-and-White," 21.

12. Ruth Fine, *The Art of Romare Bearden* (Washington: National Gallery of Art, 2003), 92-95. Fine cites Deborah Willis and Carla Williams, *The Black Female Body: A Photographic History* (Philadelphia: Temple University Press, 2002), 56-57.

13. Fine, 95. For a discussion of the risk Bearden took in portraying the black female nude, see Sharon F. Patton, *Romare Bearden: Narrations* (Purchase, NY: Neuberger Museum of Art, Purchase College, State University of New York, 2002), 11–12.

14. Patton, 13.

15. Bearden, *The Painter's Mind*, 122–23.

PL. 26

Winter (Time of the Hawk), 1985
Collage of various papers with paint, ink, and graphite on fiberboard, 10 ¾ × 13 ¾ inches

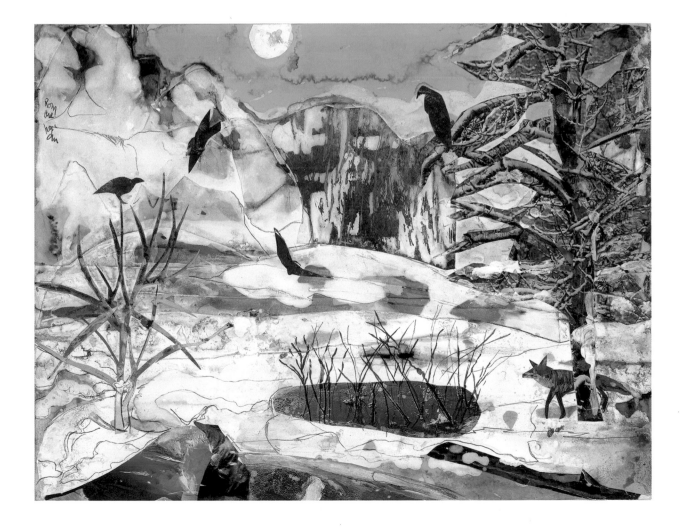

ROMARE BEARDEN'S MECKLENBURG MEMORIES

Glenda Elizabeth Gilmore

You know, in Eliot's poem, The Four Quartets, he talks about time, and you're going back to where you started from, but maybe you're bringing another insight, another experience to it. And things that may be nonessential have been stripped away, and you can see that the things that still stick in your mind must be of some importance to you. Like the people I remember, the pepper jelly lady, a little girl [who] kind of played with me, Liza. All of these things that now came back to me.

Romare Bearden[1]

The traditional narrative of Romare Bearden's life is a heartwarming story of the poor made rich and the primitive made highbrow. It is an American story that posits progress as linear, generational class position as steadily improving, and racial discrimination as inexorably fading—from the Emancipation Proclamation to Martin Luther King's "I Have a Dream" speech. But Bearden's life and the lives of three generations of his Southern black family before him belie the typical story of people rising very slowly as they climbed. What happened to them was much worse: the political economy of racism constantly remade itself to thwart their hopes. Each generation ascended the mountaintop, only to be knocked back by protean white supremacy.

Bearden's family began Reconstruction with middle-class trappings: literacy, good jobs, a large Victorian home with a wraparound front porch, and a small business. Each generation followed the playbook of the American dream: they worked hard, went to college, and were civic activists. But the malignant growth of white oppression overwhelmed their striving. It diminished the value of their homes and businesses, forced college graduates

into menial jobs, threatened to take young Romare away from his parents, and caused them to flee the South for their safety.[2]

Bearden understood the nonlinear path of his family as he reconstructed his historical memory of the South in his art. He told an interviewer, "Time is a pattern. . . . You can come back to where you started from with added experience and you hope for more understanding." But, he hinted, his homecoming slipped the bonds of reality and entered the realm of the mythical: "You leave and then return to the homeland of your imagination."[3] Art historians, interviewers, and biographers have assumed that Bearden actively remembered Mecklenburg County from his childhood, but there was a far more complicated process at play in his artist creation. His biographer marveled, "Bearden seems singular in having internalized much of the subject matter of his art by the time his memory was fully formed."[4] However, Bearden could not see these memories in whole. Instead, they were fragments of a past that he found he could recover through the process of collage. He began with rectangular planes of color, added paper, incorporated cutout material such as illustrations or fabric, and painted

and drew his memories across the disjunctures. He followed the same process again and again in the same work. If something nagged at him, but he could not quite see it in his mind, he turned to the Sears, Roebuck and Company catalogue. Much like an historian using an archive, Bearden kept a copy of the catalogue (circa 1900) in his studio. He used it as a memory prompt. For example, when he was trying to depict a Singer sewing machine, he recalled: "It was hard to carry the full memory of something like that in your mind."[5]

Bearden did not expect to traffic in "full" memories—their wispiness was part of his artistic experience. He counted on the pieces that surfaced to lead him on: "Well, the memories are just there; they're just really with me. It's strange, the memories are there." "Sometimes," he conceded, "you have to surrender something," but often enough, he "stayed with it, and finally it came through."[6] Bearden trusted the process: "Maybe sometimes a third of the way through, I'll say, 'I know this is coming through.'" He understood his work to be like that of Édouard Manet, whom he quoted as saying, "A painting isn't finished; sometimes you get on the surface."[7] Bearden's art provides a rich archive of the African American experience, a lesson in modernism, and a lyrical legacy of Southern history.

Romare Bearden's great-grandfather Henry B. Kennedy was born in South Carolina in 1845 or 1846, and had been a "servant" to President Woodrow Wilson's father, Joseph. A young Presbyterian minister, Joseph Wilson moved to Staunton, Virginia, in 1849. Despite his Ohio roots, Wilson supported the Southern Presbyterians in their split from their Northern co-religionists over slavery, yet he tried to save the souls of slaves at the Sunday school he ran especially for them. In 1860, when young Thomas Woodrow Wilson was four, the Wilsons moved to Augusta, Georgia. It was probably there that Henry Kennedy, then about fifteen, became the Wilsons' "servant," a euphemism used after the Civil War to mean an enslaved person. Kennedy married Rosa Catherine Gosprey in 1863, when he was about seventeen. Rosa Catherine Gosprey was born in South Carolina in 1847, the daughter of Francis Gosprey, a white Portuguese carpenter who lived in both Chester and Charleston. In the years just before Rosa's birth, his prosperous household included thirteen white people, one free black man, and five slaves.[8] Like her husband, Gosprey appeared as a mulatto in the census. Emancipation and literacy brought Henry Kennedy a job as a mail agent on the Charlotte, Columbia, and Augusta Railroad, a position to which he clung until the end of Reconstruction, around 1877. The Kennedys treasured their legacy from the Wilsons: Joseph Wilson's favorite armchair, which they proudly showed off in their large, beautiful, Victorian home in a racially mixed neighborhood on South Graham Street, in downtown Charlotte. Today, the empty lot on which the Kennedy house once stood is in the shadow of the enormous stadium where the Carolina Panthers football team plays. Henry also owned a grocery store and some smaller rental houses in Charlotte.[9]

The Kennedys' daughter, Rosa Catherine ("Cattie"), was born as the Civil War ended, in 1865. Hope and progress served as the watchwords for this first generation after Emancipation. They lived in a fast-growing city, where one out of four people had been enslaved. Possibility abounded, and intersectional spaces opened up everywhere, from street corners to courthouses. Hope and progress meant walking a tightrope across such divides. It was important that they did not misstep. The Kennedys were among those African Americans who thought that if they could demonstrate to their white neighbors their ability to lead prosperous, pious, and productive lives, they would prove themselves worthy of citizenship. Freedom meant constraint.

At age fifteen, Cattie fell in love with Richard B. Bearden, a prosperous harness maker (figs. 7–8). By her seventeenth birthday, in 1882, their first son, Harry, had arrived, followed by daughter Anna in 1884, and Richard Howard (known as Howard) in 1888.[10] When Richard Sr. died unexpectedly in 1891, Cattie's children were three, seven, and nine. The widow continued to live with her parents in the family home and became a leading clubwoman active in the Woman's Christian Temperance Union (WCTU) #2, the African American affiliate of the white women's WCTU.[11]

Despite her early widowhood, life for Cattie Bearden and her three children seemed promising. Young Howard Bearden, Romare's father, grew up after his father's death

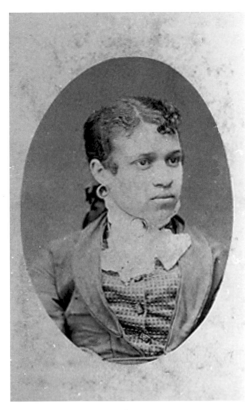

Fig. 7
Rosa Catherine (Cattie) Kennedy Bearden, date unknown
Courtesy of Robinson-Spangler Carolina Room, Charlotte Mecklenburg Library

Fig. 8
Richard Bearden, date unknown
Courtesy of Robinson-Spangler Carolina Room, Charlotte Mecklenburg Library

Fig. 9
Bearden surrounded by his great-grandparents; standing from left, his Aunt Anna, mother and father, and grandmother, circa 1917
Courtesy of Rousmanière Alston and Aida Bearden and Myron Schwartzman

in the security of his grandfather Henry Kennedy's home. He entered Bennett College, a private Methodist University in Greensboro, around 1906.[12] Howard married Bessye Johnson, a graduate of Virginia Normal and Industrial Institute in Petersburg, Virginia. Meanwhile, Cattie's daughter, Anna, married, bore a daughter, and become a widow. Cattie moved to Greensboro with Anna and her granddaughter around 1910.[13]

As newlyweds, Howard and Bessye Bearden moved to Charlotte, settling just around the corner from Howard's grandparents. Their son, Fred Romare Harry Bearden, was born on 2 September 1911. When Romare was three or four, around 1915, his parents left the South for Harlem; thereafter, he visited his grandmother in Greensboro and his great-grandparents—whom he simply referred to as his grandparents—in Charlotte over the course of five summers (fig. 9).

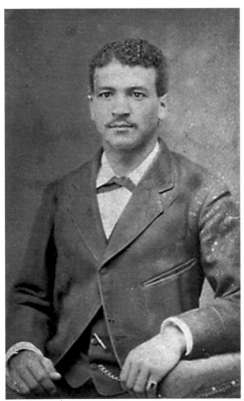

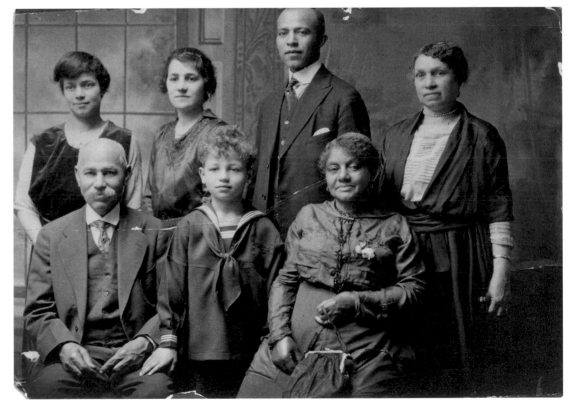

In 1940, Bearden returned to the South for the first time in fifteen years. His last visit had been in 1925, the year that both his great-grandmother Rosa Kennedy and his grandmother Cattie Bearden died.[14] In the previous decade, he had begun a career as a cartoonist while still an undergraduate at New York University, publishing in the college humor magazine and in the African American press. Bearden majored in education, hoping to teach math, but emerged upon his graduation in 1935 into the Great Depression. He published cartoons in *The Crisis*, the journal of the National Association for the Advancement of Colored People, and, for over two years, penned a weekly cartoon for the *Baltimore Afro-American* newspaper.

Being a cartoonist did not mean that Bearden took art lightly. He had studied with the expatriate artist George Grosz from 1933 to 1935. The German-born Grosz had leapt at a chance to teach at New York's Art Students League a few months after Hitler's takeover, in part because the artist had been a leading figure in what the Nazis called *Entartete Kunst*, or degenerate art. Grosz's years of formal study—1911 in Dresden, 1912 in Berlin, and 1913 in Paris—coincided with the revolutions in art that ushered in modernism. Artists rejected traditional methods of painting and familiar motifs, and many abandoned realism and emphasized parts over the whole. Some used color as a structural element, not simply as a reflection of nature.

Grosz shaped Bearden's work in fundamental ways. First, he taught Bearden techniques of draftsmanship that the young artist used to draw cartoons and later to plot collages. Grosz drew with a reed pen and instructed Bearden in the poetics of lines.[15] Second, he conveyed the excitement of three decades of European modernism by relating his American students' artistic inclinations to the new European movements. By the 1940s, Bearden's own work incorporated Fauvism, Cubism, and the photomontage of Dadaism. Bearden identified himself as a Cubist even after the mid-1950s, when he turned primarily to montage and later to "collage paintings," as he called his work from the 1970s onward.[16]

While Grosz formally taught Bearden, 1930s Harlem provided some of the richest lessons that an artist could imbibe. Bearden took a position as a caseworker in the New York City Department of Social Services in 1935, a job he kept for almost two decades. He worked with Gypsies by day and painted at night and on weekends. Despite the difficulties that the Depression presented, African Americans—an overwhelming majority of them Southerners—found Harlem a heady place. The hard times, and occasionally New Deal programs, nourished artists. Bearden attended the founding meeting of the Harlem Artists Guild, later led by sculptor Augusta Savage. Bearden's cousin by marriage, artist Charles "Spinky" Alston, a Charlotte native who had also moved to New York with his family as a child, shared studio space at 306 West 141st Street with a number of black artists, young and old. Bearden spent much of his free time there, and he participated in activities sponsored by the Works Progress Administration at the Harlem Community Art Center and the Harlem Art Workshop.[17]

In the late 1930s, Bearden decided that he wanted to move beyond the social realism of his cartoons and pursue fine art exclusively. He abandoned cartooning and began painting with gouache on brown paper, completing roughly twenty works, but he cast about for subjects.[18] When, in 1940, Bearden returned to the South for the first time as an adult, he was inspired by African American life and the Southern landscape. *Cotton Workers*, circa 1936–44 (pl. 27), is probably one of the paintings that sprang from this journey to Greensboro, Charlotte, and Atlanta.

In search of familiarity, Bearden instead found alienation. The people he portrays in *Cotton Workers* turn their backs on him, leaving a distance between the artist and his subjects that cannot be breached. They are strangers to him. The landscape is alien as well. Only the burlap sacks in which the workers tote the cotton seem Southern. Unlike his collages from the 1960s and 1970s, works that capture Southern places in lush and true detail, the people in *Cotton Workers* could be anywhere. In fact, they resemble figures in Social Realist murals by Mexican artist Diego Rivera, who interested Bearden at the time.[19] Like Rivera, Bearden depicts his workers in a universal setting. The particularity and peculiarity of the South was not immediately available to him.

After his 1940 trip, however, Bearden began to reclaim the South through its people. He commenced

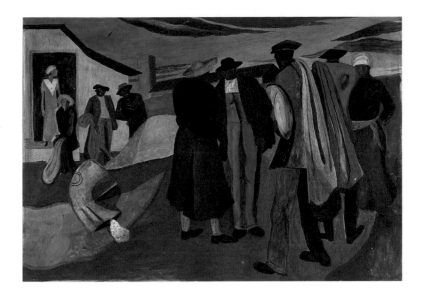

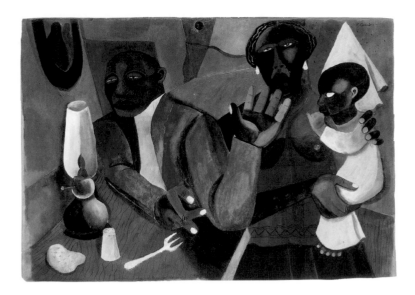

Pl. 27

Cotton Workers, circa 1936–44
Gouache on paper on board,
31 × 43 ⅝ inches

Pl. 28

The Family, circa 1941
Gouache with ink and graphite on
brown paper, 29 ⅛ × 41 ¼ inches

Pl. 29

Family, 1971
Paint, photographs, paper, and fabric
on board, 22 ½ × 25 ¾ inches

Pl. 30

Mecklenburg Family, circa 1976
Collage and mixed media on board,
17 ¾ × 26 ¾ inches

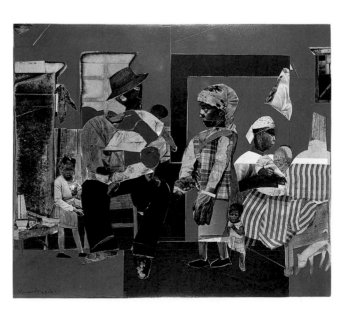

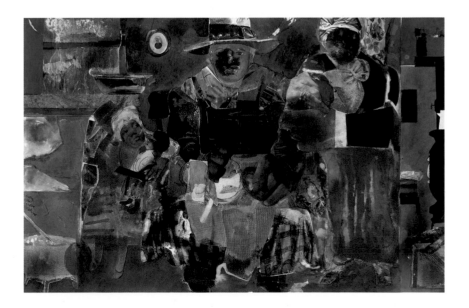

painting families in 1941, and returned to them as late as 1986, two years before his death. Bearden called the South that he created "a homeland of my imagination," and he turned increasingly to this mental landscape in the last three decades of his life.[20] Two works in the exhibition—*The Family*, circa 1941, and *Family*, 1986, depict his own relations. *Family*, 1971, and *Mecklenburg Family*, circa 1976, represent African American life as he learned about it from Southern migrants to Harlem, from his own journeys to the South as an adult, and from the deep recesses of his early experience, a place even deeper than memory. The differences between his renderings of the two sorts of families—his own and others'—provide a window into Bearden's past and his artistic process.

Contrast the anonymity of *Cotton Workers* (pl. 27) with the intimacy of *The Family*, circa 1941 (pl. 28). The middle-class position of Bearden's family is striking, especially when juxtaposed with the black farmers in *Cotton Workers*. Graphite and ink lines make the little family grouping in *The Family* resemble cutouts, foreshadowing Bearden's later work in collage. The man wears a suit, leaving a menacing fork aside and holding up an outsized hand to block the view of the black Madonna and child standing behind him, to the right. These people were not strangers to Bearden: the image depicts his father, his mother, and himself as a baby. Over the next forty-five years, Bearden returned again and again to family scenes that he could not possibly remember. His 1940 trip to the South awakened troubling images from within himself, even as he rendered blander scenes from the Southern landscape.

A traumatic experience in Charlotte had precipitated the Bearden family's departure from the city. In 1914, when the artist was three years old, on the cusp of adult recall, a white mob in Charlotte tried to take him away from his father. Darker-skinned Howard Bearden had taken his light-complexioned child—with curly blond hair and green eyes—just a few blocks away from their grocery store in downtown Charlotte. White men surrounded them, and asserted that the "black" father had kidnapped the "white" child. Three-year-old Romare would have heard the cacophony, seen the struggles, and felt fear. Father and son escaped, but Bearden's parents quickly left the South for Harlem. He never could quite go home again.[21]

Visual recall, a part of memory, rarely flows smoothly in the channels that storytelling excavates. As an artist, Bearden relied on memory to render a visual narrative of his life, but the traumatic rupture in his early personal history, repeated in other variations over the next decade, haunted him. He teetered on the verge of making memory into a coherent narrative, but each time he reached for it, it shattered on his canvas. His memories fell into pieces in collage.

Bearden had a long association with collage before he turned to it as his primary medium in the mid-1950s. George Grosz told an interviewer in 1928, "When John Heartfield and I invented photomontage in my South End studio at five o'clock on a May morning in 1916, neither of us had any inkling of its great possibilities, nor of the thorny yet successful road it was to take. As so often happens in life, we had stumbled across a vein of gold without knowing it."[22] Of course, Heartfield and Grosz did not invent montage, as collage was most often called until mid-century, but they did popularize it as Dada artistic practice. Georges Braque and Pablo Picasso used collage techniques—putting ready-made material and oils together—as early as 1912, notably in Picasso's *Still Life with Chair-Caning*. That year, the *Salon d'Automne*, Paris's annual exhibition of progressive art, introduced Cubism to the world. Grosz moved to Paris to study art a few months later.[23] Bearden referred to his work as montage, rather than collage, as late as January 1969.[24]

Collage became a medium through which Bearden could depict his own fractured experience as well as the communal orchestration of African American life in the South (for example, the borrowing and sharing of traditions such as jazz and quilting), but his use of the art form also owed a debt to modernist painting. Bearden proclaimed Henri Matisse his favorite artist.[25] Around 1905, influenced by Paul Cézanne's late work, French artists Matisse and André Derain shook free of pictorial conventions and founded Fauvism.[26] Fauvism was characterized by "a violence of colours . . . by roughness of execution and by a bold sense of surface design."[27] "Les Fauves" (the wild beasts) outlined their figures using thick black lines, incorporated roughly hewn geometric shapes, and washed everything with the sun-drenched colors

of Catalonia.[28] It was a new art for a new century: free, young, and brash.[29] Fauvism uncorked high artistic spirits that could never be put back in the realist bottle. Matisse's work of the Fauvist period provided lessons in color, composition, and abstraction that Bearden later applied in his collages.

Bearden's second family iteration in the exhibition is a collage. *Family*, 1971 (pl. 29), depicts an African American family not his own. He used paint, photographs, fabric, and paper to construct the interior of their Southern home. Children abound here. Nearly everyone holds one, unlike in Bearden's own family, for he was an only child. In this family, the Madonna figure is a black man who awkwardly holds a baby with one fist clenched. He is featureless, unable to face the mother who looks at him accusingly, another child clinging to her skirts. Two recurring features of Bearden's art anchor the piece. First, rectangular shapes structure the space: a fireplace, the characteristic open window, the implied door, and a strip of carpet. Second, a pale cat appears in the far right of the painting, a staple of his Southern interiors. The cat, goddess and guardian of the home, follows the form of Egyptian deities. Bearden certainly knew this, since he named one of his own cats Tutankhamun. The cat may represent the domestic purity of the Southern African American home—disputed by white supremacists—or it may represent white supremacy itself, always lurking underfoot in black life.

Family, 1971, originated at a time when Bearden's collages were garnering great acclaim. In 1970, he received a grant from the Solomon R. Guggenheim Foundation to write a history of African American art, and a cover design for *The Crisis* appeared in March. Bearden and his wife Nanette Rohan spent the summer of 1971 traveling in Europe. The years that followed would be some of his most productive. His first retrospective, *Romare Bearden: The Prevalence of Ritual*, opened at the Museum of Modern Art in 1971 and included fifty-six works dating from 1941 to 1971. The show traveled the next year to Raleigh, North Carolina, and a headline in the *Charlotte Observer* reported, "A Leading Black Artist Drawing Crowds in Raleigh." Interestingly, it was not the first time that the *Observer* had noticed him. In 1952,

before Bearden turned primarily to collage, the newspaper's art critic Don Bishop interviewed him and filed a story entitled, "Bearden is Rising as a Modern Artist."[30]

Bearden built *Mecklenburg Family*, circa 1976 (pl. 30), around a central figure who is as immobile as a rock. The previous year he had produced an etching of the same family grouping, with two differences. In the earlier iteration, entitled *The Family*, a nude woman is visible through an open door, and the central figure, who first appears to be a man, is actually a woman. She sits with her legs apart at a table that might be her lap, balancing her cooking tasks in front of her. The matriarch wears an apron with trousers underneath, a common sartorial choice of old Southern women. There are no men in the 1975 recollection. In the collage *Mecklenburg Family*, the nude has vanished. In her place is a white horse, seen through a window. The central, seated figure, whose sex was once ambiguous, is now clearly male. He wears the denim overalls of Southern farmers, but on his head sits a stylish 1970s hat, broad-brimmed, perhaps leather, and cocked at an angle. The immobile matriarch has become a man; indeed, a dude, wearing a hat that recalls both Vincent Van Gogh and Bo Diddley. On his left, a child holds a baby, and another wears a version of the broad-brimmed hat. As the man eats, a woman on his right brings him a gift, which she clutches to her breast with enormous hands. It is a flour sack—or perhaps a money sack—that she offers to him. On the wall behind him is a Victorian cameo portrait of a woman, suggesting an ancestor. Amid the tumultuous 1970s, Bearden's thoughts had turned to black manhood, a theme rarely taken up in his works about Mecklenburg. In *Mecklenburg Family*, he re-imagines manhood in an era of Black Power.

In the last family-themed work on exhibition, *Family*, 1986 (pl. 31), Bearden returns to his own family as subjects (fig. 10). He depicts his father and mother standing on the front porch of Henry Kennedy's home. The Victorian curlicues beside the porch column and wicker chair resemble those seen in photographs of the Kennedy/Bearden home. Rosa Kennedy, Bearden's great-grandmother, sits beside Henry, Bearden's great-grandfather, dressed to Victorian perfection. Rosa holds baby Romare demurely. Her hair is impeccably coiffed in a bun; her

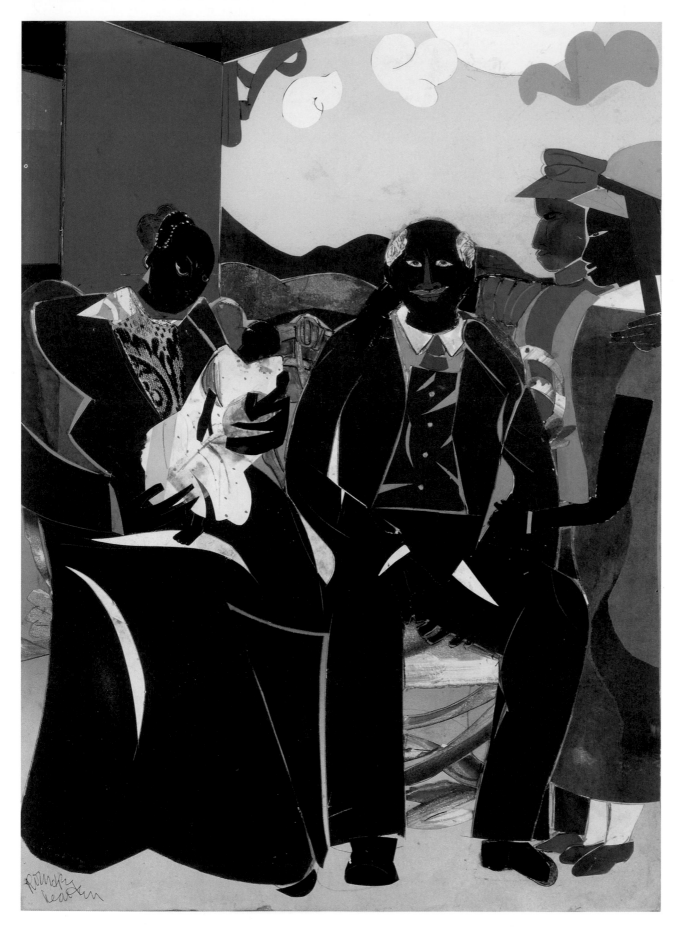

Pl. 31

Family, 1986
Collage on wood, 28 × 20 inches
Smithsonian American Art
Museum, Washington, DC.
Transfer from the General
Services Administration, Art-in-
Architecture Program

deep blue suit-dress is perfectly proper. Her blouse conveys a hint of opulence. Henry, Rosa's husband, is her equal. His blinding white cuffs and collar may be detachable, but his gentlemanly air is permanent. These are happy, rooted, and successful people.

In *Family*, 1986 Bearden has collapsed time by a few years to depict his parents, Howard and Bessye, as they would have looked in the late 1910s or early 1920s. They appear to have returned to Charlotte to present baby Romare to Howard's family. But returned from where? Bearden was born in Charlotte. Here, Bessye is the modern mother—a flapper—in the year of Bearden's birth (1911), dressed as his earliest memories would have rendered her. Howard, outfitted in a railroad uniform, does not seem appropriately dressed to run his grandfather's grocery store. Upon leaving Charlotte, Bearden's father had left behind all privilege. With his Bennett College degree, Howard Bearden took a job as a waiter on the New York-based Atlantic Coast Line Railroad, working the Washington, D.C. to Key West train.

It was the leaving that made Romare Bearden an artist. Snatched out of the nest of a large family with comfortable surroundings, banished from blue Carolina skies, the warm air coming in through the windows and doors, and the bright colors of urban gardens, Bearden found himself set down in Harlem. He ricocheted back and forth between maternal relatives in Pittsburgh and his parents in Harlem, while his father served travelers in dining cars up and down the East Coast. In the fall of 1917, Bearden entered the first grade in Harlem. Soon, however, the family moved again, this time to Moose Jaw, Saskatchewan, Canada, where his father worked for the railroad. Bearden attended the second and third grades there. Plucked up by the roots, he was disoriented. Like so many early memories, his recollections of Charlotte were made mysterious and complex by their sudden inaccessibility. Yet, there is no Canadian landscape in Bearden's work. The time is literally frozen out of his memory as if it had never existed.

When the Beardens returned to New York from Canada in 1920, Romare did not join them. He attended the fourth grade in Pittsburgh, where Bessye's grandmother, Carrie Banks, ran a boarding house. He turned nine that year, and it is likely that he had not been back to Charlotte since he was six. It was after this move to Pittsburgh that he began to return to Greensboro in the summers to stay with his grandmother Cattie Bearden, who lived just across the street from Bennett College. Henry and Rosa Kennedy, now in their seventies, remained in Charlotte, and Cattie took Romare and his cousin Mabel to visit them.[31]

Bearden always remembered the sadness of finding himself exiled to Pittsburgh. His memories of that time were clear, and they were grim. His Pittsburgh art is from a nine-year-old's memory; from that of a young boy left with a grandmother he barely knew in a place he had rarely been. Yet, in his retelling of his first decade of life, there is no drama. When asked as an adult why his family left the South, he answered, "Well, they left Charlotte, I

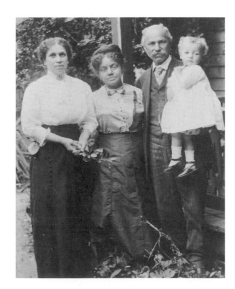

Fig. 10
Bearden with H. B. and Rosa Kennedy and grandmother, Rosa Catherine (Cattie) Bearden, 1912
Courtesy of Rousmanière Alston and Aida Bearden and Myron Schwartzman

Fig. 11
Tomorrow I May Be Far Away, 1966–67
Collage of various papers with charcoal and graphite on canvas, 46 × 56 inches
National Gallery of Art, Washington, Paul Mellon Fund. 2001.72.1

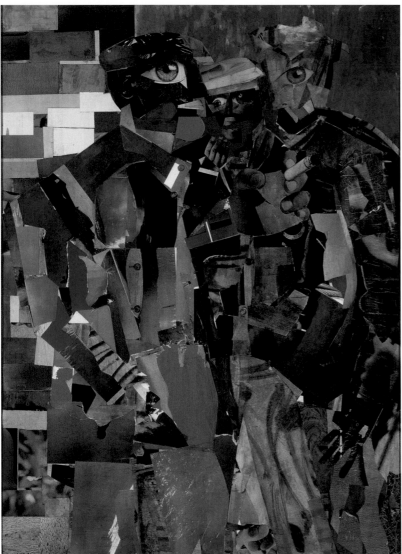

Pl. 34

Tidings from the *Prevalence of Ritual* series, 1973
Paper and polymer on composition board, 16 × 25 inches

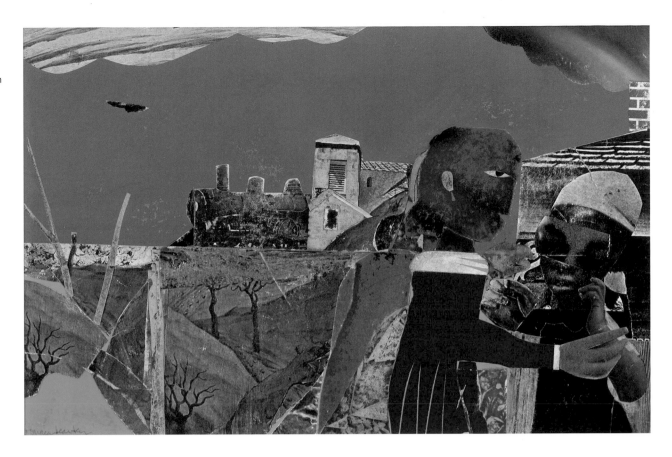

Pl. 35

Prevalence of Ritual: Tidings, 1964
Collage of various papers with graphite on cardboard, 7 ¾ × 10 ½ inches

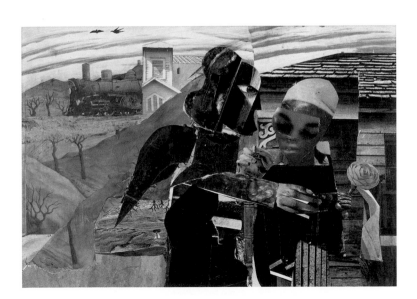

Pl. 36

Farmhouse Interior, 1966
Collage and mixed media on board, 9 ⅜ × 12 ⅜ inches

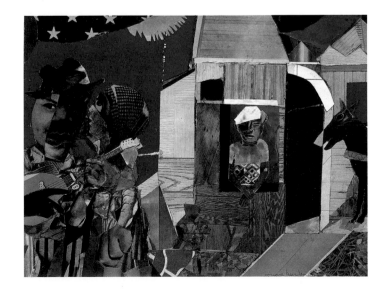

guess when lots of people [were]. The migration of the twenties, when Negroes began to leave the South and come up for better work."[32] Having established herself in Harlem as a Democratic Party operative, journalist, school board secretary, and real estate agent, Bessye Bearden sent for Romare after his fourth-grade year in Pittsburgh. He spent five school years in New York before returning to Pittsburgh to finish the last two years of high school. His father found a position as an inspector with the New York City Sanitation Department.

Despite Bearden's bland description of the Great Migration of Southern African Americans to the North, the intricate collage *Tomorrow I May Be Far Away*, 1966–67 (fig. 11), hints at a deeper memory, one of quick, confusing movement, with ghosts of the past leaning over windowsills and behind fences. Sadness lingers over the central figure, who looks off into the distance. A patch covers his right eye, so that he can only look in one direction. In *Tomorrow I May Be Far Away*, that direction is into the future. This man's past is literally blinkered.[33]

In his Pittsburgh works, Bearden gave men pride of place in the frame. Indeed, a man replaces the stolid, immobile maternal figure in *The Family*. And scarcity has replaced abundance. His Charlotte work is matriarchal; his Pittsburgh work is masculine, but not patriarchal. The men are scary. Sadness literally colors Bearden's Pittsburgh images. In his imagination, Charlotte appears as a tropical—or African—setting. The bright primary colors are exuberant, and the expressive African American people who appear in them seem to live outside of white society. In contrast, Bearden's Pittsburgh memories are covered with a fine, gray grit.

Like Charlotte, Bearden experienced Harlem as a warm and welcoming place. The Great Migration, during which over two million black Southerners immigrated to the North, represents the world's largest movement of a population in peacetime.[34] Once there, these migrants maintained black Southern culture even as they thrived in the relative freedom of the North. For example, upon the passage of the Nineteenth Amendment (Woman Suffrage) in 1920, Bessye Bearden became a force in the Democratic Party and was appointed to the school board. In North Carolina, when about two hundred Southern

black women showed up to vote that same year, white politicians tried to prevent them from doing so.[35]

Evening, 9:10, 461 Lenox Avenue, 1964 (pl. 32), a relatively early Bearden collage, reflects the vivacity of black life in Harlem. Unlike most of his depictions of Southern families, the people in this group are having fun. Nonetheless, his use of color recollects the "palette austère" of dun, olive, brown, and gray that the Cubists had used in the 1910s and 1920s. Bearden employed this palette until the mid-1960s, when he began to adopt primary colors to depict Southern landscapes and Southerners.[36] One can begin to see the palette that Bearden took up in his subsequent work on the South in *Three Men*, 1966–67 (pl. 33). Its subjects seem as sinister as any of the Cubist Pittsburgh figures Bearden had already depicted. Here, however, bright blues, reds, and greens begin to overtake them and structure the piece.

Likewise, *Tidings* from the *Prevalence of Ritual series*, 1973 (pl. 34), illustrates the transition from Bearden's Cubist period. He had produced the first version of this theme, *Prevalence of Ritual: Tidings*, almost a decade earlier, in 1964 (pl. 35). In the first *Tidings*, his palette is austere in the Pittsburgh tradition, and the central figure is a winged angel who embraces a sightless Madonna. The trees are bare, a Southern black church stands beside a Spanish mission, and vultures hover. In the second *Tidings*, Bearden has returned to the South. The palette is brighter, the angel has lost her wings, and the Madonna holds flowers in both hands. The trees bloom, a rainbow fills the sky, and an airplane soars. Only the trains and a Victorian curlicue like the one on his great-grandparents' porch remain from the original work.

To underscore the difference in artistic approaches in Bearden's Northern and Southern *Tidings* paintings, it is useful to contrast *Evening, 9:10, 461 Lenox Avenue*, with *Farmhouse Interior*, 1966 (pl. 36). African Americans take their leisure in Harlem in the first image, and go to work in the second, Southern setting. Bearden's rectangular framing in *Farmhouse Interior*, always most pronounced in his work on the South, enabled him to combine indoor and outdoor life through doors and windows, just as many Southerners did. In addition, the rectangular plan facilitated the bold use of color characteristic of his Southern work.

Pl. 37 (not in exhibition)

*Of the Blues: Mecklenburg County,
Saturday Night*, 1974
Mixed media collage on Masonite,
50 × 44 inches

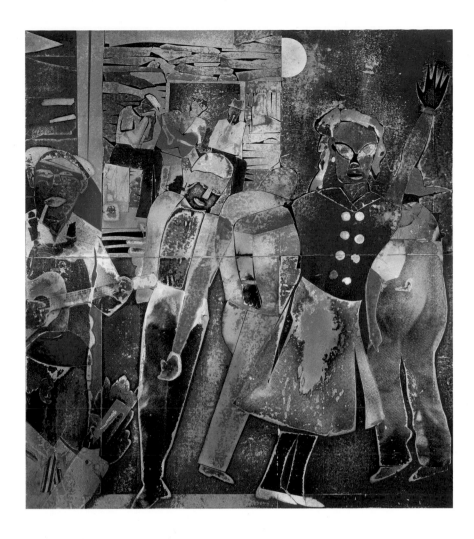

Pl. 38

Of the Blues: Carolina Shout, 1974
Collage and acrylic and lacquer on
board, 27 ½ × 51 inches

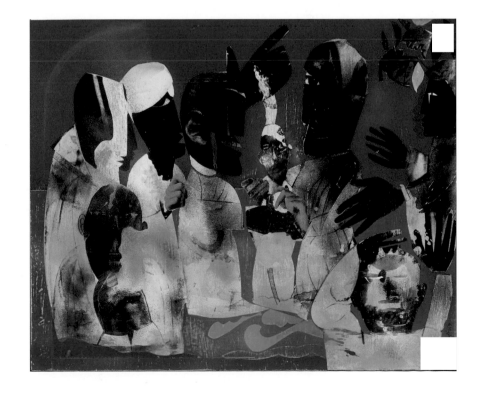

Of the Blues: Mecklenburg County, Saturday Night, 1974 (pl. 37), is an unusual Mecklenburg County scene in which Bearden portrays pure leisure. *Mecklenburg County, Saturday Night* is not a childhood memory; he probably saw similar people in juke joints when he returned to Greensboro, Charlotte, and Atlanta in 1940. The figures are thoroughly modern people, dating to around World War II. The men wear overalls, which were everyday work wear during the 1930s. The dancing woman, with her short pleated skirt and fashionable flat shoes, looks like a World War II-era teenager. Her colorful outfit reflects her modernity and Bearden's turn to primary colors in the mid-1970s, after his gritty, gray Pittsburgh period. Remarkably, there appears to be a map of Africa superimposed on her skirt, from her waist down her right thigh, which Bearden introduced through surface abrasion. Is this the ultimate Rorschach test? Bearden used various papers, paint, ink, graphite, and surface abrasion on fiberboard in *Mecklenburg County, Saturday Night*. The Carolina moon is shining, and people move between outside and inside as if the walls are permeable.[37]

If *Mecklenburg County, Saturday Night* is secular, Bearden's grandmother's culture of piety lives on in *Of the Blues: Carolina Shout*, 1974 (pl. 38). This collage depicts a baptism amid expressive, charismatic celebration. Overcome by the spirit of God, members of the congregation throw up their hands, one man cries, and all shout as the larger-than-life preacher begins to immerse the repentant in the stream. *Carolina Shout*, which includes lacquer and acrylic on board, uses vibrant colors and decorative borders that recall Matisse's Fauvist paintings.

On a clear day, from the Charlotte lot where the Kennedy/Bearden home once stood, one can see the hills of the Piedmont on the horizon, past the trains in the foreground. The family home was just set back from the main Southern Railway line. To the left of the house, a smaller rail line came across Graham Street on a trestle that hung almost over the dwelling. Trains must have appeared to Bearden as if they were flying out of the sky and across his frame of vision. As a toddler, he would have heard trains night and day. He remembers his grandmother "waving a white apron to passing trains on that trestle across the clay road."[38] His great-grandfather,

his great uncle James Gosprey, and his father all worked on the railroad. *Watching the Good Trains Go By*, 1964 (pl. 39), incorporates fascinating aspects of Bearden's changing artistic practice in the mid-1960s. It bears the palette of his Pittsburgh period—the austere grays and earth tones of Braque. The mountain on the left so closely resembles Cézanne's paintings of Mont Sainte-Victoire painted in a style that inspired Cubism, that it is likely that Bearden meant for the viewer to recognize it as such.[39] The faces, particularly that of the guitar player, are also Cubist in style. For all of the European influences, however, the train is pure South Graham Street, Charlotte, North Carolina. It comes out of the sky, as if on that trestle above the clay road; it takes people from a place in the bucolic South, where there are roosters in their yards, to the industrial North, where there are neither roosters nor yards. Coupled with Bearden's early memories of trains was the fact that his father left the family behind when he worked on the railroads. Bearden always associated trains with Charlotte, his father, and the Great Migration. They conveyed to him both promise and loss.

In *The Train*, 1974 (pl. 40), a complex family group dines on two Southern treats: watermelon and cane syrup. At least three generations are hungry, but the meal is meager and must be eaten by candlelight. Bearden used an elaborate rectangular background to convey the poverty of their living conditions and to transport the viewer to the outside. Inside the cabin it could be 1850, but outside modernity intrudes in the form of the powerful locomotive flying across the sky at trestle level. In *Sunset Express*, 1984 (pl. 41), an open door beckons the man whom it frames. He is seated at a table dressed in his railroad uniform, and appears to be praying with an older woman. It is 3:40 in the afternoon, and sunset is still far enough away that the family can eat dinner together before the man leaves. A woman dressed in a modern, smart suit looks on, drawing attention to intergenerational difference. It is the sunset of the older couple's life; old ways are vanishing even as the man leaves home, again and again.

A train dominates Bearden's collage and watercolor *Moonlight Prelude*, 1987 (pl. 42), which he completed the year before his death. Here is the consummate Bearden train. The locomotive is on its trestle, shining light in

Pl. 39

Watching the Good Trains Go By, 1964
Collage of various papers with ink on
cardboard, 13 ¾ × 16 ⅞ inches
Courtesy Columbus Museum of Art,
Ohio. Museum Purchase, Derby
Fund, from the Phillip J. and Suzanne
Schiller Collection of American Social
Commentary Art 1930–1970

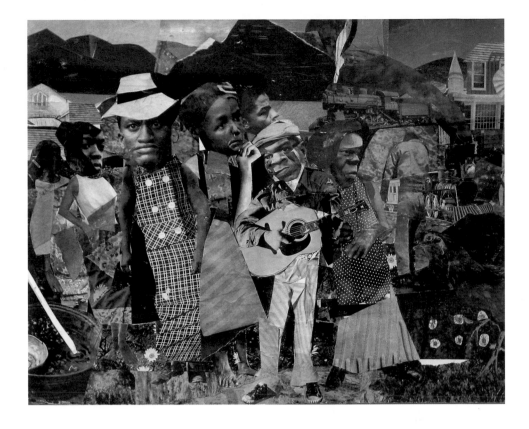

Pl. 40

The Train, 1974
Collage on paper, 15 ¼ × 19 ½ inches

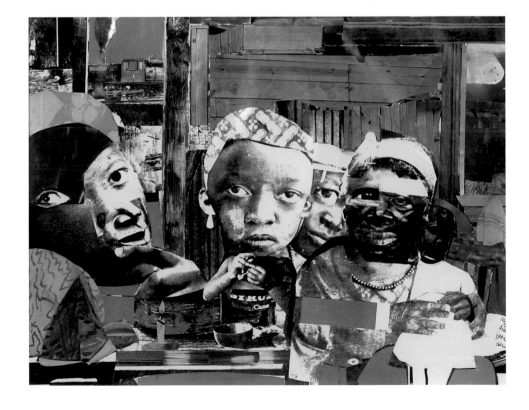

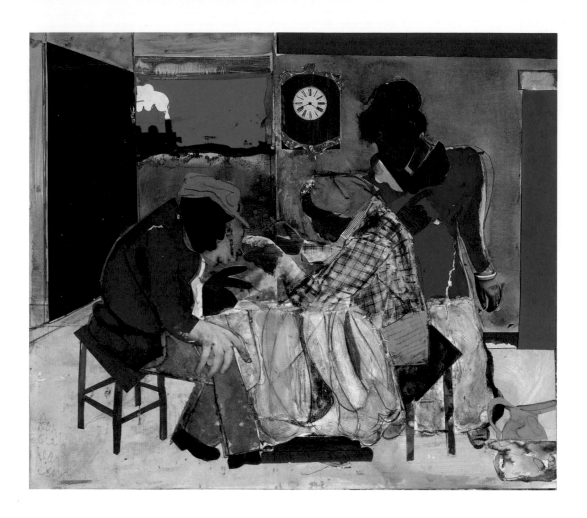

Pl. 41

Sunset Express, 1984
Collage on board, 12 ⅝ × 14 inches

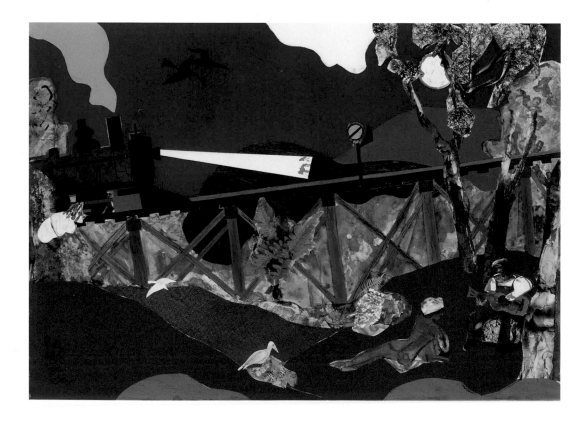

Pl. 42

Moonlight Prelude, 1987
Collage and watercolor on
mahogany board, 20 × 28 inches

Pl. 43

Return of the Prodigal Son, 1967
Mixed media and collage on
canvas, 50 ¼ × 60 inches

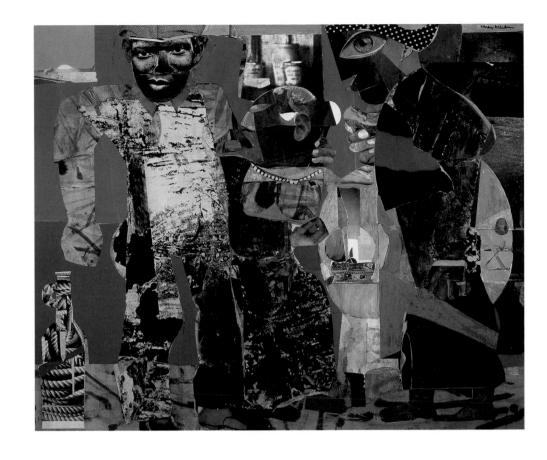

Pl. 44

Return of the Prodigal Son, 1984
Collage on board, 12 × 8 ½ inches

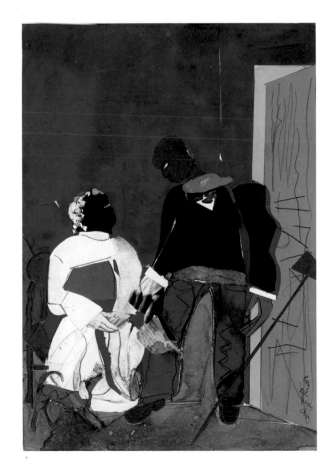

the darkness. The colors are vivid, the birds soar high, and, finally, people are having a great deal of fun. A man strums the guitar, smoking, and perhaps singing to the reclining nude before him. A full moon shines through the limbs of an old oak tree. Certainly the scene is the prelude to intimacy to come, even as it is a prelude to Bearden's death. The past no longer haunts Bearden. All is calm, vivid, and natural.

A similar resolution of emotional issues from the past appears when comparing two works bearing the same title: *Return of the Prodigal Son*, 1967 (pl. 43), and *Return of the Prodigal Son*, 1984 (pl. 44). The earlier work incorporates an austere palette, and primary colors block out space. The son wears what appears to be a railroad uniform, or at least overalls with a railroad cap, and a rope-covered bottle sits in front of him. He appears to be drunk. An elderly Victorian woman wearing pearls entreats him, while a more powerful, even mythical, woman hovers to the right. The candle that lit the trio's vigil has burned low, and the sun is just rising outside the open window. Bearden's father began to drink heavily after the family left Charlotte. Once, on a return visit, he was arrested and spent the night in jail. The family departed for the North the next morning, and Howard Bearden vowed never to return to the South. It appears that he did not, at least after 1925, when both his grandmother and mother died. Henry Kennedy lived on until 1932, taking in roomers in the big house on South Graham Street. Romare Bearden did not visit him in those last seven years before the elder man's death.[40] This second rupture coincided with Bearden's high school and early college years, a period of self-absorption in most lives, and perhaps the time that he was least likely to visit elderly relatives on his own. But Bearden regretted not going to see the old man, judging from his fascination with his great-grandfather late in his life.

In 1984, Bearden produced a much less conflicted *Return of the Prodigal Son*. In the later work, the judgmental Victorian woman is very elderly, sitting with her feet propped up. The prodigal son seems to be a ghost, his railroad uniform assuming a magical appearance. Propping his axe against the door, the son reaches down and takes the woman's hand. Home at last.

In the late 1970s and 1980s, Bearden's frequent visits to the South refreshed his ability to recall childhood scenes and maternal imagery and to suffuse them with magical elements. *Early Carolina Morning*, 1978, and *Maudell Sleet's Magic Garden*, 1978, are from a series that Bearden entitled *Profile/Part I: The Twenties*. Of the two, *Early Carolina Morning* (pl. 45) is more typical of the collages that preceded it. It is rectangular in the extreme. Here, as he often did, Bearden honored women's work and African American domesticity. A well-dressed small child stands facing the light shining through the front door, poised on the doorstep of the future. The child hovers beside a powerful maternal figure, who sits with her hands folded in her lap. The fact that her hands do not match one another—one is large, dark, and powerful; the other is smaller, lighter, and delicate—reflects more than the formal juxtapositions of collage. Bearden makes the woman the rock of the home, capable of both "men's" work and "women's" work with those hands.

In 1977, Bearden created *Madeleine Jones' Wonderful Garden* (pl. 46), a fantastic image with flying flowers, birds, and perhaps even bodies, recalling the work of Marc Chagall. In this work, the mother and child are rooted in, and almost overwhelmed by, an inside/outside place. If *Early Carolina Morning* implies scarcity through its stark interior, *Madeleine Jones' Wonderful Garden* calls forth the abundance that Southerners might wrest from the land, from the floral landscape to the hanging country ham to the long-handled fishing net propped up beside the mother and child.

Madeleine Jones' cabin appears in the background again the next year in *Maudell Sleet's Magic Garden* (pl. 47), which moves from flowers to vegetables to depict another strong woman amid a sensuous Southern environment. Before Charlotte entombed itself in pavement and cinched tight that tomb with encircling interstate highways, there was a time of day known as the cool of the evening. After supper, but before the dew fell, old women would go out to their gardens with hats, hoes, and bushel baskets. The moon would rise before the sunset, so they could still see well enough to work. Most people in Southern cities had gardens, and many kept chickens in their yards.

Profile/Part I, The Twenties:
Mecklenburg County, Early
Carolina Morning, 1978
Collage on board, 29 × 41 inches

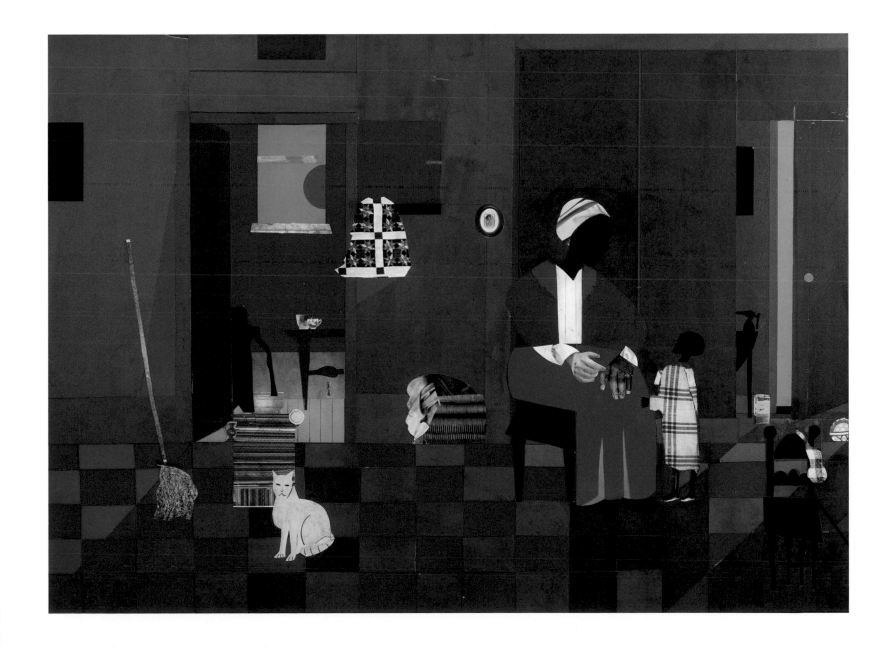

Pl. 46

Madeleine Jones' Wonderful Garden, 1977
Collage of various papers with ink, graphite, and surface abrasion on fiberboard, 13 × 15 ½ inches

Pl. 47

Profile/Part I, The Twenties: Mecklenburg County, Maudell Sleet's Magic Garden, 1978
Collage on board, 10 ⅛ × 7 inches

Maudell Sleet's arms are enormous, big enough to raise a hoe—to do a man's work. On the farm, growing crops was a man's job, but it was the women—both white and black—who "kept" gardens in urban yards. White women, recently country-come-to-town, wore sunbonnets in their gardens. Black women wore straw hats. No one mixed this up. Maudell Sleet makes vegetables come out of the earth, a process that struck Bearden as magical. She kneels in the midst of abundance that she has created. Bearden seems in awe of her power, which turns supernatural as the vegetables become phantasmagorical creatures. To be small in Charlotte in the summer meant to imagine squash and tomato vines growing so fast that they looked like monsters, blossoming, spreading, becoming pregnant and bulbous, taking over the ground, moving so fast you expected to see the vines entwining. Bearden told interviewers that Maudell Sleet had been a neighbor of his "grandparents"—as he always called his great-grandparents—in Charlotte.

The year after creating the *Profiles* series, Bearden abandoned his strict adherence to rectangular shapes and quotidian scenes in *Early Carolina Morning*, 1979 (pl. 48). Here is an example of Bearden's imagination working in concert with his memory. The dreamlike landscape of *Maudell Sleet's Magic Garden* persists, and a classical nude rises from an estuary. The lushness of the Southern landscape is a theme to which Bearden returned again and again. For example, he was fascinated by his memory of Rosa Kennedy's tiger lilies, one of which appears in *Madeleine Jones' Wonderful Garden*. During his childhood, these flowers grew in front of his great-grandparents' Charlotte home. On one summer visit, he pitched a fit when Rosa picked a lily to put on her white dress for church. His great-grandfather assured him that the tiger lilies would bloom again for his visit the next year. The beauty of the tiger lily—so outrageously constructed and colored—stuck in Bearden's memory, and he wrote:

> Sometimes I remember my grandfather's house,
> A garden with tiger lilies, my grandmother
> Waving a white apron to passing trains
> On that trestle across the clay road.[41]

In *Evening Church*, 1985 (pl. 49), we can imagine that Rosa Kennedy has snapped off a tiger lily and pinned it on her white dress. Her husband, Henry, carries a lantern; Cattie Bearden accompanies her parents; and a little girl leads the march to Grace African American Episcopal Zion Church, which still stands in downtown Charlotte. Bearden recalled "a little girl [who] kind of played with me, Liza," and this may be her. Liza haunted him; he mentioned her in several interviews. No one named Liza lived close to the Kennedys in Charlotte, according to the 1910 and 1920 censuses. Perhaps he misremembered her name. Lucille Kennedy, the "adopted daughter" of his great-grandparents, was eight when Bearden was born. She lived with the Kennedys and would have been fourteen when he left for Harlem. Surely she would have played with him. He never mentions Lucille, however, and she disappears from the record.[42]

Maudell Sleet visited Bearden's imagination once more, some three years later in *Summer (Maudell Sleet's July Garden)*, 1985 (pl. 50). In this collage on board, Sleet herself has disappeared, and the magic has taken over. Bearden's white cat has taken flight as a graceful bird, his vegetables have become beautiful stars, and the bluebird of happiness perches prominently. Of Sleet, Bearden said, "I've done her about two or three times; and each time the facial characteristics are different: I wouldn't recognize her as the same woman one for the other, but it's all right for my *memory*, because I'm *recalling* this thing."[43] Re-calling, asking that something or someone return to mind, is not the same thing as remembering. In the African American tradition of call and response, Bearden did not try to remember what happened; rather, he called out to see if the past would answer. He explained, "I paint out of the traditions of the blues. You start with a theme, then you call and recall it."[44] He wasn't sure who Maudell Sleet was, or even how she looked, but her fantastic vegetables and flowers haunted him. The historical record shows . . . nothing. There was no Maudell Sleet in Charlotte. Ever.

In *Summer (Maudell Sleet's July Garden)*, Bearden finally made his peace with his past. He had been gravely ill for three years; he would die three years later. The year after he finished *Summer*, he hired an assistant to help him with his collages, and they became less magical,

Pl. 48

Early Carolina Morning, 1979
Collage on board, 16 × 23 ⅞ inches

Pl. 49

Evening Church, 1985
Collage on board, 14 × 11 ⅝ inches

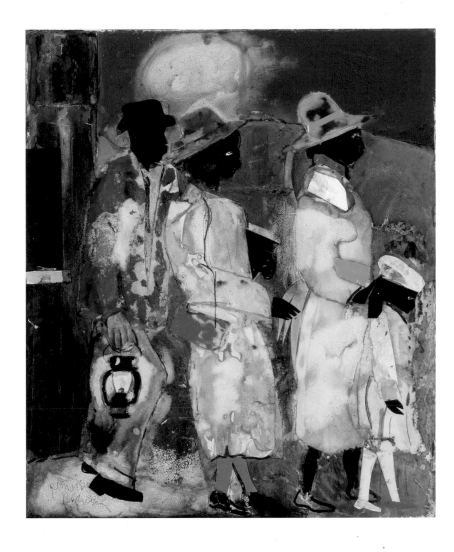

Pl. 50

Summer (Maudell Sleet's July Garden), 1985
Collage of various papers with paint, ink,
graphite, and bleached areas on fiberboard,
11 ⅞ × 13 ½ inches

more rectangular again, and more prosaic. *Summer* records Bearden's dreamlike migration back to 1914, when he felt the Southern heat, saw Southern colors, and sensed that he was a much-loved child. As for his five-decade quest to return to the homeland of his imagination, he put it this way: "What is it? I'm really trying to remember. The clock has stopped. Now I can never know where the edge of my world can be. If I could only enter that old calendar that opens to an old, old July and learn what unknowing things know . . ."[45] Bearden made a final promise to his great-grandfather, so long gone:

> I will wait here for you or for Liza
> To take me where there are tiger lilies
> And where I can hear the whistle of night trains.[46]

Bearden once said, "I never left Charlotte, except physically." Wherever he went, tiger lilies brightened his work and the whistles of night trains pierced his dreams. As Bearden waited for his great-grandfather, he found peace in the past. He put it this way: "For other people, death comes as an intruder, but a real painter has no fear of dying."[47]

Notes

1 Romare Bearden, interview by Avis Berman, 31 July 1980, Romare Bearden Papers, 1937–1982, Archives of American Art, Smithsonian Institution.

2 Major works on Bearden include Myron Schwartzman, *Romare Bearden: His Life and Art* (New York: Harry N. Abrams, 1990); Ruth Fine, *The Art of Romare Bearden* (Washington: National Gallery of Art, 2003); Robert O'Meally, *Black Odyssey: A Search for Home* (New York: DC Moore Gallery, 2008); M. Bunch Washington, *The Art of Romare Bearden: The Prevalence of Ritual* (New York: Harry N. Abrams, 1973); Sharon F. Patton and Mary Schmidt Campbell, *Memory and Metaphor: The Art of Romare Bearden, 1940–1987* (New York: Oxford University Press, 1991), esp. "History and the Art of Romare Bearden"; Richard J. Powell, "What Becomes a Legend Most?," *Transition* 55 (1992): 62–72; Richard J. Powell, Margaret Ellen Di Giulio, Alicia Garcia, Victoria Trout, and Christine Wang, eds. *Conjuring Bearden* (Durham, NC: Nasher Museum of Art, 2006); Jerald Melberg and Milton J. Bloch, *Romare Bearden, 1970–1980* (Charlotte, NC: Mint Museum of Art, 1980). To trace the Bearden family history, I consulted the United States Census from 1850 until 1930. Henry Kennedy lists his birthplace as South Carolina and his mother's as Virginia.

3 Bearden, quoted in Julia Markus, "The Art of Romare Bearden Returns South with Collages Reminiscent of His Native Charlotte, Harlem, and Pittsburgh," *Smithsonian* 11 (March 1981): 70–77.

4 Schwartzman, *Romare Bearden: His Life and Art*, 18.

5 Bearden, quoted in ibid., 35–36.

6 Bearden, quoted in ibid., 35, 38.

7 Bearden, quoted in ibid., 38.

8 U.S. Bureau of the Census, Federal Census, 1840, and U.S. Federal Census Mortality Schedules, 1850–85 (Francis Gosprey spelled Frances and Francis), as cited at AncestryLibrary. com, http://www.familysearch.org/ Eng/Search/AF/individual_record. asp?recid=39698044&frompage=99; http://www.familysearch.org/Eng/Search/ AF/family_group_record.asp?familyid= 10525488&frompage=99 (accessed 27 January 2011).

9 C. H. Watson, ed., *Colored Charlotte Souvenir: The Fiftieth Anniversary of Freedom of the Negro* (1915), n.p., 7; Richard Maschal, "Acclaimed American Artist Celebrates His Charlotte Roots," *Charlotte Observer*, 5 October 1980, F1, F4, F5. Sanborne Maps, Charlotte, North Carolina, 1911, Sheet 13, microfilm, Robinson-Spangler Carolina Room, Charlotte Mecklenburg Library, Main Branch, Charlotte, North Carolina; city directories listed in n. 10; Schwartzman, *Romare Bearden: His Life and Art*, 13–14.

10 Bureau of the U.S. Census, Ninth, Tenth, Twelfth, and Thirteenth Censuses, 1870,

1880, 1900, 1910, Charlotte, Mecklenburg County, North Carolina, www.ancestry.com. James Gosprey, Rosa's brother, lived with them from 1880–87, with his wife, Lizzie, as did Charlie Oates, who was perhaps Henry Kennedy's half-brother. See *Charlotte City Directory* (Charlotte: R. E. Blakey, 1887), 113; *The Directory of Charlotte, N.C. for 1893–1894* (Charlotte: J. S. Drakeford, 1893); *Maloney's 1900–1901 Charlotte City Directory* (Atlanta: Maloney Directory Co., n.d.); *Charlotte, North Carolina City Directory, 1911–1920* (Asheville: Hackney and Moale Co., various dates); *Charlotte, North Carolina City Directory, 1921* (Asheville: Commercial Service Company Publishers, 1921); *Charlotte, North Carolina City Directory, 1923–24, 1926, 1927* (Asheville: The Miller Press, various dates); *Hill's Charlotte (North Carolina) City Directory 1931* (Richmond: Hill Directory Company, 1932); *Hill's Charlotte (North Carolina) City Directory 1933* (Richmond: Hill Directory Company, 1933).

11 *Star of Zion*, 23 June 1898, 7. On the rising black middle class in Charlotte, see Janette Greenwood, *Bittersweet Legacy: The Black and White "Better Classes" in Charlotte* (Chapel Hill: University of North Carolina Press, 2001); and Patricia Ryckman, *An African American Album: The Black Experience in Charlotte and Mecklenburg County* (Charlotte: Charlotte Mecklenburg Library, Main Branch, 1992).

12 Virginia Ann Sutton, "The Early History of Bennett College, Greensboro, North Carolina" (master's thesis, Wake Forest University, 1969), 64, 68.

13 *Hill's Directory of Greensboro, NC, 1928* (Richmond, VA: Hill's Directory, 1928); *Catalogue and Circular of Bennett College, 1900* (Greensboro, NC: Bennett College, 1900), 55; and *Catalogue and Circular of Bennett College, 1920–1921* (Greensboro, NC: Bennett College, 1920), 34–35, Bennett College Archives.

14 Bearden family headstone, Pinewood Cemetery, Charlotte, North Carolina. The headstone lists the death date for Cattie Bearden as 1925 (the same year as Rosa Catherine Kennedy), yet some sources list 1925 as the year of her move to Maryland, where Romare Bearden visited her.

15 Ursula Zeller, "George Grosz," in *Dictionary of Art* 13, ed. Jane Turner (London: Macmillan Publishers, 1996), 697–99; Romare Bearden, interview by Henri Ghent, 29 June 1968, Romare Bearden Papers, 1937–1982, Archives of American Art, Smithsonian Institution.

16 Romare Bearden, "Rectangular Structure in My Montage Paintings," *Leonardo* 2, no. 1 (January 1969): 11–19; "The Collage Art of Romare Bearden: Fragmented Images of Black Life," *New York Times*, 3 January 1987; Fine, "Romare Bearden: The Spaces Between," in Fine, *The Art of Romare Bearden*, 30.

17 Bearden, interview by Ghent, 29 June 1968; Schwartzman, *Romare Bearden: His Life and Art,* 62–95. Charles Alston's widowed mother married Harry Bearden, Romare's uncle.

18 Bearden, interview by Ghent; Schwartzman, *Romare Bearden: His Life and Art*, 116.

19 Schwartzman, *Romare Bearden: His Life and Art*, 118.

20 Bearden, quoted in Markus, "The Art of Romare Bearden Returns South," *Smithsonian* 11 (March 1981): 70–77.

21 Schwartzman, *Romare Bearden: His Life and Art*, 17.

22 John Heartfield, quoted in "Documents Dada," http://dadasurr.blogspot.com/2010/02/george-grosz-john-heartfield.html (accessed 2 May 2011).

23 Lewis Kachur, "Collage," in *Dictionary of Art* 7, ed. Jane Turner (London: Macmillan Publishers, 1996), 557–58.

24 Bearden, "Rectangular Structure," 11–19. Fine, "Romare Bearden: The Spaces Between," 30–31.

25 Henry Louis Gates Jr., quoted in Felicia R. Lee, "An American Life in Mixed Media," *New York Times*, 12 September 2003.

26 Dora Perez-Tibi, "Fauvism," in *Dictionary of Art*, ed. Turner, 697–99, 840; Nicholas Watkins, "Matisse," http://www.oxfordartonline.com/subscriber/article/grove/art/T055953?q=matisse+watkins&search=quick&pos=2&_start=1#firsthit (accessed 2 May 2011).

27 Dora Perez-Tibi, "Fauvism," in ed. Turner, 839.

28 Ibid., 839; Gaston Diehl, *Les Fauves, Ouvres de Braque, Derain, Dufy, Friesz, Marquet, Matisse, Van Dongen, Vlaminck* (Paris: Les Éditions du Chêne, 1943).

29 Diehl, *Les Fauves*, 3–6.

30 Patricia Krebs, "A Leading Black Artist Drawing Crowds in Raleigh," *Charlotte Observer*, 4 May 1972; Don Bishop, "Bearden is Rising as a Modern Artist," *Charlotte Observer*, 3 August 1952; Bishop, "Dixie All Over: Modern Art Has Unique Place, Says Bearden," *Charlotte Observer*, 3 August 1952.

31 *Hill's Directory of Greensboro, NC, 1920–1928* (Richmond: Hill's Directory, various dates), microfilm, Greensboro Public Library, Main Branch, Greensboro, North Carolina; U.S. Bureau of the Census, Thirteenth, Fourteenth, and Fifteenth Censuses, 1910, 1920, 1930, Greensboro, Guilford County, North Carolina, www.ancestry.com.

32 Bearden, interview by Avis Berman, 31 July 1980.

33 Fine, "Romare Bearden: The Spaces Between," 54–55.

34 Glenda Elizabeth Gilmore, *Defying Dixie: The Radical Roots of Civil Rights, 1919–1950* (New York: W. W. Norton, 2008), 17.

35 On black women and women's suffrage, see Glenda Elizabeth Gilmore, *Gender and Jim Crow: Women and the Politics of White Supremacy in North Carolina, 1896–1920* (Chapel Hill: University of North Carolina Press, 1996), chap. 8.

36 M. Lampué, quoted in Bernard Dorival, "Le Cubisme," in Dorival, ed., *Les Peintres du XX Siècle* (Paris: Éditions Pierre Tisné, 1957), 73.

37 Bearden depicted leisure and celebration in New Orleans, New York, and the Caribbean, but rarely in Mecklenburg County. See Fine, "Romare Bearden: The Spaces Between," 70–75.

38 Bearden, "Sometimes I remember my grandfather's house," http://www.beardenfoundation.org/artlife/beardensart/musicpoetry/artwork/sometimes.html (accessed 25 January 2011).

39 Ruth Fine notes the resemblance of Paradise Peak on St. Martin, where Bearden vacationed, to Mont Sainte-Victoire. See "Romare Bearden: The Spaces Between," 85, 87.

40 *Hill's Charlotte (North Carolina) City Directory 1932* (Richmond: Hill Directory Company, 1932); Schwartzman, *Romare Bearden: His Life and Art*, 17.

41 Bearden, "Sometimes I remember my grandfather's house."

42 U.S. Bureau of the Census, Thirteenth Census, 1910, Charlotte, Mecklenburg County, North Carolina, www.ancestry.com; "Local Scenes Recur in Bearden's Memory, Art," *Charlotte Weekly*, 14 September 1980, clipping in Vertical Files, Robinson-Spangler Carolina Room, Charlotte Mecklenburg Library, Main Branch, Charlotte, North Carolina.

43 Bearden, quoted in Schwartzman, *Romare Bearden: His Life and Art*, 33.

44 Bearden, interview by Avis Berman, 31 July 1980. For Bearden on the connections between his art and music, see Ben Wolf, "Abstract Artists Pay Homage to Jazz," *Art Digest* 20 (1 December 1946): 15; Nelson Breen, ed., "To Hear Another Language: Alvin Ailey, James Baldwin, Romare Bearden, and Albert Murray in Conversation," *Callaloo* 40 (Summer 1989): 431–52; Joy Peters, "Romare Bearden: Jazz Intervals," *Art Papers* 7 (January–February 1983): 11; Bearden, "Reminiscences," *Riffs and Takes: Music in the Art of Romare Bearden* (Raleigh: North Carolina Museum of Art, 1988). In addition to his art making, Bearden wrote or co-wrote the lyrics to some twenty songs.

45 Bearden, quoted in Gail Gelburd and Thelma Golden with Albert Murray, *Romare Bearden in Black and White: Photomontage Projections, 1964* (New York: Whitney Museum of American Art, 1997), 63, quoted in Margaret Ellen Di Giulio, "Memory, Mysticism, and Maudell Sleet," in *Conjuring Bearden*, 50.

46 Bearden, "Sometimes I remember my grandfather's house."

47 Bearden, quoted in Avis Berman, "I Paint Out of the Tradition of the Blues," *Art News* 79 (December 1980): 62.

ON THE IMAGE OF BEARDEN

Jae Emerling

You're not looking to "document" in some scientific, linear, orderly, factual way where we came from, how we got here; you are uncovering these details, but also exploring the gaps, the spaces in the shadows that facts don't allow us to see, the *mystery*.

bell hooks[1]

Only by art can we emerge from ourselves, can we know what another sees of this universe that is not the same as ours and whose landscapes would have remained unknown to us as those that might be on the moon. Thanks to art, instead of seeing a single world, our own, we see it multiply, and as many original artists as there are, so many worlds will we have at our disposal, more different from each other than those that circle in the void.

Marcel Proust[2]

Over the past decade, there has been a "return to Bearden" of sorts within the study of modern and contemporary art history.[3] This return focuses primarily on Romare Bearden's collages, one of the earliest examples being the small-scale *Gathering*, circa 1964 (pl. 51). Bearden's collage strategy required him to appropriate and recontextualize photographic images excised from popular magazines such as *Life*, *Newsweek*, *Time*, *Look*, and *Ebony*, as well as art historical images, notably African masks.[4] After cutting, adjusting, and fixing the photofragments into a fractured image, Bearden would then often, but not always, photograph or Photostat the collages, enlarging them significantly in order to minimize the traces of his artistic labor (rough edges, gaps, overlaps).[5] These collages certainly complicate the modernist narrative of art history as the autotelic progression from figuration to abstraction, which also putatively signaled the reduction of medium-specific characteristics to their essence. Beyond challenging a Eurocentric art historical narrative, they also confront a longstanding tension within African American culture that Bearden himself termed "the Negro artist's dilemma;" that is, the obligation of the

artist to present figurative images (vernacular realism) that counter negative racial stereotypes.[6] This dilemma foists upon African American artists a cultural imperative that is at once political and ethical. Throughout the history of African American art and culture there have been intense debates about this obligation. One point of contention is whether or not this mandate circumscribes a desire for artistic expression within a social-political precondition. Bearden's work has recently been foregrounded because it brilliantly negotiates this dilemma in ways that are neither reductive nor dismissive.

The Mint Museum's exhibition *Romare Bearden: Southern Recollections* frames the entirety of Bearden's oeuvre, including the collages, around the fact of his birth in 1911 in Mecklenburg County, North Carolina. Many of the titles of his collages directly refer to his childhood. *Memories: Mecklenburg County*, 1979 (pl. 52), and *Mecklenburg County, Sunset Limited*, from the series *Profile/Part I, The Twenties*, 1978 (pl. 53), are just two examples of many. While there is no doubt that Bearden had a special affinity for the South of his youth, it is wise to hesitate before presuming that these images depict Bearden's

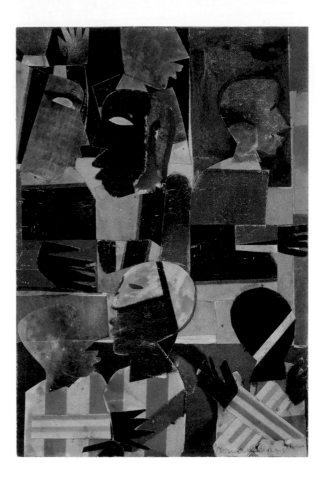

Pl. 51

Gathering, circa 1964
Collage on paperboard,
8 ⅜ × 5 ⅝ inches

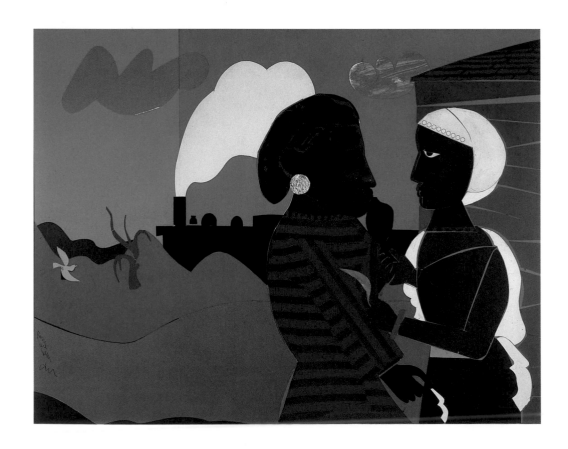

Pl. 52

*Memories: Mecklenburg
County*, 1979
Collage on board,
31 × 40 inches

Pl. 53

*Profile/Part I, The Twenties: Mecklenburg
County, Sunset Limited*, 1978
Collage on board, 15 ½ × 20 ¼ inches

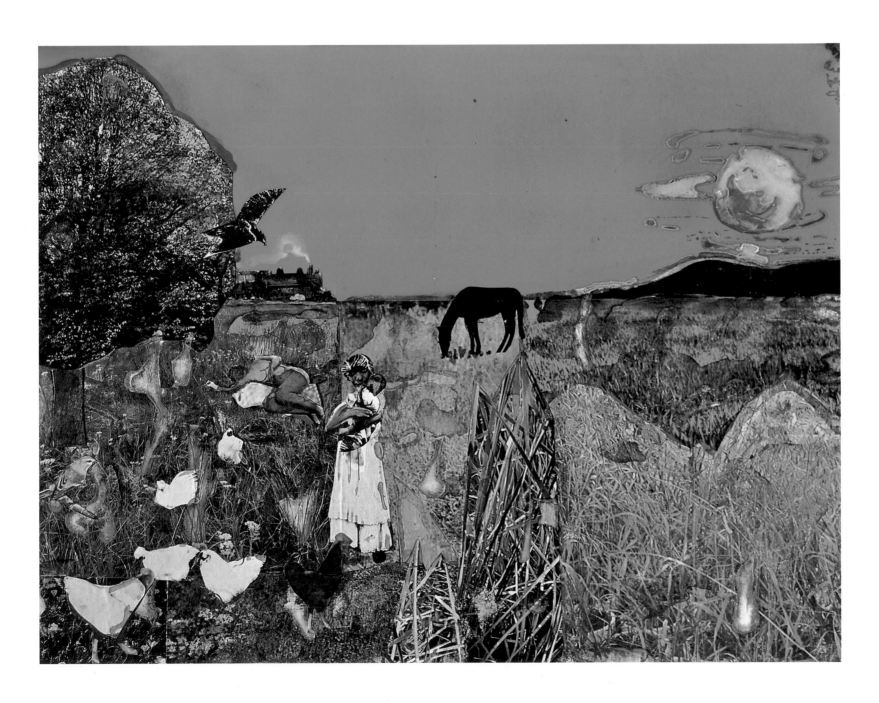

biographical memories. Our efforts to separate the artist's life from the work are part of this "return to Bearden." His images are not merely memories, or perception-images; that is, images of perceptions he had when he lived in and around Charlotte, North Carolina, or elsewhere. We must approach the works in the exhibition as possessing a life-work that is not limited to his biography. These images give us an image of Bearden that transcends his personal memories. Hence, the importance of the term "recollection" in the exhibition title. These works are recollections in the sense that Bearden translated his life into images that exceed the framework of his biography.

Repetitive themes worked through time and again by Bearden, such as "The Prevalence of Ritual" (see pls. 34–35, 65, and 67–68), or "The Three Musicians" (pls. 54–57), combine the composure of African art, the clamor of Dada, the oversized painted hands of Pablo Picasso (fig. 12), the quiet of Byzantine mosaics, the speed and solemnity of Abstract Expressionism, and the graphic colors of Pop Art, with the haptic quality of the Baroque. But the space in which these fragments and remnants encounter one another is not a passive backdrop; rather, it is "dynamic" and expressive in advance.[7] The space created—this opening—is the image as such. Instead of figures or setting, it is the historical and aesthetic space Bearden constructed that functions as an opening into the past. For within these recollections, it is less a matter of Bearden projecting his memories onto a passive screen than it is about the past itself within the

present as something being made and becoming undone. Consider *The Woodshed*, 1969 (pl. 58), which Richard Powell has brilliantly written about in relation to the jazz term "woodshedding," meaning "an artist's period of retreat into a private world of study, contemplation, and creative winnowing and rearranging"; that is, "isolated practice and perfection of one's talents."[8] The practice of woodshedding depends on the immanence of the past in the present: it is a creative mode in which past musical lines, rhythms, and melodies coexist and meld to create variations and inflections. This process is an essential part of how an artist finds his or her own voice.

The coexistence of the past *and* the present is crucial to any reading of Bearden's practice. The "tissue of quotations" that constitutes Bearden's work only functions if we understand a recollection as a creation, as an event through which the space of history opens.[9] Only the work of art gives us this space of history, which is a liminal space between temporalities and cultures. The images Bearden presents us create a temporal and cultural threshold: a common place, a shared terrain, a community of difference. Bearden's images open a space of history that interrupts our lives and forces us to think. This is why the power of his "recollections" rests less with their relation to his own biography than with the artist's remarkable ability to create images synthetically and disjunctively, through variations that repeat the original differently. In other words, Bearden gives us variations that become original. His ability to create new interpretations of both

Fig. 12
Pablo Picasso
Three Musicians, 1921
Oil on canvas, 79 × 84 ¾ inches
The Museum of Modern Art,
New York, New York. Mrs. Simon
Guggenheim Fund © 2011 Estate
of Pablo Picasso / Artists Rights
Society (ARS), New York

Pl.54

Three Folk Musicians, 1967
Collage of various papers
with paint and graphite on
canvas, 50 ⅛ × 60 inches

Pl. 55

Folk Musicians, 1942
Gouache with ink and
graphite on brown paper,
35 ½ × 45 ½ inches

Pl. 56

Back Porch Serenade, 1977
Collage with color inks and
pencil on Masonite,
6 × 9 inches

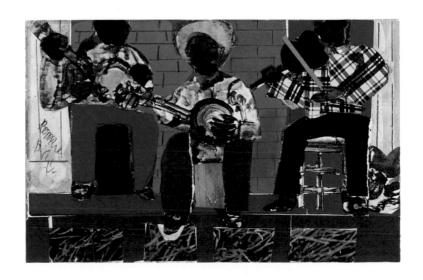

Pl. 57

Soul Three, 1968
Paper and fabric collage on board,
44 × 55 ½ inches

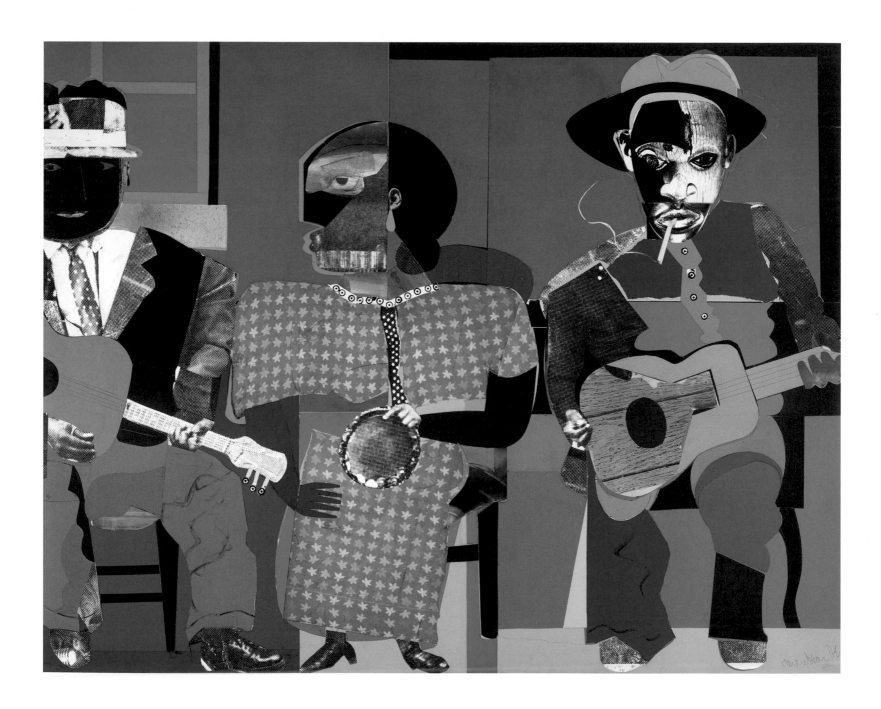

Pl. 58

The Woodshed, 1969
Cut and pasted printed and colored
papers, Photostats, cloth, graphite,
and sprayed ink on Masonite,
40 ½ × 50 ½ inches
The Metropolitan Museum of Art,
New York. George A. Hearn Fund,
1970. 1991.47

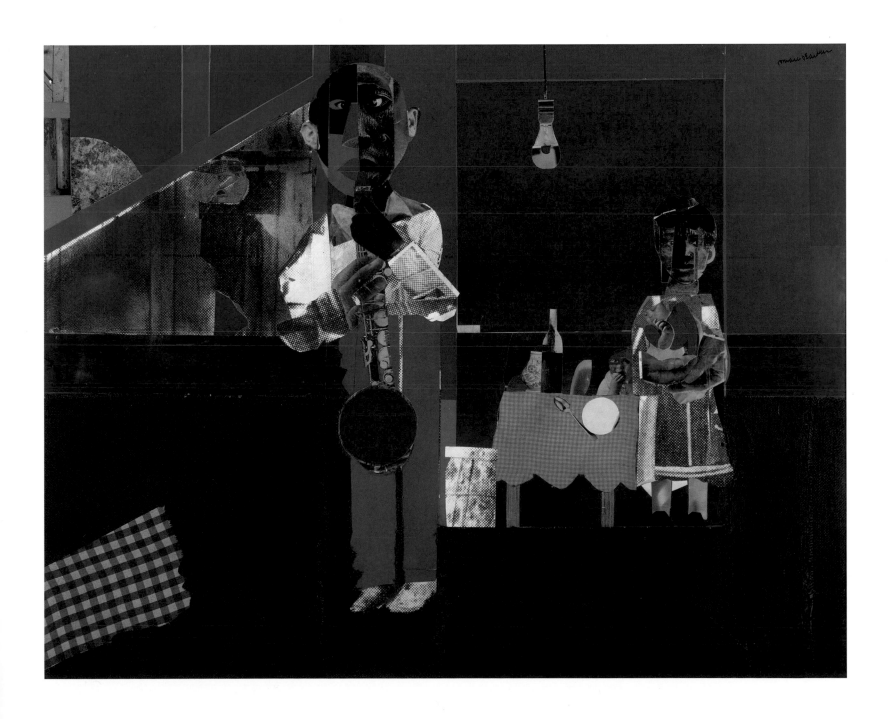

European avant-garde aesthetic strategies and techniques predominant within the aesthetic traditions of the African diaspora is unparalleled because he redefines each tradition without arriving at a synthesis or reconciliation.[10]

The advent of photomontage at the end of World War I and throughout the 1920s was a response to an epochal "memory crisis" signaled by modernity.[11] Attempts to negate history and any semblance of the continuity of tradition characterized European avant-garde art in Germany, Russia, Italy, and France in the first decades of the twentieth century. The Dada group, centered in Berlin, which included Richard Huelsenbeck, Hannah Höch, Raoul Hausmann, John Heartfield, and others, developed montage as a means of challenging traditional notions of art such as originality and uniqueness by re-presenting readymade photographic images. It was meant to engage viewers directly by drawing on a surplus of readymade photographs and rearranging them to create new images that exposed and/or undermined the very capitalist culture that generated this surplus in the first place. The audience was not conceived of as passive consumers of the image; rather, they were meant to become agitated, politicized participants in the larger socio-political world.

However, there are distinctions to be made in the history of the avant-garde's use of photomontage. As Benjamin Buchloh's admirable work on the topic makes evident, the emphasis on "discontinuity and fragmentation in the initial phase of Dada-derived photomontage" was meant to refract the "'shock' experience of daily existence in advanced industrial culture."[12] This strategy aimed to "dismantle the myths of unity and totality that advertising and ideology consistently inscribe" on modern consumers and political subjects. But this position was ultimately deemed ineffective, and another conception of photomontage sought. Buchloh writes:

> Already in the second moment of Dada collage (at the time of Hannah Höch's *Meine Haüsspruche*, 1922), for example, the heterogeneity of random order and the arbitrary juxtapositions of found objects and images, and the sense of a fundamental cognitive and perceptual anomie, were challenged as either apolitical and anti-communicative, or as

esoteric and aestheticist. The very avant-garde artists who initiated photomontage (e.g. Heartfield and Höch, Klutsis, Lissitzky, Rodchenko) now diagnosed this anomic character of the Dada-collage/montage technique as bourgeois avant-gardism, mounting a critique that called, paradoxically, for a reintroduction of the dimensions of narrative, communicative action, and instrumentalized logic within the structural organization of montage aesthetics.[13]

The move toward more minimal, controlled, in a sense "readable," photomontages by artists such as Laszlo Moholy-Nagy—for instance, his *Leda and the Swan*, 1925, with its "narrative, communicative" possibilities—indicates how the shock-value of random juxtapositions and surprising syncretic constructions in the first photomontages was unable to dismantle the learned, conventional aesthetic frameworks through which viewers read them. For both photomontage and subsequent experiments in exhibition design by avant-garde artists and architects, the goal was communal rather than personal experience: individual viewers were to be transformed into active, collective subjects.

Two aspects of early twentieth-century photomontage become evident here in relation to Bearden's collages. First, he turned to the technique as a means of negotiating collective interests and concerns. In 1963, the union leader A. Phillip Randolph met with Bearden and Hale Woodruff after the March on Washington and asked them how artists could participate in the Civil Rights Movement. Bearden and Woodruff decided to form a group of artists called Spiral. The group's name refers to an Archimedean spiral, one that "from a starting point" moves "outwards embracing all directions, yet constantly upwards."[14] Along with Bearden and Woodruff, the Spiral group was comprised of Charles Alston, Emma Amos, Norman Lewis, Reginald Gammon, William Majors, and Richard Mayhew. As has been recounted by Amos and others, at one meeting Bearden arrived with an archive of cut images and suggested the group compose a collage along the lines of Pablo Picasso's *Guernica*, 1937. There was little interest among Spiral members, and the idea

was not actualized. However, Bearden independently pursued his concept for a collective artistic response that would engage viewers about the Civil Rights Movement, an endeavor that resulted in his famed *Projections* exhibition (1964). Second, in contradistinction to the aims of the European avant-garde, Bearden turned to collage not to foreground a "memory crisis" (a failure of memory and tradition), but as a way to transmit a relation to the past, a relation that remains vital and present.

Bearden traced a new line through the history of modern art, one that overlays past and present, individual and collective, subject and object. As Ralph Ellison wrote of Bearden's practice, "his technique has been used to discover and transfigure its object" rather than to simply take it as a given.[15] The artist created images that force us to rethink concepts like time, memory, and identity, both individual and collective. His images inscribe "a community forged out of and through interruption, and a community whose appropriate (and appropriated) means of communication are found in the avant-garde techniques of collage and photomontage."[16] It is for this reason that we must further interrogate two interrelated concepts in Bearden's practice: citation and space.

Citation is essential because Bearden's collages are an assemblage of disparate, often contradictory, images of blackness found throughout the optical unconscious of American visual culture. The political lines of his work stem from him reading this archive of blackness against the grain. In other words, he cites images from

this archive and reinscribes them within the space of his collages. This reinscription of photographic imagery and visual discourses that have abetted the subjugation of African American populations does not simply or naïvely negate that archive; rather, it acknowledges that it must be continually located and made visible (see fig. 13). Bearden's work is a series of citations that "expose precisely what is excluded . . . and seek to show and to reintroduce the excluded into the system itself."[17] From the archive of American visual culture, Bearden created an image—what he called "a world within the collage"—that "retains the right to speak for itself."[18]

One of Bearden's more well-known black-and-white photomontages, *Mysteries*, 1964 (pl. 59), is an exemplary and haunting instance of citation. It is a composition of several people, mostly female, in what appears to be the interior of a small, rural Southern house. The viewer is positioned as an intruder in relation to these figures; their pressing returned gazes attest to the viewer being from *without*, possessing an intrusive, seemingly unwanted presence. "These figures dominate their space," Lee Stephens Glazer writes, "their hands form a continuous barrier across the lower part of the composition; their imposing eyes meet the viewer's face and prevent the outsider from entering their house and assessing its contents . . . resulting in an exchange of gazes that challenges the expected relationship between viewer and viewed."[19] Moreover, as Bearden commented, "I have incorporated techniques

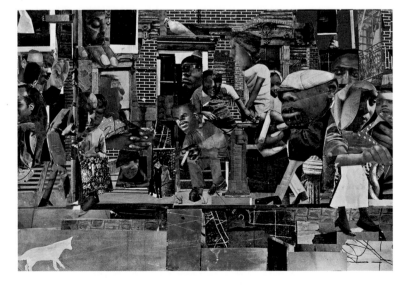

Fig. 13
The Dove, 1964
Cut and pasted printed papers, gouache, pencil, and colored pencil on board, 133 7/8 × 183 3/8 inches
The Museum of Modern Art, New York, Blanchette Rockefeller Fund, 1971

Pl. 59

Mysteries, 1964
Photostat on fiberboard,
28 ½ × 36 ¼ inches

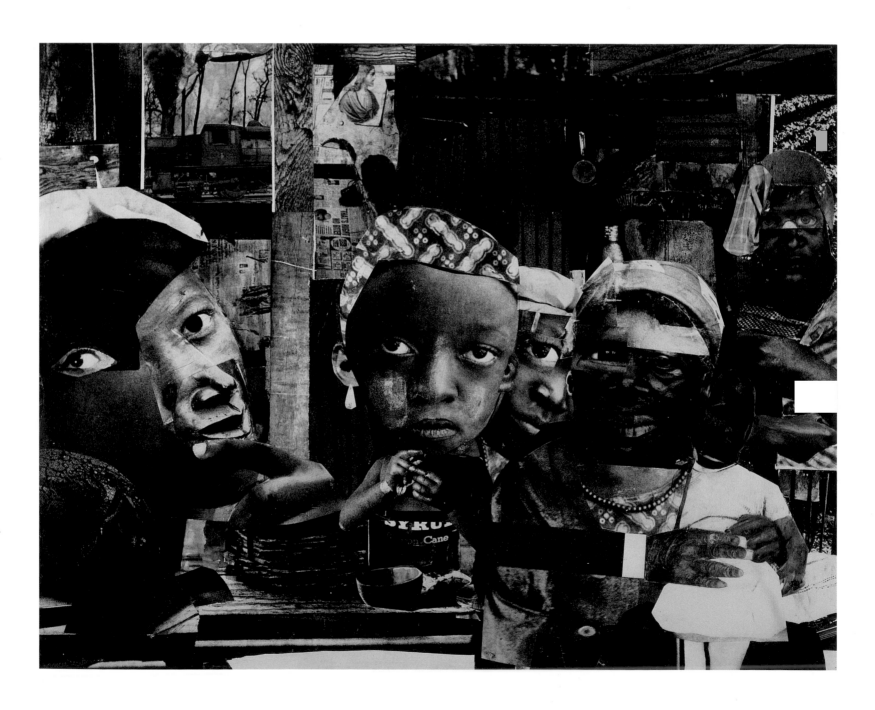

of the camera eye and the documentary film to, in some measure, personally involve the onlooker."[20] But something takes place within Bearden's pictures that does not occur in a documentary image.

There are similarities between Bearden's montages and journalistic accounts of Southern black life. In citing a 29 July 1963 *Newsweek* article focusing on "The Negro in America," Glazer calls attention to the image of a "typical" Southern black household that she argues Bearden attempted to correct. The article asserted, "Negroes *still* live in *old*, unpainted shacks with collards in the garden, petunias in a coffee can . . . a dimestore picture of Christ or an almanac ad for Sweet Railroad Mills Snuff tacked on the wall [Glazer's emphasis]."[21] Glazer continues by noting the nearly identical re-creation of this "old, unpainted shack" in Bearden's *Mysteries*: "At first glance, the image bears a remarkable similarity to the *Newsweek* description: newspapers patch the corrugated walls of a dwelling supported by rough wooden beams; one of the newspapers (above and to the left of the center figure) includes an advertisement for chewing tobacco. A family group sits around a table, and in the background, just above the head of the center figure, hangs a "dimestore picture" of Jesus.[22] This visual similarity was no coincidence. Bearden cited an archive of imagery, often of blackness, in order to express a counter-documentary impulse. The practice of citation and reinscription recurs in several collages throughout Bearden's oeuvre. One need only to think of *Late Afternoon*, 1971 (pl. 60); the collage and watercolor *The Tin Roof*, 1978 (pl. 61); or the simple quiet of the late work *Evening Guitar*, 1985 (pl. 62), to see how Bearden enacted this counterdocumentary impulse.

The illusions of transparency or objectivity that have accompanied documentary images, particularly those depicting African Americans, veil their implications in structures of power. This idea runs parallel to the opening passage of Ellison's 1952 novel *Invisible Man*: "I am invisible, understand," Ellison writes, "simply because people refuse to see me. . . . That invisibility . . . occurs because of a peculiar disposition of the eyes of those with whom I come in contact. A matter of the construction of their *inner* eyes."[23] Paradoxically, it is an archive of images

that renders African Americans "invisible," because the archive has scopic and psychological effects. Acknowledging the inextricable bond between visuality and recognition—how one's identity is tied to recognition of the other—Bearden cites archival sources to create an image, a *visibility*. In other words, he strives to present the undocumented: presence not absence, visibility not invisibility, the lives protected and signified by the returned gaze in *Mysteries*, for example. Bearden exposes naive mimesis to historical and cultural interpretations that undermine the allegedly universal character of vision. Bearden does not speak for these figures; he makes a space for their (lost) voices—their gazes.

The strategy of countering negative, often exploitative, documentary depictions with images of community and togetherness is clearly evident in Bearden's *Family Dinner*, 1968 (fig. 14); *Evening, 9:10, 461 Lenox Avenue*, 1964 (fig. 15); and *Mecklenburg County, Morning*, from the series *Profile/Part I, The Twenties*, 1978 (pl. 63). Even the title *Evening, 9:10, 461 Lenox Avenue* alludes to anthropological studies; the simple act of three people playing cards is elevated beyond observable fact. A diagonal running from upper left to lower right breaks the closed frame of the image. Between the open windows, whose four panes each reveal a distinct scene outside, and the bold clock face in the lower right corner, Bearden's anthropological study transgresses the frame of the small interior space by citing Paul Cézanne's *Card Players* and Zora Neale Hurston's study of anthropology with Franz Boas. There is a comparison to be made between Bearden's collage and Carrie Mae Weems's *The Kitchen Table Series: Untitled (Woman and Daughter with Children)*, 1990 (fig. 16), as both offer the viewer access to a private setting often hidden from sight. It is a setting imbued with strife and joy, tension and rest.

As much as Bearden's use of citation evinces a political element to his collage practice, it is also inseparable from his efforts to present the complex spaces wherein African diasporic culture takes place. When Bearden stated that collage "forges a variety of contrary images into one unified expression," he was not claiming that expression is necessarily a single voice.[24] On the contrary, his citation of images from the mass media, alongside

Pl. 60

Late Afternoon, 1971
Collage on cardboard, 18 × 24 inches
Montclair Art Museum, Montclair,
New Jersey. Museum purchase; funds
provided by The William Lightfoot
Schulz Foundation. 1979.6

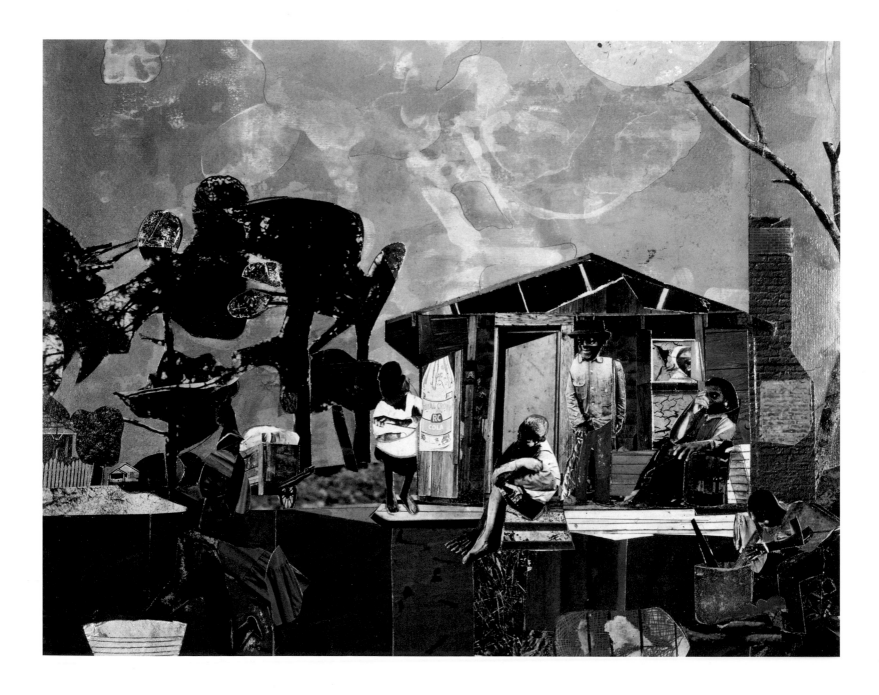

Pl. 61

The Tin Roof, 1978
Collage and watercolor on
paper, 6 ¼ × 9 ½ inches

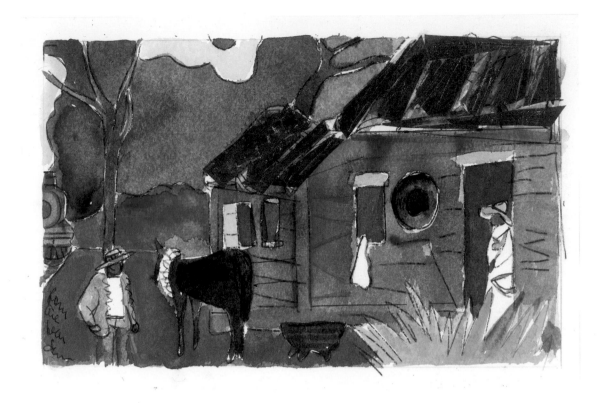

Pl. 62

Evening Guitar, 1985
Collage on board,
12 ½ × 15 inches

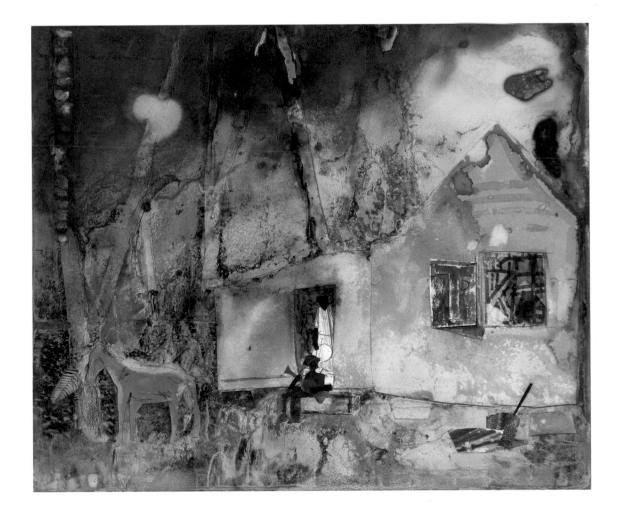

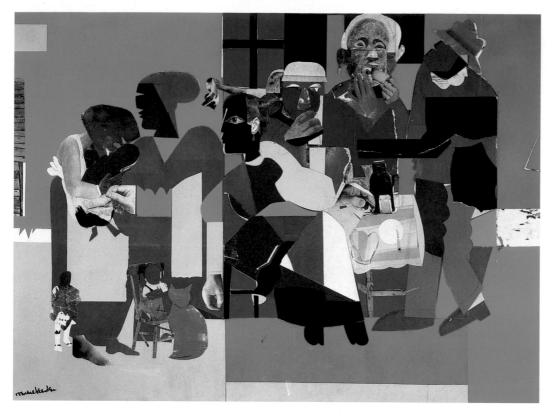

Fig. 14
Family Dinner, 1968
Collage on board, 30 × 40 inches
Toledo Museum of Art, Ohio

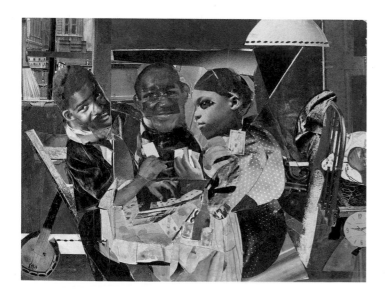

Fig. 15
Evening, 9:10, 461 Lenox Avenue, 1964
Collage of various papers with paint, ink, and graphite on cardboard, 8 ⅜ × 11 inches

Fig. 16
Carrie Mae Weems
The Kitchen Table Series: Untitled (Woman and Daughter with Children), 1990
Platinum print, 20 × 20 inches
The Cleveland Museum of Art. Purchase from the J. H. Wade Fund 2008.116.16
Courtesy of the Artist and Jack Shainman Gallery, New York and The Cleveland Museum of Art

Pl. 63

*Profile/Part I, The
Twenties: Mecklenburg
County, Morning*, 1978
Collage on board,
10 ¾ × 7 inches

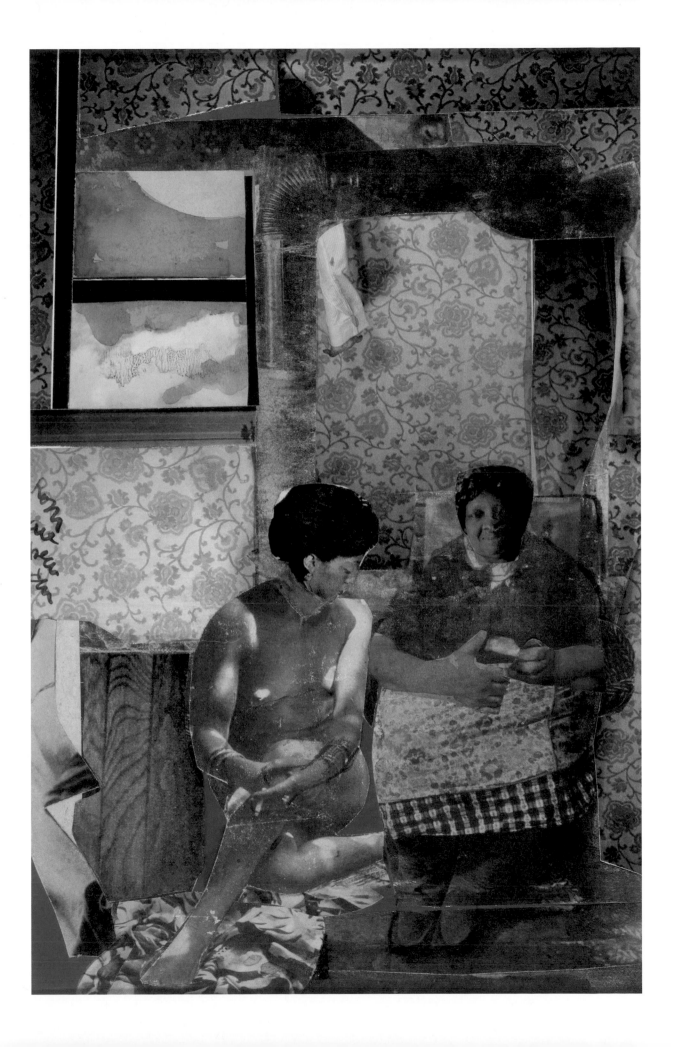

those from African and African American art and culture, gives us a disjunctive synthesis. This is what Homi Bhabha means when he writes that "cultures come to be represented by virtue of the process of iteration and translation through which their meanings are very vicariously addressed to—through—an Other. This erases any essentialist claims for the inherent authenticity or purity of cultures."[25] Bearden's art embodies a diasporic "hybrid modernity" that creates relations between the past and the present.[26] This is evident in a number of his collages wherein the train signifies movement between places and cultures (a material means of migration and return) but is also a metaphorical bearer of tidings that functions analogously to the repeated images of the annunciation (pls. 64–65) that punctuate Bearden's work (both the train and the archangel Gabriel can be interpreted as messengers). Messages are transmitted and shared, but there is no desire here to resuscitate the past as it was, because as every diasporic tradition—whether African or Jewish, for example—makes perfectly clear, that is not the genuine work of memory. Consequently, culture (visual art, music, dance, theater) must devise ways to transmit rather than represent the past. It is the epistemic and aesthetic power of art to give us a more complex temporality than simply a linear progression. Bearden offers us a temporality in which the past does not return whole or intact, but rather is *recollected*. It takes place *between* tenses. There is an historical continuity, but it must be *conjured* and transfigured, made anew rather than taken as a given (pl. 66).

This is certainly one of the reasons that the figure of the "conjur woman" (Bearden's spelling) repeats throughout the artist's collages: continuity and transmitting the past to the present is her charge (pl. 67). She replaces the Greco-Roman oracle because she represents the African diaspora. The conjure woman is a "conduit for the spiritual powers and knowledge of Africa," who "manipulates unseen, unfamiliar forces that heal or destroy. Her mysterious persona and penetrating gaze denote her traditional stature and power . . . in the culture of African Americans."[27] Bearden presents this figure as a hybrid, but also as a metonym for art itself. It is her presence between two cultures, ability to transmit knowledge of the past by translating it into new forms, and openness to forces and sensations that render

her one of Bearden's privileged figures for survival, for life as such (pl. 68).

It is here that Ellison's famous description of Bearden's collage work becomes clear: "Bearden's meaning is identical with his method. His combination of technique is in itself eloquent of sharp breaks, leaps in consciousness, distortions, paradoxes, reversals, telescoping of time and surreal blending of styles, values, hopes, and dreams which characterize much of Negro American history."[28] Bearden's work is not about his own personal memories. Its significance lies in understanding how those individual, subjective memories contain within them aspects of an entire cultural tradition, one that survives after the historical and cultural traumas of the Black Atlantic.[29] For Bearden, collage is a form of artistic practice that deploys a variety of modes of survival, including appropriating and reinscribing images from the mass media and techniques from European culture. The space of history in Bearden's images is an openness in time. Within his images, the past is recollected as coextensive with the current day; it is transmitted through fragments and pieces that he renders present. Unable to be made whole, the past nevertheless exerts a tremendous force, one that echoes *Haarlem* in Harlem, one that reverberates Chopin in *Kind of Blue*.

Bearden's images open a threshold between the past and the present, wherein we are faced, in the words of German-Jewish philosopher Walter Benjamin, with "a unity of experience that can by no means be understood as a sum of experiences."[30] It is a relation of immanence laced with singularity and repetition, alterity and belonging. In contrast to traditional ways of conceiving memory, history, and collective identity, Bearden cited the past so that it became incapable of fulfilling itself in the present. He did not work to retrieve the past as a whole, as if it existed intact in some realm outside of the present-day. Instead, he aimed to transmit the past as a force: to recollect it *within* the present.

In this regard, his work shares much with that of Benjamin, who eloquently put into words what Bearden's images present to us. Benjamin's uniqueness lay in his ability to discern within modernity and its social, economic, and historical ruptures—in short, our existence in the

Pl. 64

Sunset Limited, 1974
Mixed media collage on
Masonite, 14 × 20 inches

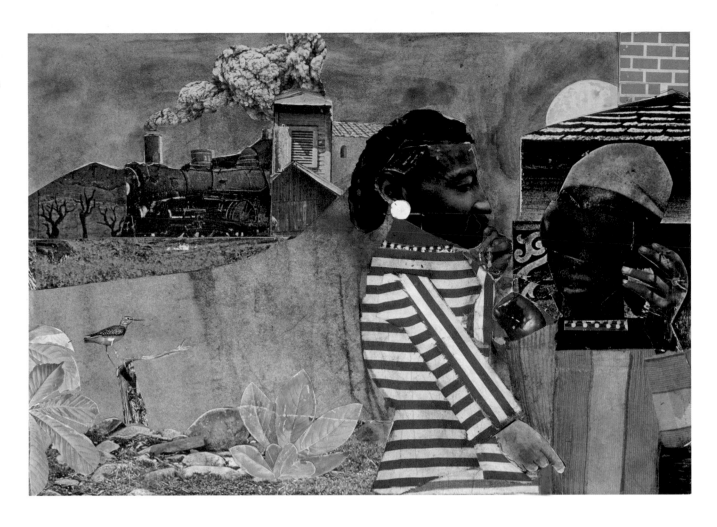

Pl. 65

Prevalence of Ritual: Tidings, 1964
Photostat on fiberboard,
27 ¼ × 37 ½ inches

Pl. 66

Continuity, 1980
Collage and mixed media on board,
14 × 17 inches

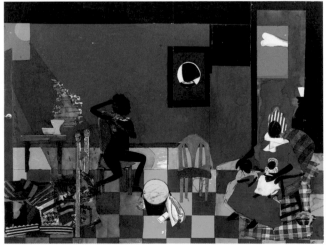

ON THE IMAGE OF BEARDEN — JAE EMERLING

Pl. 67

*Prevalence of Ritual: Conjur Woman
as an Angel*, 1964
Collage of various papers with paint and
ink on cardboard, 9 ³/₁₆ × 6 ⁷/₁₆ inches

Pl. 68

*Prevalence of Ritual: Conjur
Woman*, 1964
Collage of various papers with foil,
ink, and graphite on cardboard,
9 ¼ × 7 ¼ inches

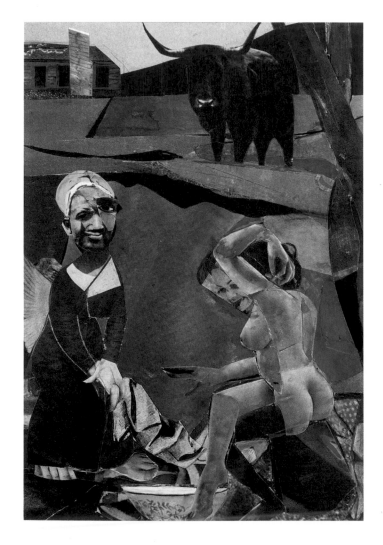

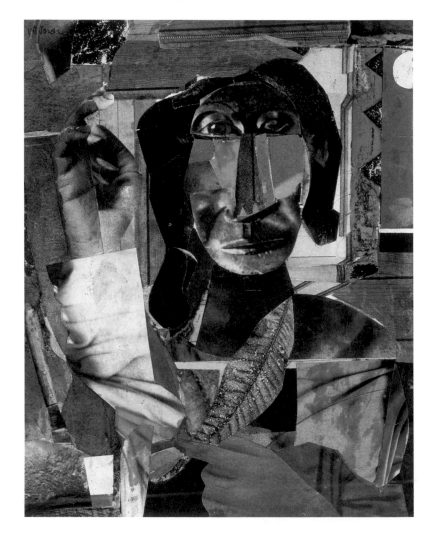

aftermath of collective experience—a chance to enact an event of memory, to grasp what is exposed by these "tiny sparks of accident," which he called the "turn of recollection."[31] This "turn" takes place precisely where the faculty of memory is no longer capable of maintaining something like tradition; that is, where and when there is an absence of collective experience. In the late 1930s, Benjamin composed his childhood memories of Berlin in a text entitled "Berlin Childhood around 1900" that parallels Bearden's childhood memories of the South. Written from the perspective of exile and with an acute awareness of the passage of time, it is over "the threshold of a century" that Benjamin writes: "I deliberately called to mind those images which, in exile, are most apt to waken homesickness: images of childhood. My assumption was that the feeling of longing would no more gain mastery over my spirit than a vaccine does over a healthy body. I sought to limit its effect through insight into the irretrievability—not the contingent biographical but *the necessary social irretrievability—of the past* [emphasis mine]."[32] It is this radical idea that marks the work of both Benjamin and Bearden. *Irretrievability* casts doubt on the possibility of simple representation, autobiography, or any narration of life. For Benjamin and Bearden, renewal signifies neither a representation nor a recuperation of the past. It demands a peculiar practice: an act of recollection that is not about what actually *occurred*, but about what remains "as yet unlived" in the past, what remains open to the future.

This is the image of thought that Bearden presents. His work transmits the disquiet of the past (to play upon Hegel's "the quiet of the past") to the future. This disquiet—its haunting, repetitive, differentiating aspect—is a clamor that causes as much anxiety and dread as excitement and possibility. An image *deframes* the past by opening a radical outside within it. Here, what falls outside of the frame of what we call the "past" folds itself into an aleatory, unforeseen future. These temporal aspects are immanent, but only an image can give us what Marcel Proust called "a strange sectioning of time," a phrase Benjamin frequently quotes. Time is invisible and indivisible, yet it is possible for an image—a sensation—of it to appear, as a flash, as a vertiginous opening. This time-image causes vertigo because its appearance is the result of a "discharge," a shock, a flash of illumination that exposes a terrain that is not the past, not even the past as lost time. Rather, it gives us time regained, which is not what has been lived or experienced.

It is this image of Bearden that indelibly colors work by contemporary artists such as David Hammons, Carrie Mae Weems, Willie Cole, Julie Mehretu, Betye Saar, and others. He is there cutting and selecting images, creating new forms and spaces, rendering imaginary but no less real configurations of figures and scenes. Throughout their work, Bearden is there citing the past, assembling blocks of sensation, bent over a worktable set under a calendar and a large photograph of his great-grandparents (who were also Duke Ellington's grandparents). It is a photograph that was taken long ago in Charlotte, and yet there it is (fig. 17).

It is this image of Bearden that we inherit. An image that appears in fragments and flashes, one that remains irretrievable even as it never ceases to be present—that is, contemporary.

1 bell hooks, *Art on My Mind: Visual Politics* (New York: The New Press, 1995), 75.

2 Marcel Proust, *Remembrance of Things Past, Volume 3*, trans. C. K. Scott Moncrieff and Terence Kilmartin (New York: Vintage Books, 1981), 932.

3 In particular, I have in mind the work of Kobena Mercer, notably his "Romare Bearden: African American Modernism at Mid-Century," in *Art History, Aesthetics, Visual Studies*, ed. Michael Ann Holly and Keith Moxey (Williamstown, MA: Sterling and Francine Clark Art Institute, 2002); and "Romare Bearden: Collage as Kunstwollen," in *Cosmopolitan Modernisms*, ed. Kobena Mercer (Cambridge, MA: MIT Press, 2005). In addition, see Richard J. Powell, *Cutting a Figure: Fashioning Black Portraiture* (Chicago: University of Chicago Press, 2008); Darby English, *How to See a Work of Art in Total Darkness* (Cambridge, MA: MIT Press, 2007); Louis Kaplan, "Community in Fragments:

Fig. 17
Frank Stewart
Romare Bearden, Long Island studio, 1980
Photography © Frank Stewart/
Black Light Productions

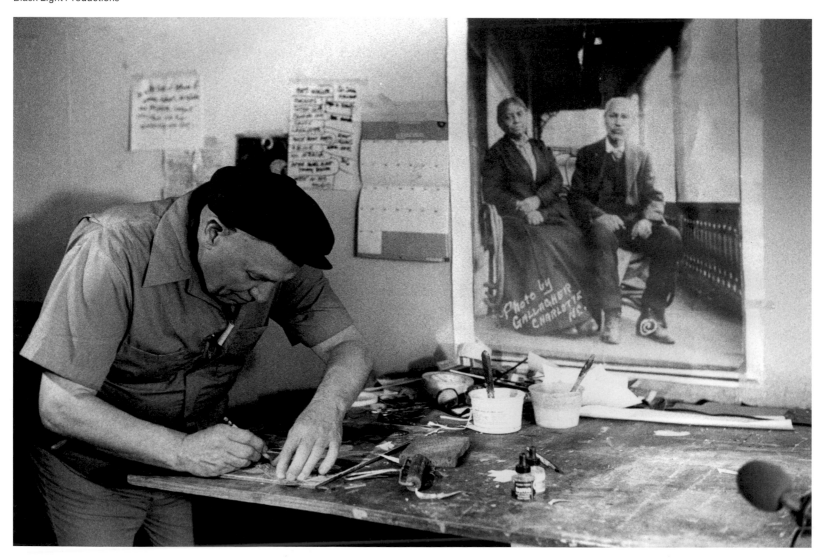

Romare Bearden's Projections and the Interruption of Myth," in *American Exposures: Photography and Community in the Twentieth Century* (Minneapolis: University of Minnesota Press, 2005); and Ruth Fine and Jacqueline Francis, eds., *Romare Bearden, American Modernist*, Studies in the History of Art: Center for Advanced Study in the Visual Arts. Symposium Papers 48 (Washington: National Gallery of Art, 2011). My own interest in Bearden began with my master's thesis, "The Politics of the Fragment: A Theory of Romare Bearden's Black-and-White Photomontages" (master's thesis, University of California, Los Angeles, 2000).

4 Judith Wilson stresses the importance of Bearden's use of photomontage to "represent black history and culture": "His unique contribution to this fundamentally modernist medium, of course, was the conflation of high-art references with pop cultural images, in the form of mass media photography." Here we see a common refrain about Bearden's work; namely, that it bridges jazz (Wilson uses the term "visual syncopation") and the Pop and Assemblage art that was prevalent in the 1960s. See Wilson, "Getting Down to Get Over: Romare Bearden's Use of Pornography and the Problem of the Black Female Body in Afro-U.S. Art," in *Black Popular Culture: A Project by Michelle Wallace*, ed. Gina Dent (New York: Dia Center for the Arts, 1992), 116.

5 As Lee Stephens Glazer notes, "The idea of working from fragmented images culled from magazines and Bearden's vast store of art-historical reproductions [resulted] in the series of works that became Projections." See "Signifying Identity: Art and Race in Romare Bearden's Projections," *Art Bulletin* 76, no. 3 (1994): 415. As Bearden himself said: "I then have my small original works enlarged so the mosaic-like joinings will not be so apparent." Quoted Sharon Patton, "Memory and Metaphor: The Art of Romare Bearden, 1940–1987," in Patton and Mary Schmidt Campbell, *Memory and Metaphor: The Art of Romare Bearden 1940–1987* (New York: Studio Museum in Harlem, 1991), 44.

6 See Bearden, "The Negro Artist's Dilemma," *Critique* 1, no. 2 (November 1946): 16–22. Bearden was responding to a variety of cultural debates, but one was undeniably the discourse generated by Alain Locke on "the new Negro" during the Harlem Renaissance. bell hooks notes, "Although he was critical of Locke and felt that it was a mistake for black folks to think that all black art had to be protest art, Bearden was obsessed with his ancestral legacy, with the personal politics of African-American identity and relationships. This subject matter was the groundwork that fueled all his art. He drew on memories of black life—the images, the culture." See *Art on My Mind: Visual Politics* (New York: New Press, 1995),

5. Richard J. Powell adds that Bearden's essay was "in post-World War II America, just as much a response to the conservative political climate of the day (and to the desire for racial integration) as it was a reflection of his belief in universal ideals in art and in the integrity of individual artistic expression." See "What Becomes a Legend Most?: Reflections on Romare Bearden," *Transition* 55 (Spring 1992): 70. See also Alain Locke, ed., *The New Negro: Voices of the Harlem Renaissance* (1925; repr., New York: Atheneum, 1992).

7 "Space is all-embracing; it is . . . dynamic," Bearden wrote. Quoted in Gail Gelburd, "Romare Bearden in Black-and-White: The Photomontage Projections of 1964," in Gelburd and Thelma Golden, with Albert Murray, *Romare Bearden in Black-and-White: Photomontage Projections, 1964* (New York: Whitney Museum of American Art, 1997), 29.

8 See Powell, "The Woodshed," in *Romare Bearden, American Modernist*, ed. Fine and Francis, 202.

9 Roland Barthes, "The Death of the Author" in *Image-Music-Text*, trans. Stephen Heath, (New York: Hill and Wang, 1977), 146.

10 As Mercer writes: "Working through aspects of this dilemma in the vernacular realism of his early gouaches and then with his deepening interest in post-Cubist pictorial space, Bearden found a synthesis in collage and photomontage that reconciled his commitments to the high modern ethos of individuality and complexity, on the one hand, and to the call-and-response ethos in black American 'folk' culture, on the other." See Mercer, "Romare Bearden: African American Modernism at Mid-Century," 30.

11 The concept of a "memory crisis" is developed by Richard Terdiman in *Present Past: Modernity and the Memory Crisis* (Ithaca: Cornell University Press, 1993). It addresses the amnesia of modernity as well as attempts to create new cultural models of memory; that is, attempts to form new relations between the past and the present.

12 Benjamin H. D. Buchloh, "Gerhard Richter's *Atlas*: The Anomic Archive," in *The Archive*, ed. Charles Merewether (Cambridge, MA: MIT Press, 2006), 91. See also Buchloh's invaluable essay "From Faktura to Factography," in *The Contest of Meaning: Critical Histories of Photography*, ed. Richard Bolton (Cambridge, MA: MIT Press, 1989), 49–85.

13 Buchloh, "Gerhard Richter's *Atlas*," 91–92. See also Maud Lavin, *Cut with the Kitchen Knife: The Weimar Photomontages of Hannah Höch* (New Haven: Yale University Press, 1993).

14 This is Hale Woodruff's definition as quoted in Floyd Coleman, "The Changing Same: Spiral, the Sixties, and African-American Art," in *A Shared Heritage: Art by Four African Americans*, ed. William E. Taylor and Harriet G. Warkel (Indianapolis:

Indianapolis Museum of Art, 1996).

15 Ellison, "The Art of Romare Bearden," in *Going to the Territory* (New York: Random House, 1986), 227.

16 Kaplan, "Community in Fragments," 110.

17 Judith Butler, *Bodies That Matter: On the Discursive Limits of "Sex"* (London: Routledge, 1993), 45.

18 Bearden, quoted in Patton, "Memory and Metaphor," 43.

19 Glazer, "Signifying Identity," 424.

20 Bearden, quoted in Thelma Golden, "Projecting Blackness," in *Romare Bearden in Black-and-White*, 49.

21 Glazer, "Signifying Identity," 423–24.

22 Ibid.

23 Ellison, *Invisible Man* (1952; repr., New York: Vintage, 1995), 3.

24 Bearden, quoted in Charles Childs, "Bearden: Identification and Identity," *Art News* 63 (October 1964): 62.

25 Homi Bhabha, *The Location of Culture* (London: Routledge, 1994), 58.

26 "Hybrid modernity" is a concept Mercer develops in his readings of Bearden. See "Romare Bearden: African American Modernism at Mid-Century," 31.

27 Patton, "Memory and Metaphor," 40.

28 Ellison, "The Art of Romare Bearden," 237.

29 See Paul Gilroy's remarkable study, *The Black Atlantic: Modernity and Double Consciousness* (Cambridge, MA: Harvard University Press, 1993).

30 Walter Benjamin, *Selected Writings, Volume 1: 1913–1926*, ed. Michael W. Jennings et al. (Cambridge, MA: The Belknap Press of Harvard University Press, 1999), 104, 109.

31 It is the potentiality of recollection to render the incomplete complete, and the accomplished unaccomplished. Benjamin's use of the German word *Eingedenken* signifies not merely a remembrance, but a "bearing or a calling in mind." This "bearing in mind" is an openness, an attentiveness (*Aufmerksamkeit*). Recollection bears oblivion in mind, thereby distorting any and every relation between memory and forgetting. For this reason, Benjamin views the "turn of recollection" as a radical alteration of our liberal humanist, even scientific, conception of knowledge. See *The Arcades Project*, trans. Howard Eiland and Kevin McLaughlin (Cambridge, MA: The Belknap Press of Harvard University Press, 1999), 388.

32 See Benjamin, *Selected Writings, Volume 3: 1935–1938*, ed. Howard Eiland and Michael W. Jennings (Cambridge, MA: The Belknap Press of Harvard University Press, 2002), 344. This concept of the "necessary social irretrievability of the past" was central to my doctoral thesis, "The Gesture of Collecting: Walter Benjamin and Contemporary Aesthetics" (Ph.D. diss., University of California, Los Angeles, 2006). See also Emerling, "An Art History of Means: Arendt-Benjamin," *Journal of Art Historiography* 1 (December 2009).

BEARDEN'S CROSSROADS: MODERNIST ROOTS / RIFFING TRADITIONS

Leslie King-Hammond

As African-American visual artists confronted the challenge to be modern, they would have to consider how they would navigate notions of heritage and the engagement of "tribal" arts, of primitivism and authenticity, of plastic radicalism and stereotypical caricature, of secularism and spirituality. To do so they would have to perform the seemingly impossible task of addressing the expectations both on the part of the larger white society and within the black community. Herein lay the challenge of the modern for African-American artists.

Lowery Stokes Sims[1]

The survival of African Americans in the New World is in part attributable to the retention of ancestral African belief systems, spirituality, respect for nature, and bonds of family and community. What was lost or scrambled in its original cultural intent from Africa was *re*-configured and *re*-visioned to address the needs of survival in the New World. Due to insufficient critical research, art historians have heretofore been unable to address the ways in which artists—especially those of Romare Bearden's generation and the present day—have identified, preserved, and incorporated these ancestral beliefs and cultural practices into their artistry. Yet for decades, New World African diasporic artists have fused knowledge from African, European, and indigenous American cultures to form a distinctively modern sensibility. Bearden and his peers sought to create aesthetic voices that would give visual meaning and presence to ordinary people—living ordinary lives, in ordinary environments—in an extraordinary era of modernist invention.

Bearden emerged as an artist during a period of history when African Americans were popularly believed to lack the capacity to create art that reflected an innovative vision of the modern world. Sociopolitical and economic marginalization, grounded in pseudoscientific notions of intelligence, left little room for artists of African descent to be recognized as an important part of the artistic legacy of American culture. Bearden, a man of enormous vision, genius, and invention, created bodies of work that traversed traditions, cultures, identity, geography, spirituality, and religious belief systems from the crossroads of African, European, Asian, and Native American cultures. Moreover, he had a relentless appetite for researching and writing about art—his own process, as well as the art that informed his particular worldview.[2] In spite of all the critical and scholarly writing about Bearden's imagery and artistic process, however, the silent, spiritual, and invisible worlds of black life and culture that are the foundation and roots of his artistry have been very little explored. The aesthetic vocabulary utilized in Bearden's collages, paintings, and prints is loaded with signifiers drawn from the inner sanctums of the black communities that formed his identity. Derived from jazz idioms, these signifiers are visual riffs that capture moments of intensity, pathways, and beauty in slices of energy that combine

to create an aesthetic experience of profound elegance and majesty.

Contrary to popular belief, African Americans did not lose all of their Africanisms or cultural markers as a result of slavery and the Middle Passage. Bearden was a hypersensitive observer and participant in the community of a middle-class family based in Charlotte (Mecklenburg County), North Carolina. He spent many summers there with his grandmother and other family, a marked contrast to the urban lifestyle he experienced in Pittsburgh and New York City's Harlem neighborhood, where his grandparents and parents migrated from the South in the 1920s. His early works, such as *Untitled (Harvesting Tobacco)*; circa 1940 (pl. 69); *Untitled (Husband and Wife)*, circa 1941 (pl. 70); *The Visitation*, 1941 (pl. 71); and *Presage*, 1944 (pl. 72) recorded events that reflected the people he observed in the communities where he lived. Bearden was clear and insistent about his artistic goals, stating, "It is not my aim to paint about the Negro in America in terms of propaganda. [It is to depict] the life of my people as I know it, passionately and dispassionately as Brueghel. My intention is to reveal through pictorial complexities the life I know."[3] The "pictorial complexities," or sources, of Bearden's painting and collage compositions are often cited as having used Western references. Bearden confronted the challenge of addressing modernism from a truly African-descendent position with humble materials that yielded profound insights. These works have yet to be adequately articulated or fathomed within the context of the ethos of the black experience in the United States.

The challenge of the "modern" also fascinated fellow artists such as Jacob Lawrence, William H. Johnson, Palmer Hayden, and Archibald Motley. Each was intrigued by the myriad possible ways to make visible the story of African American life. From a position of interiority, each sought to capture and record the daily lives of ordinary people, their unique cultural attributes, and the irrational difficulties associated with living in a racially hostile America. Each artist tried to tell his story in a visual language that had not yet engaged the possibility of the black subject as central or crucial to the discourse of modernism. There was no place of recognition or inclusion for a people forced to live outside the mainstream of American culture and life. Bearden and his contemporaries' challenge was to make visible the invisible.

Bearden's narrative "complexities" have profound connections to Africa, as affirmed by the scholarship of Melville J. Herskovits, Zora Neale Hurston, Joseph E. Holloway, Eugene D. Genovese, Leland G. Ferguson, Ira Berlin, Lorenzo Dow Turner, John Michael Vlach, Sterling Stuckey, and Robert Farris Thompson.[4] Thompson, in his 1984 text *Flash of the Spirit*, stated that African American aesthetics "illuminate art and philosophy connecting black Atlantic worlds . . . opening lines of inquiry," arguing, "identification and explanation of some of these mainlines, intellectually perceived and sensuously appreciated, provide[s] measure of the achievement of African civilizations in transition to the West, for theirs is one of the greatest migration styles in the history of the planet."[5] Bearden opened the door to a new dialogue, one that has been dormant in the discourse surrounding his work, that of his peers, and that of contemporary artists. Art historical and critical scholarship has not addressed the vibrancy and diversity of American modernism in the artwork of African-descended people.

What did it look like to *live* and *move* within a community of black citizens? How did they respond and relate to one another? How was spirituality expressed within a pictorial narrative? What was the physical nature and configuration of the environment built by black people? These are but a few of the questions Bearden faced in trying to create modernist images that reflected the complex life he witnessed and experienced in the rural South (North Carolina) as well as in the urban locales of Pittsburgh and Harlem in the North. The spaces in which African Americans lived and conducted their lives not only had a direct impact on them, but also on the perception of what has come to be recognized as American culture. Lived spaces become places of significance when folk beliefs, religion, and spiritual practice are exacted to create a sense of community, ritual, memory, and home—the feelings of *belonging* and being *safe* are essential to the quality of life desired by all people in the black community. Depictions of ritual and spiritual practice are widespread in Bearden's work; one incarnation of such practices can be found in the recurring theme of the baptism (pls. 73–74).

Pl. 69

Untitled (Harvesting Tobacco), circa 1940
Gouache on paperboard,
43 × 30 inches

Pl. 70

Untitled (Husband and Wife), circa 1941
Tempera on paper,
20 × 27 inches

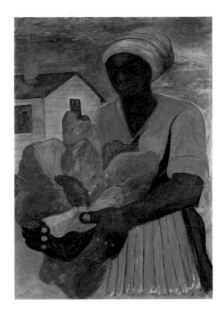 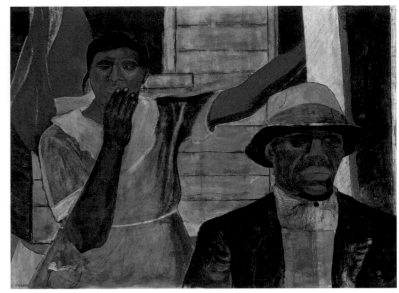

Pl. 71

The Visitation, 1941
Gouache with ink and graphite on
brown paper, 30 ⅝ × 46 ¼ inches

Pl. 72

Presage, 1944
Gouache with ink and graphite on
brown paper, 48 × 32 inches

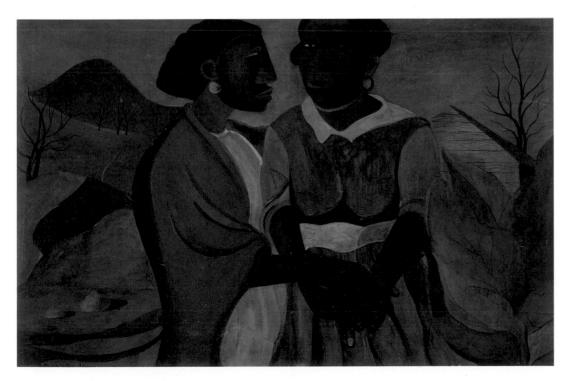 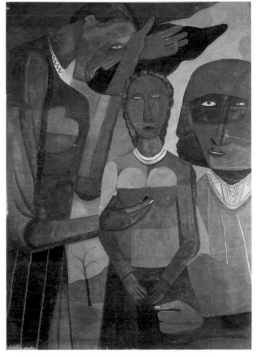

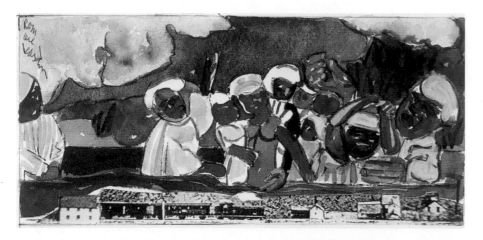

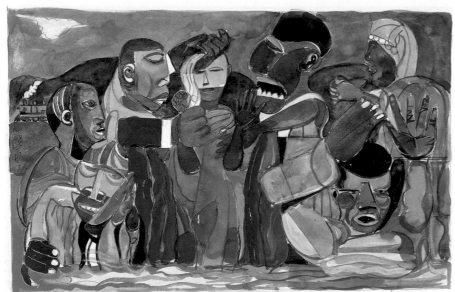

Pl. 73

Baptism, 1978
Collage and watercolor on paper,
4 ½ × 9 ¼ inches

Pl. 74

The Baptism, 1978
Watercolor, gouache, and
graphite on paper, 21 × 26 inches

Pl. 75

Mother and Child, 1971
Oil and ink on paper, cutouts
collaged and mounted onto
Masonite panel, 11 × 7 ⅞ inches

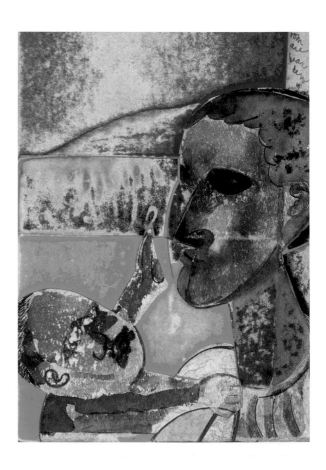

Whereas the Africanist religion of Vodun is historically associated with Haiti, Santeria with Cuba, Candomblé with Brazil, and Obeah with Jamaica, the American South became known for its conjurers, root workers (herbalists), and all of the beliefs and practices associated with Hoodoo, described by Stephanie Mitchem as "a set of practices and beliefs that draw on nature and its perceived energies in order to shape preferred conditions."[6] Hoodoo workers were everywhere in the South, and were present in both black and white communities. Bearden's youth was richly infused with Hoodoo's worldview, as expressed in the blues, religion, and the maternal care and protection of his grandmother and mother—two of the most powerful and revered forces in his life. The importance of the mother in Bearden's art can be seen in such works as *Mother and Child*, 1971 (pl. 75), in which the maternal figure takes on the dual roles of caretaker and protector. Since the days of enslavement, women of African descent have been the primary caretakers of the family and the community. As mothers, grandmothers, sisters, wives, lovers, midwives, healers, herbalists, cooks (pl. 76), seamstresses (pl. 77), and protectors, African-descended women hold important roles of leadership and authority in Southern communities.

Bearden's female characters, who possess the ability to multitask and who employ a vast repertoire of management skills, created a constant source of rich material that inspired the artist's imagination and grounded his need to record persons and activities, which were often a mystery to him. In such compositions as *Melon Season*, 1967 (pl. 78); *Untitled (Melon Season)*, circa 1967 (pl. 79); *She-Ba*, 1970 (pl. 80); and *Mecklenburg Autumn Morning*, 1983 (pl. 81), which reference the routines of daily life, Bearden portrayed ordinary, humble women as authoritative, powerful, assertive, and mysterious. It is important to note that while men were also practitioners, it was the women who were most active within the Hoodoo-conjure-root traditions—they were the keepers of the knowledge that was often held secret.

In Africa, knowledge is sacred and deeply respected—especially knowledge steeped in "invisible" powers. Mary Nooter has articulated how "secrecy is an aesthetic means of ordering knowledge, regulating power, and demarcating differences between genders, classes, titles, and professions. Secrecy is a channel of communication and commentary: a social and political boundary marker: and a medium of property and power. . . . The purpose is not to tell secrets but to explore secrecy as a strategy, and as an important dimension of African knowledge, power, and aesthetic experience."[7] However, the presence of conjurers or root workers has often elicited great fear and mystery in the African-descended community. In the 1935 publication *Mules and Men*, Zora Neale Hurston commented on the black community's attitude regarding the presence and practice of Hoodoo in their lives: "Nobody knows for sure how many thousands in America are warmed by the fire of hoodoo, because the worship is bound in secrecy. It is not the accepted theology of the Nation and so believers conceal their faith. Brother from sister, husband from wife. Nobody can say where it begins or ends. Mouths don't empty themselves unless the ears are sympathetic and knowing."[8]

Bearden, as an impressionable youth, witnessed the presence of, and even engaged with, persons "warmed by the fire of hoodoo," especially women who were gifted healers, midwives, root workers, and conjurers. In 1978, Bearden recalled, "everything they said a conjur [sic] woman could do, I believed."[9] Spectral displays of folk healing were commonplace in North Carolina; evidence of such occurrences appears in the work of Mary Lyde Hicks Williams, a white North Carolina painter. In her 1890–1900 portrait of Victoria Brown, a former slave who had grown up on the plantation owned by Williams's family, Brown wears a head wrap under which greens (kale, collard, mustard, or turnip) have been applied as a medical treatment for headaches (fig. 18). Free African women living in the South, as well as those who were enslaved and later freed, also used ginseng and cabbage leaves to cure fevers.[10] Sharla M. Fett asserts that the "herbal specialist accumulated a far more extensive pharmacopoeia for regulating, purifying, and balancing the body," explaining that "younger men and women in plantation communities learned this complex body of knowledge through an extended process of apprenticeship."[11] Kinship systems were established by the elders in the enslaved, and later freed, African American communities.

Pl. 76

Sunday Morning, 1985
Mixed media collage on board,
11 ⅛ × 7 inches

Pl. 77

*Mecklenburg Autumn: The
China Lamp* (a.k.a. *The
Dressmaker*), 1983
Mixed media collage on board,
40 × 31 inches

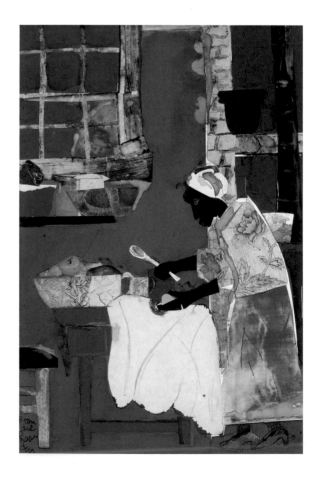

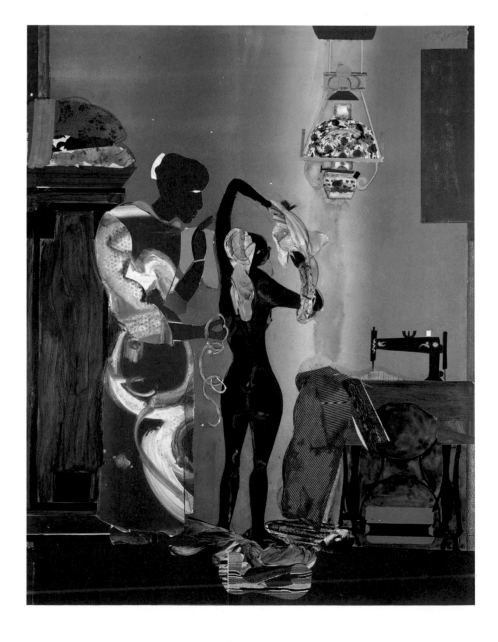

Pl. 78

Melon Season, 1967
Paper collage on canvas,
56 × 44 inches
Neuberger Museum of Art,
Purchase College, State
University of New York, gift
of Roy R. Neuberger

Pl. 79

Untitled (Melon Season),
circa 1967
Collage of papers with
ink on gessoed cardstock
mounted to board,
11 ½ × 8 ½ inches

Pl. 80

She-Ba, 1970
Collage on board,
48 × 35 ⅞ inches
Wadsworth Atheneum
Museum of Art, Hartford,
Connecticut. The Ella
Gallup Sumner and
Mary Catlin Sumner
Collection Fund

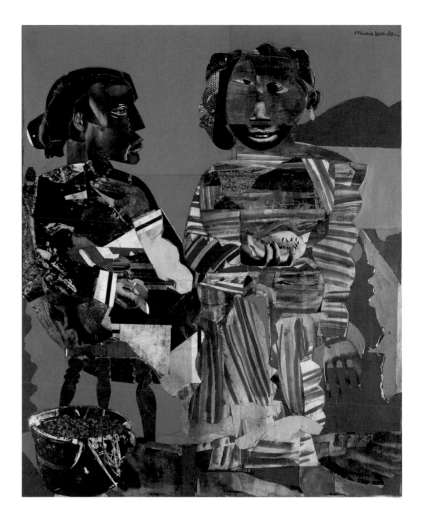

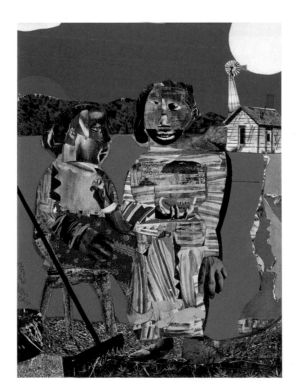

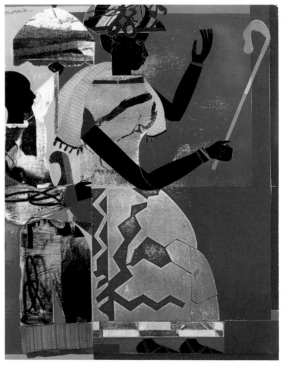

Pl. 83

Fish Fry, 1967
Paper collage on board,
30 × 40 inches

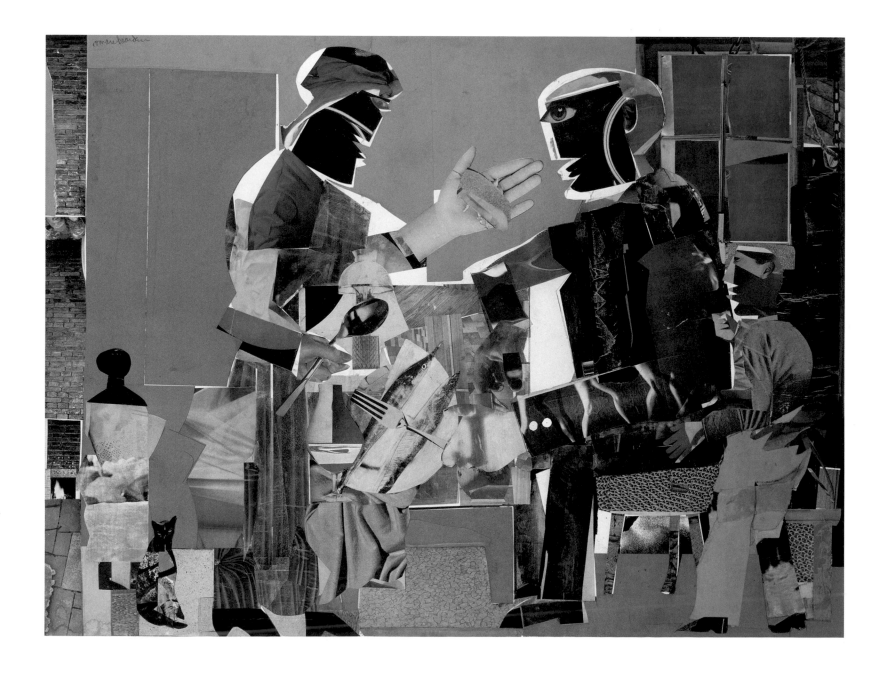

PI. 84

Before the Dark, 1971
Collage on board, 23 ¾ × 18 inches

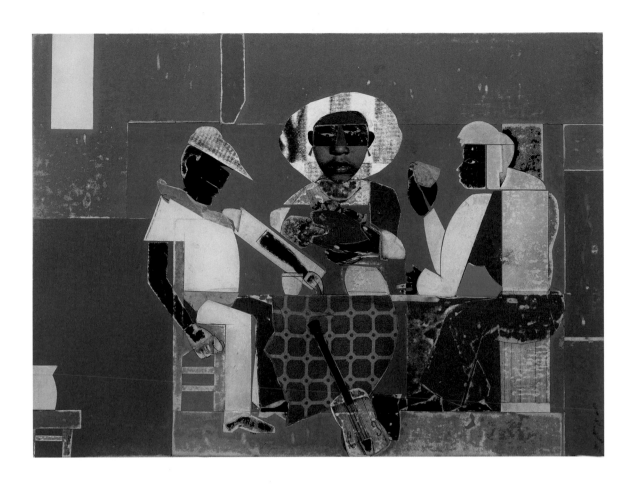

PI. 85

Carolina Sunrise, 1975
Collage on board, 15 × 20 inches

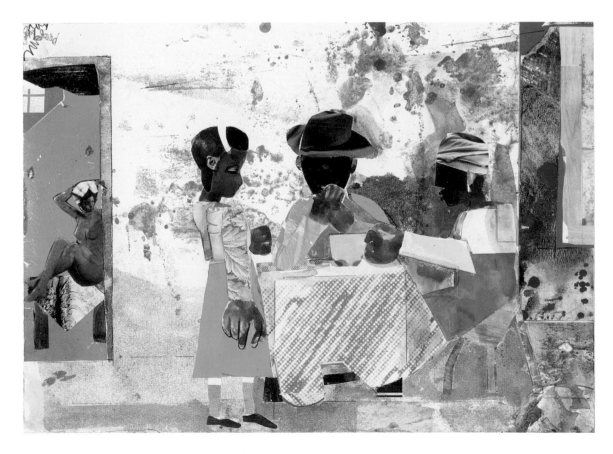

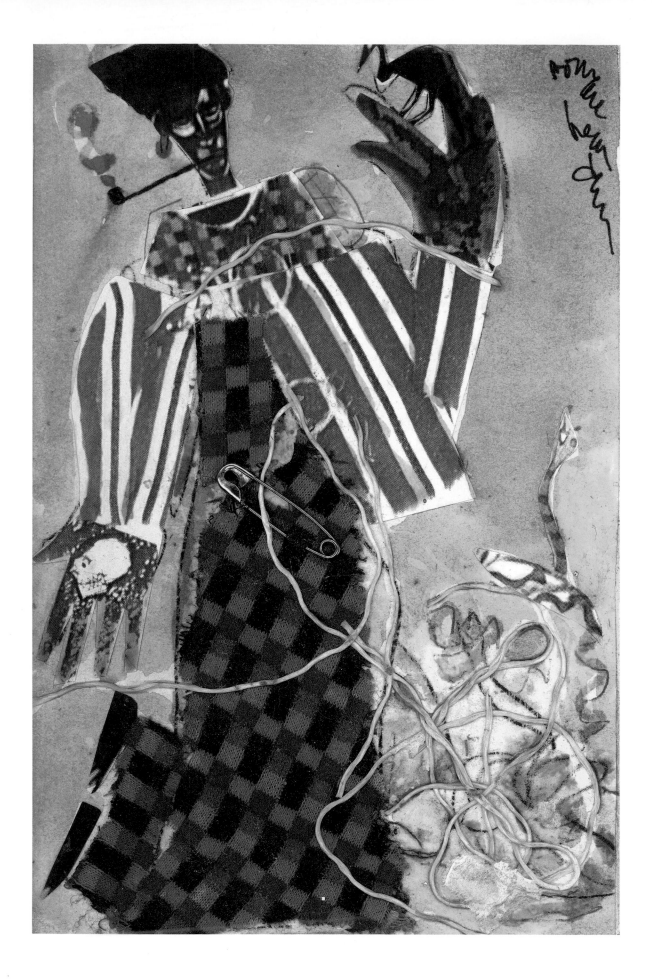

Pl. 86

*Bayou Fever—The Buzzard and
the Snake*, 1979
Gouache and watercolor on paper,
9 × 6 inches

many people of African descent who have ascended the ladder of "racial uplift" have had difficulty accepting these practices, often dismissing belief as mere superstition. Yet, Hoodoo, conjure, and root work traditions are alive and well in the twenty-first century United States. While Bearden is the primary focus of this essay, it is also important to cite other artists who had family origins in the South. In interviews with North Carolinians Juan Logan and Ce Scott; Jonathan Green, who grew up in the Gullah culture of Charleston, South Carolina; and Joyce J. Scott, whose father and mother are from North Carolina and South Carolina, respectively, all remembered numerous experiences with conjuration in their early lives.[15] Logan identified his painting, *First You Have to Believe*, 1982 (fig. 19), as the first time he openly confronted Hoodoo elements in his work: "I got tired of people being in denial about the impact and presence of these powerful beliefs."[16] Ce Scott has built altars that address the divine presence of earthly and spiritual deities. In conversation she also related that in the North Carolina dating scene, her companions are often fearful that she will "put a root" on them.[17] In his paint-

ing *Seeking*, 2008 (fig. 20), Green depicts the process of initiating young Gullah males into manhood; as part of this rite, the young men are led into the forest for seven days and seven nights for prayer and education. Joyce J. Scott's work is loaded with imagery that speaks to the human condition—its conflicts with love, lost and gained, and the trickster elements that test the moral and ethical responsibilities of humankind. In *The Many Faces of Love #2*, 2006 (fig. 21), images of ancestral Africa, erotic love, life, and death converge and confront the viewer. As a result of this Hoodoo-inflected subject matter, Scott's work is often censored from exhibitions.

In 1969, Ishmael Reed coined the term and aesthetic philosophy known as "Neo-HooDoo." In the late 1960s, during the Black Arts Movement, Reed recalled, "I came to use Neo-HooDoo, which has a history in painting and literature, including magic-realist stories from folklore, including references to 'two headed men,' conjure men and women . . . because I was part of a movement whose aim was to use non-Western resources in our work."[18] Bearden was an active member of the Black Arts Movement, and

Fig. 19
Juan Logan
First You Have to Believe, 1982
Courtesy of the Artist

Fig. 20
Jonathan Green
Seeking, 2008
Courtesy of the Artist

Fig. 21
Joyce J. Scott
The Many Faces of Love #2, 2006
Courtesy of the Artist and Goya
Contemporary/Goya-Girl Press, Inc.

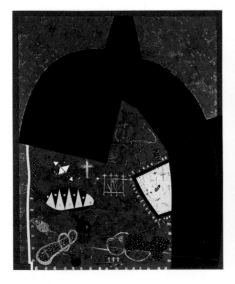

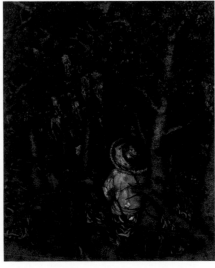

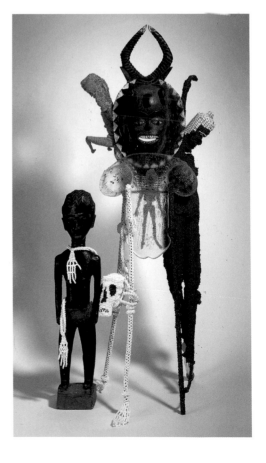

Pl. 87

Profile/Part I, The Twenties:
Mecklenburg County, Conjur
Woman and the Virgin, 1978
Collage of various papers with ink
on fiberboard, 14 × 20 inches

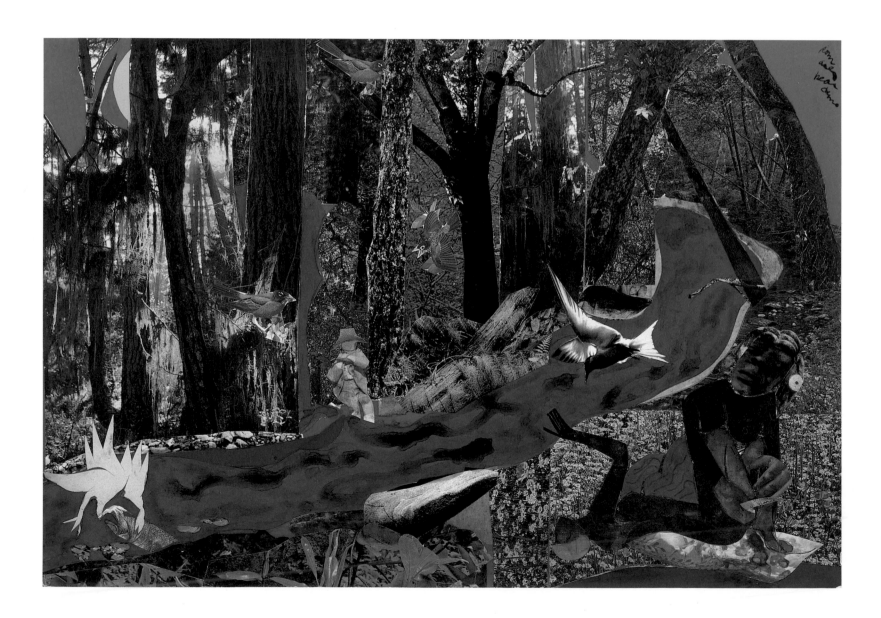

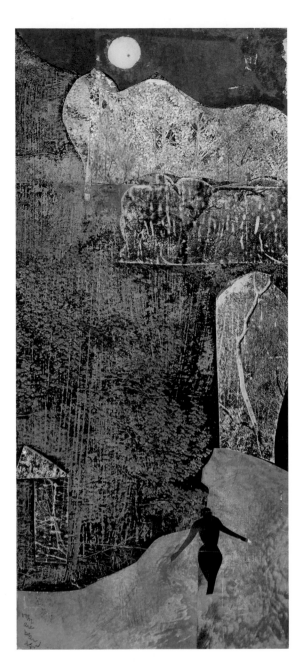

Pl. 88

Untitled (Girl in a Pond), 1972
Collage of various papers with paint
and surface abrasion on fiberboard,
17 ½ × 7 ¾ inches

Pl. 89

Blue Nude, 1981
Collage and mixed media on board,
14 × 18 inches

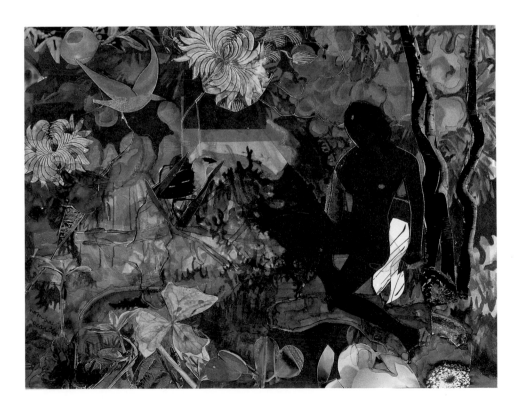

this literature also fed his creative mind. He was in the vanguard of a modernist thrust to create a visual language that recorded the spiritual life and worldview of the African American ethos. Franklin Sirmans's critical research, as presented in his 2009 exhibition *NeoHooDoo: Art for a Forgotten Faith*, finally begins to break ground and create a path of enlightenment to better comprehend the phenomenal importance of this heritage. Sirmans's intent was "to examine the multiple meanings of spirituality in contemporary art," a subject he argued "has often been treated as ethereal, apolitical, and at times, anti-intellectual, and form and composition alone are highlighted."[19]

While Hoodoo culture is most prevalent in the rural South, where Bearden first encountered such traditions as a child, it was a force that was present throughout his life. Years later, he recalled, "even in Pittsburgh, living in the house in back of my grandmother's, there was an old woman much feared for her power to put spells on people."[20] Bearden was a fearless "godfather" of the Neo-HooDoo Movement—a man ahead of his time. He maintained that, "The artist looks for a vision, not an idea," and that, "The artist's vision is transcendental."[21] Bearden plumbed the uncharted mysteries of the spiritual realm and provided future scholars and artists with the complex opportunity to more intimately understand his love of humanity—"my human compassion"—to discover the abundance of histories, stories, proverbs, prayers, and mythologies that bridge the worlds of African American life yet to be revealed.

Notes

1 Lowery Stokes Sims, "Modernism and its Discontents," in *Challenge of the Modern: African-American Artists, 1925–1945* (New York: Studio Museum in Harlem, 2003), 14.

2 For the most comprehensive bibliography, including five sections that address the range of writings by Bearden, critics, and scholars, see Ruth Fine, *The Art of Romare Bearden* (Washington: National Gallery of Art, 2003), 270–315.

3 Bearden, "Rectangular Structure in My Montage Paintings," *Leonardo* 2 , no. 1 after (January 1969): 19.

4 For further discussion of African retentions in the Americas, see: Melville J. Herskovits, *The Myth of the Negro Past* (Boston: Beacon Press, 1941); Zora Neale Hurston, *The Sanctified Church* (Berkeley: Turtle Island, 1981); Joseph E. Holloway ed., *Africanisms in American Culture* (Bloomington: Indiana University Press, 1990); Eugene D. Genovese, *Roll, Jordan, Roll: The World the Slaves Made* (New York: Pantheon Books, 1974); Leland G. Ferguson, *Uncommon Ground: Archaeology and Early African America, 1650 –1800* (Washington: Smithsonian Institution Press, 1992); Ira Berlin, *The Making of African America: The Four Great Migrations* (New York: Viking, 2010); Lorenzo Dow Turner, *Africanisms in the Gullah Dialect* (Chicago: University of Chicago Press, 1949); John Michael Vlach, *Back of the Big House: The Architecture of Plantation Slavery* (Chapel Hill: University of North Carolina Press, 1993); Sterling Stuckey, *Slave Culture: Nationalist Theory and the Foundations of Black America* (New York: Oxford University Press, 1987); Robert Farris Thompson, *Flash of the Spirit: African and Afro-American Art and Philosophy* (New York: First Vintage Books, 1984).

5 Thompson, *Flash of the Spirit*, xvii.

6 Stephanie Y. Mitchem, *African American Folk Healing* (New York: New York University Press, 2007), 15. For a related discussion, see Glenn Hinson, "Rootwork (HooDoo, Conjure)," in *Folk Life: New Encyclopedia of Southern Culture*, vol. 14 (Chapel Hill: University of North Carolina Press, 2009), 221–26.

7 Mary H. Nooter, "Introduction: The Aesthetics and Politics of Things Unseen," in *Secrecy: African Art that Conceals and Reveals* (Munich: Prestel, 1993), 24.

8 Zora Neale Hurston, *Mules and Men* (Bloomington: Indiana University Press, 1935; repr., 1978), 195.

9 Bearden, quoted in *Romare Bearden: Collages: Profile/Part I: The Twenties* (New York: Cordier and Ekstrom, 1978). Bearden inscribed brief narratives on the gallery walls beneath each work in the 1978 exhibition at Cordier and Ekstrom in New York. This quote appeared in association with the collage *Conjur Woman and the Virgin*, 1978.

10 Sharla M. Fett, *Working Cures: Healing, Health, and Power on Southern Slave Plantations* (Chapel Hill: University of North Carolina Press, 2002), 70–71.

11 Ibid., 75.

12 Allen F. Roberts, *Animals in African Art: From the Familiar to the Marvelous* (Munich: Prestel, for the Museum of African Art, New York, 1995), 65. See also Henry Drewel, "Mask (Gelede)," in *For Spirits and Kings: African Art from the Paul and Ruth Tishman Collection* (New York: Henry N. Abrams, for the Metropolitan Museum of Art, 1981), 114-15; and Henry and Margaret Drewel, *Geleda: Art and Female Power Among the Yoruba* (Bloomington: Indiana University Press, 1990), 74, 183, 206.

13 Catherine Yronwode has created a website of books, products, and references for Hoodoo practitioners, and has identified at least six thousand references and products that date back to the 1800s. See "HooDoo in Theory and Practice: An Introduction to African American Root Work," and "HooDoo: African American Magic," http://luckymojo.com (accessed 11 March 2011).

14 Zora Neale Hurston, "HooDoo in America," *Journal of American Folklore* 44 (October–December 1931): 317–417.

15 Jonathan Green, Juan Logan, Ce Scott, and Joyce J. Scott, interviews with the author, 26–28 January 2011.

16 Logan, interview with the author, 26–28 January 2011.

17 Ce Scott, interview with the author, 26–28 January 2011.

18 Reed, quoted in Franklin Sirmans, "An Interview with Ishmael Reed," in *NeoHoo-Doo: Art for a Forgotten Faith*, ed. Franklin Sirmans (New Haven: Yale University Press, 2009), 76–77.

19 Ibid., 12.

20 Bearden, quoted in Sharon F. Patton, *Memory and Metaphor: The Art of Romare Bearden, 1940–1987* (New York: Oxford University Press, 1991), 40.

21 Bearden, quoted in Lowery Stokes Sims, *Origins and Progressions* (Detroit: Detroit Institute of the Arts, 1986), 42.

NO STAR IS LOST AT ALL: REPETITION STRATEGIES IN THE ART OF ROMARE BEARDEN

Mary Lee Corlett

...modern painting progresses through cumulative destructions and new beginnings.

Romare Bearden[1]

The art of Romare Bearden presents a kaleidoscopic interplay of color and form, sources and subjects, references and revisions. Revealed through a recurring yet shifting repertoire of iconography and allusions, these elements are organized through a prism of multiple reference points, including art history, literature, jazz and blues, and autobiography. Bearden's art explores the enigma of memory and recollection, as well as the importance of narrative to human existence. Meaning in Bearden's work is constructed, with each successive layer adding nuance, building upon its own history in a process that is itself a metaphor for the experience of living. It is, after all, the essence of the human condition that we act within a perpetual state of becoming, constantly reinventing ourselves "through cumulative destructions and new beginnings." A focused examination of related sets of Bearden works provides the opportunity to explore the collective threads of these destructions and new beginnings, and the distinctive role this methodology plays in Bearden's art.

Bearden's imagery was shaped throughout his career by his early life experiences in his birthplace, Mecklenburg County, North Carolina. When he was about three years old, he moved with his parents to New York City, but he continued to summer with his relatives in Charlotte. The memories of those times stayed with him, providing a fundamental framework for his art. During his teen years Bearden also spent time in Pittsburgh with his maternal grandmother; this city, too, played a

significant role in his repertoire of experiences, as did Harlem, where he was based.

From the start of his career, domestic interior scenes that called forth the Southern rural life Bearden knew as a child held a significant place in his work. The collage *Falling Star*, 1979 (pl. 90), is one of many such examples. Focusing on a composition such as this, of which there are at least three versions in different media, opens an avenue for exploring metaphors evoked through literary and visual sources and references. The star imagery also has resonant counterpoints in other collages, providing a basis for examining the common lexicon of motifs in Bearden's work. Our appreciation of how Bearden's art conveyed life's richness is enhanced by exploring the sophisticated pictorial strategies that reflect, as Ruth Fine has explained, the fact that Bearden "never stopped using what he started with, in his subjects and his techniques."[2]

Falling Star was executed shortly after Bearden's seminal *Profile/Part I: The Twenties* collages, which were exhibited at Cordier and Ekstrom in New York in 1978.[3] A lithographic version (fig. 22) was printed from aluminum plates in Joseph Kleineman's New York City workshop in 1979.[4] In addition, a closely related watercolor is signed and annotated with the title *The Falling Star.*[5] Although the compositional structure is essentially the same in each of these three versions of the theme, significant differences exist among them, revealing that Bearden made subtle adjustments in contour and modifications in color with each new incarnation.

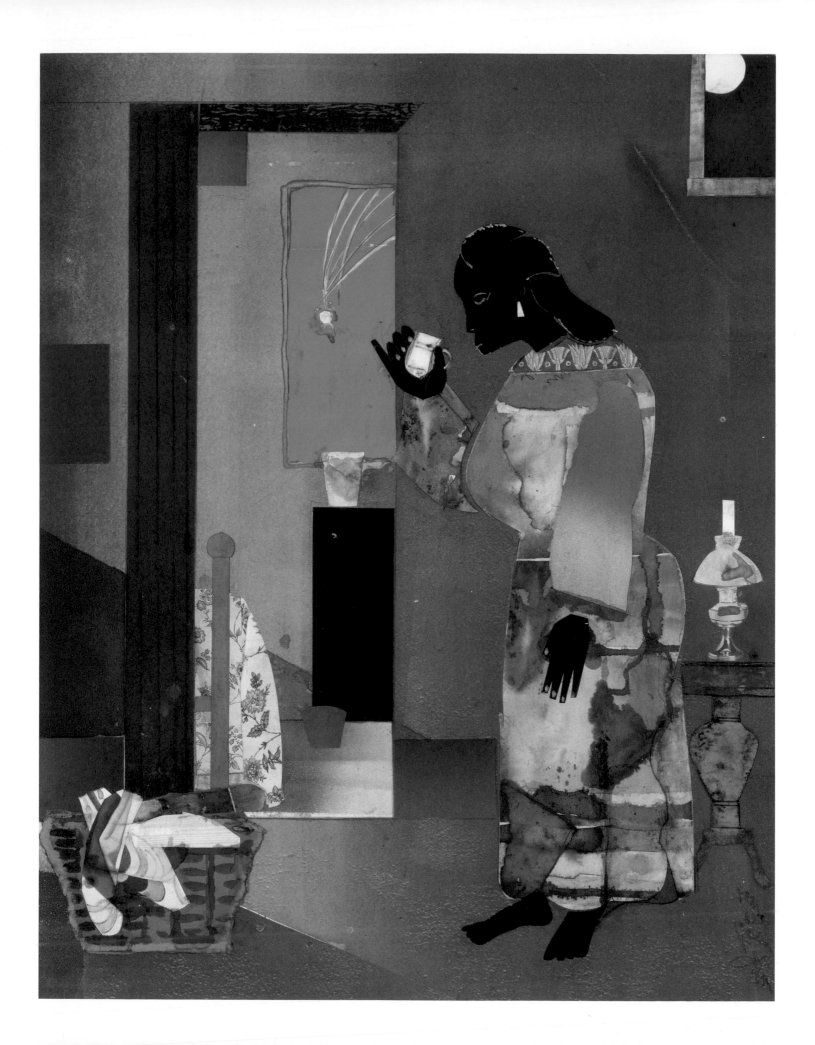

The transition from collage to print did not produce a mechanical duplication. Bearden began with the collage as a model, using transfer paper to lay down the print's basic structure. He then worked the plates directly, using lithographic crayon and tusche applied with brush and crow-quill pen, with his printer assisting by laying in the largest areas of color using tusche.[6] Thus there are numerous subtle differences between the collage and the print. The collage was not an image to be copied, but a starting point. Each image in Bearden's oeuvre is a potential touchstone for another.

The metaphor of the falling star has a multitude of possible sources in art, music, and literature. Star patterns are abundant in American quiltmaking—falling stars, shooting stars, blazing stars, in seemingly infinite forms and varieties. Bearden often depicted quilts in his interior scenes and was obviously familiar with their patterns. The quilt on the bed in the *Falling Star* collage is a preprinted paper, probably wallpaper, the floral pattern of which Bearden sensitively rendered in the lithographic version. It is one of many such detailed patterns Bearden incorporated into his oeuvre.[7]

There are multiple musical associations for falling star imagery, including the lyrics to "My Lord, What a Mornin'," one of a number of Negro spirituals arranged by Harry T. Burleigh, a frequent visitor to the Bearden household in New York when Bearden was growing up:[8] "My Lord, what a mornin', my Lord, what a mornin', Oh, my Lord what a mornin', When de stars begin to fall, When de stars begin

to fall."[9] Bearden also used star imagery in song lyrics he wrote during the 1950s, such as "the perfumed kiss of a star light night; Awakening love that still burns so bright," from his most famous song, "Seabreeze."[10] In another, unpublished, song, "It's Twilight In My Heart," Bearden wrote, "Soon the pale stars will cry and the cold moon up high will come to remind me of you."[11]

Bearden's library included a copy of John Donne's *The Complete Poetry and Selected Prose*, and one literary reference for his star imagery might be the well-known Donne poem "To Catch a Falling Star." The theme of the poem implies the impossibility of finding "a woman true, and fair," possibly a counterpoint to the overt serenity and monumentality of Bearden's image.[12] It is well documented that Bearden was a voracious reader and a lover of books, as is the fact that he maintained a large personal library. In her 2009 dissertation, Nora Niedzielski-Eichner offered an in-depth look at the role of literature and literary theory (New Criticism) in Bearden's artistic practice, and she noted that her personal inventory of the artist's library revealed "more literary criticism than art criticism, and more books by Modern writers than books about Modern painters."[13] Niedzielski-Eichner records that Bearden's library included "at least half a dozen studies of T. S. Eliot, whose criticisms in the 1920s began the discourse that became New Criticism."[14] The impact of Eliot's worldview on Bearden's own can be seen in his remarks recorded by Avis Berman in 1980:

Pl. 90

Falling Star, 1979
Collage with paint, ink, and graphite on fiberboard, 14 × 18 inches

Fig. 22
Falling Star, 163/175, 1979
Lithograph on paper,
25 ¼ × 20 ¼ inches
Telfair Museums, Savannah,
Georgia. Museum purchase,
1997.10.1

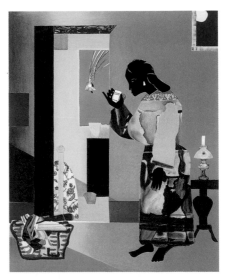

You know, in Eliot's poem, "The Four Quartets," he talks about time, and you're going back to where you started from, but maybe you're bringing another insight, another experience to it. And things that may be nonessential have been stripped away, and you can see that the things that still stick in your mind must be of some importance to you. Like the people I remember, the pepper jelly lady, a little girl [who] kind of played with me, Liza. All of these things that now came back to me. . . . The meaning of it becomes clearer.[15]

Literature, history, music, and myth all function as means of storytelling, and all are critical to understanding Bearden. As he told Henri Ghent, "If you equate a lot of the things that happened in Negro life you see there's a continuity with many of the great classical things that have happened before. And this is what I tried to find in my work, this connotation of many of the things that have happened to me with the great classical things of the past."[16] Bearden sought to discover the universal in the personal through the overlay of multiple storytelling traditions in which themes and motifs resonate with the meaning of past references. Their reuse invites additional allusion and new layers of interpretation, a characteristic that extended to the stories the artist told about himself.[17] An anecdote about the unattractive woman who taught him about aesthetic beauty is worth quoting here for what it reveals about Bearden's sense of narrative:

One evening Claude McKay and I were coming downstairs, and the ugliest woman we ever saw was at the door. She was so homely that Claude said she looked like *a locomotive coming around a corner*. She was shaking her keys at us, which meant she was selling herself. She said, "Two dollars, one dollar, 50 cents, 25 cents. Oh, just take me!" I felt sorry for her. I told her, "You're in the wrong business." I went to my mother, who had influence in the community, and she got the woman, Ida, a job. Ida started coming to clean my studio every Saturday. She felt she owed it to me. At the time I was painting on brown paper and I stuck a

piece up on the easel. Every Saturday she'd come and see the same piece of blank paper because I couldn't discover what to draw. One day she asked me, "Aren't you supposed to be an artist? I don't see any painting. Is that the same brown piece of paper from last week and the week before?" I said, "Yes, I'm trying to get my mind together." She said, "You told me *I* was in the wrong profession. Well, I'm going to tell you something. I think you're in the same boat. Why don't you paint me?" I looked at her. "I know I'm homely," she said, "but when you can look at me and find what is beautiful, then you're going to be able to put something down on that piece of paper." *After she left, I started thinking and I saw Ida was right. I thought about who I was and what I liked, and I began to paint pictures of the people I knew and remembered down South* [emphases added].[18]

Thus, Bearden tells a story of a metaphorical journey of self-discovery that begins with a train reference and ends with him finding his way home, to the South. This metaphysical approach to the narrative has a clear counterpart in the themes and motifs of Bearden's art.

Bearden's oeuvre is replete with sun, moon, and stars. They often are viewed through windows or doorways, and often are simultaneously presented. Ambiguity of time is a constant.[19] In the *Falling Star* compositions, the shooting star against a bright blue sky visible through one window, paired with the moon against a darkened sky in the other, leaves room for simultaneous references and multiple interpretations. In 1977, Bearden discussed the role of ambiguous time and place with Calvin Tomkins: "What's essential is that you make some statement, that you offer some vision of life. For example, Persia—Iran—seems to be largely a desert country. But in Persian miniatures I've never seen any desert. There's always the garden, which is in daylight, but at the top the stars are out. It's the vision of the oasis."[20]

Iconographic and compositional threads in Bearden's oeuvre connect the *Falling Star* works to others, such as *A Summer Star*, 1982 (pl. 91).[21] Here the female form on the right of the composition echoes that of her counterpart

Pl. 91

A Summer Star, 1982
Collage on board, 30 × 40 inches

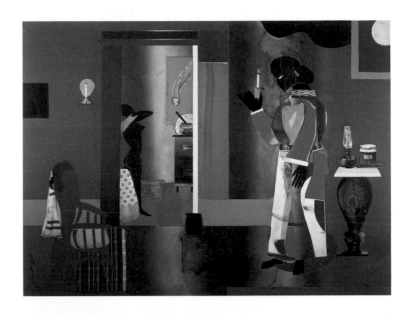

Pl. 92

Sun and Candle, 1971
Collage of various papers with paint,
ink, graphite, and surface abrasion on
fiberboard, 10 ½ × 12 ⅞ inches

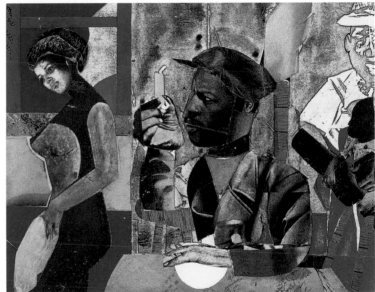

Pl. 93

Early Morning, 1967
Collage of various papers with paint
on board, 44 × 56 inches

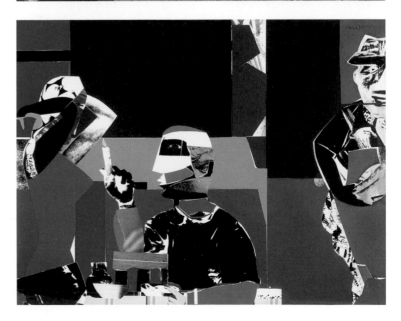

in the *Falling Star* collage. Both figures evoke a moment of quiet domesticity, and each communicates nobility in her calm expectancy. Both works include similar compositional elements, such as the table with lamp, and both offer window views of a shooting star and the moon. But in *A Summer Star*, the woman holds a candle instead of a cup. And there are numerous other variations, including the addition of a lone figure in *A Summer Star* seen through the back doorway, which provide a significant change in mood, sensibility, and suggested meaning.[22]

The raised candle is a gesture that has antecedents in other Bearden compositions, such as the collagraphs *Untitled (Sun and Candle)*, circa 1969,[23] and *Early Morning*, circa 1970s,[24] and the collage *Sun and Candle*, 1971 (pl. 92). In *Sun and Candle*, the figure with the candle is clearly male. It is possible that the title of this collage refers to Elizabeth Barrett Browning's acclaimed poem, "How Do I Love Thee?" (1850), which includes the lines: "I love thee to the level of every day's / Most quiet need, by sun and candle-light."[25] The *Sun and Candle* compositions also are related to still earlier collages, such as *Early Morning*, 1967 (pl. 93). The associated themes and interpretations of the candle and star motifs become layered in their repetition, providing an evocative connection between the works and over time.

Bearden famously told Berman, "I paint out of the tradition of the blues, of call and recall. You start a theme and you call and recall."[26] This practice defined Bearden's methodology and was in play within individual works and between compositions. In addition, call and recall in Bearden's work reflected his philosophical engagement with the broader history of art, literature and music, culture and myth: "In my work, if anything I seek connections, so that my paintings can't be only what they appear to represent. People in a Baptism, in [a] Virginia stream, are linked to John the Baptist, to ancient purification rites, and to their African heritage. I feel this continuation of ritual gives a dimension to the works, so that the works are something other than mere designs."[27] In 1981, Mary Schmidt Campbell described the notes Bearden kept pinned to his studio walls, offering further insight into the many ways in which thematic recall and repetition were intrinsic to the artist's process:

As Romare Bearden works on his latest collage series, he keeps tacked up on the wall next to his work table a list of the subjects he wants to include: "Fats Waller, Paradise, House Rent Parties, Savoy, Lafayette, A Block, An Interior." The list reads like an index to the several collages he has already stacked against the wall of his studio in Long Island City, New York, and indeed these same subjects have appeared over and over in Bearden's collage-paintings for the past 15 years. . . . For 15 years, Romare Bearden has been looking for connections, stating and restating his motifs, linking his seemingly straightforward list of subjects to archetypal myths and rituals.[28]

The Frank Stewart photograph (see fig. 17) that accompanies Schmidt's text shows Bearden at work, with the wall, the lists, and a photograph of his great-grandparents (Henry and Rosa Kennedy) behind him.

In Bearden's work, there is an inseparable connection between content and structure. Doorways and windows are ubiquitous compositional devices in his interiors, always serving a structural function, but their omnipresence also signifies passages, and they are equally suggestive of things present but hidden from view (pl. 94).[29] Moreover, these passageways create a structural link between narrative themes. Their repetition, along with other recurring motifs such as the sun and moon, the cup and the profile figure, fashions an evolving time-space continuum within Bearden's oeuvre and often establishes a subtle connection between the rural South (*Falling Star*) and the urban North (as seen in *Allegheny Morning Sky*, 1978, or *Susannah in Harlem*, 1980).[30]

The importance of these passageways as a compositional foundation is further underscored in related scenes such as *Carolina Interior,* 1970; *Mecklenburg Morning,* circa 1978; and *Mecklenburg Morning*, circa 1979 (pl. 95).[31] As Ruth Fine has pointed out, "the earlier two have as their base image photostatic enlargements of an as yet unidentified source, each of them a different size. The circa 1979 collage is considerably smaller than its predecessors and has as its base image a color photocopy from a photographic slide, probably made from the 1970 *Carolina*

Pl. 94

Before Dawn on Shelby Road, 1986
Paper, fabric, print, ink, and graphite
on board, 16 × 20 inches

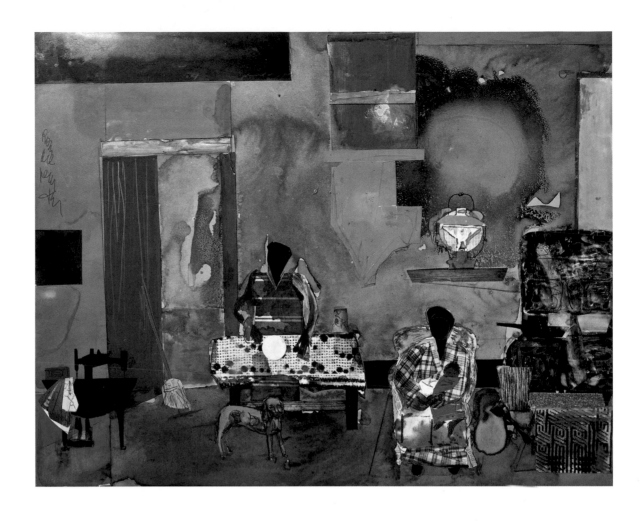

Pl. 95

Mecklenburg Morning, circa 1979
Collage of various papers with
paint, ink, and graphite on
fiberboard, 7 × 15 inches

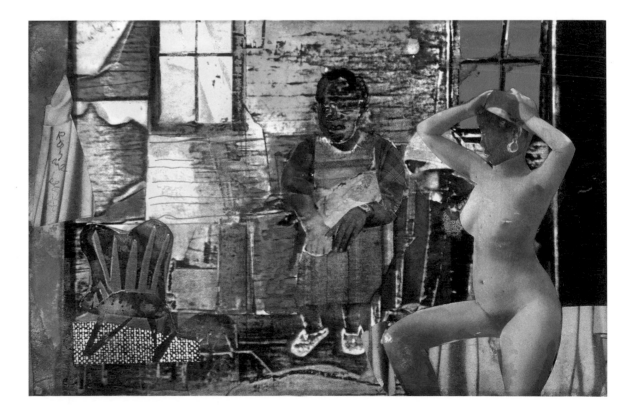

Interior version."[32] These collages demonstrate that the photocopy had become a significant device in Bearden's toolbox for building connections between compositions.[33] The window motif and the underpinning it provides are repeated in new contexts. These three works share a common baseline structure in which the windows, through the utilization of the photocopy, set up an intracompositional riff and provide the basis for an improvisational variation. Albert Murray wrote that "the esthetics of jazz musicianship have conditioned [Bearden] to approach the creative process as a form of play and thus dispose him to trust his work to the intuitions that arise in the course of creating it."[34] And Bearden himself noted, "the more I just played around with visual notions as if I were improvising like a jazz musician, the more I realized what I wanted to do as a painter, and how I wanted to do it."[35]

In his 1981 discussion of the role of repetition in black culture, James Snead contended, "Not only improvisation, but also the characteristic 'call-and-response' element in black culture . . . requires an assurance of repetition. . . . While repetition in black music is almost proverbial, what has not often been recognized in black music is the prominence of the 'cut.' The 'cut' overtly insists on the repetitive nature of the music . . . skipping it back to another beginning which we have already heard."[36] The "cut" has several correlations and equivalencies in Bearden's artistic practice, most obviously in his recurrent themes and motifs, and is particularly direct in the use of the Photostat to construct a framework upon which a new compositional

structure is organized. Through improvisation and the "cut," Bearden's art fits into the jazz aesthetic to which it has often been compared.[37]

Snead states, "Black music sets up expectations and disturbs them at irregular intervals . . . it draws attention to its own repetitions."[38] This can certainly be applied to compositional relationships throughout Bearden's oeuvre. As one aspect of call and recall, repetition "cut" by variation through improvisation can be seen clearly in the comparison of compositional sequences such as *Jazz (Chicago) Grand Terrace—1930s*, 1964;[39] *Jazz: Kansas City*, 1977 (pl. 96); and *Jazz II*, 1980 (fig. 23). Clearly repetitive but not reproductive, the image cuts across three decades. Variation becomes part of its historiography, and is enriched by the added dimension of *Jazz: Kansas City* having been created as a commission for an album cover for Warner Brothers Records, as part of a commemorative boxed set that was released in 1977.[40] In addition, *Jazz: Kansas City* incorporates collage elements cut from Photostats of previous Bearden images, including *Jazz (Chicago) Grand Terrace—1930s*, a repurposing that correlates to the sequential use of the Photostat in the *Carolina Interior/Mecklenburg Morning* compositions identified by Ruth Fine and discussed above.[41] This jazz-themed progression of collages, like the *Falling Star* images, "draws attention to its own repetitions," while the specific nature of their interrelationship also "sets up expectations and disturbs them at regular intervals."

A photograph taken by Frank Stewart in 1979 (fig. 24) shows Bearden working on what might be a proof for the *Jazz II* screenprint, with an image of *Jazz: Kansas City* (perhaps the album cover) clearly propped up against the wall at the back of the table.[42] Another Stewart photograph (fig. 25) also shows Bearden consulting a photographic

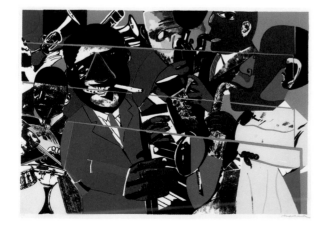

Fig. 23
Jazz II, 1980
Screenprint, 26 ¾ × 37 ½ inches
Collection of The Mint Museum,
Charlotte, North Carolina. Gift of
Emily and Zach Smith and Jerald
Melberg Gallery. 2006.45

Pl. 96

Jazz: Kansas City, 1977
Collage and paint on board,
18 ¼ × 27 inches

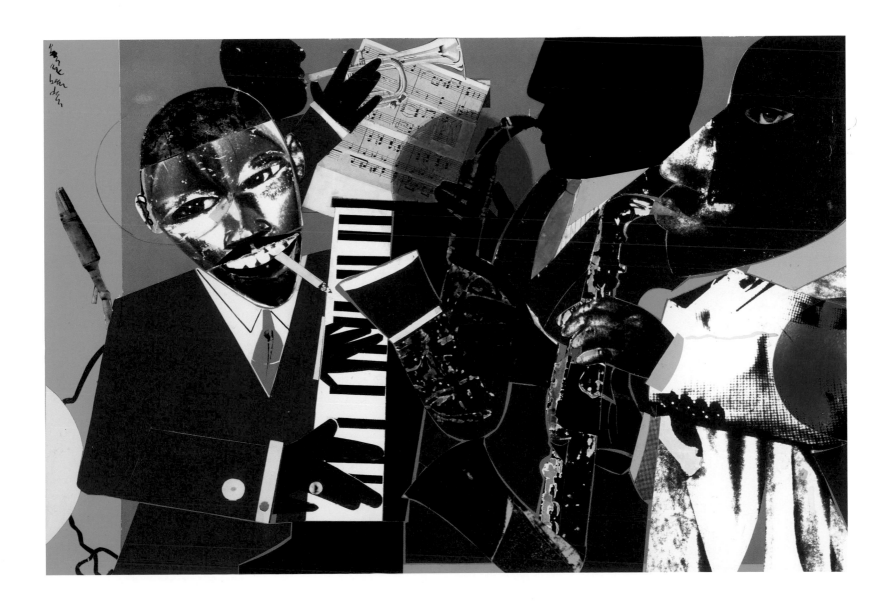

Fig. 24
Frank Stewart
Bearden in studio with Jazz:
Kansas City, 1979
Photography © Frank Stewart/
Black Light Productions

Fig. 25
Frank Stewart
*Bearden in studio with Bunch
Washington book*, early 1980s
Photography © Frank Stewart/
Black Light Productions

Fig. 26
Mysteries, 1964
Photostat on fiberboard,
28 ½ × 36 ¼ inches

Fig. 27
Mysteries, 1974
Collagraph, 14 ½ × 17 ½ inches
Romare Bearden Foundation

Fig. 28
The Train, 1975
Etching and aquatint,
18 × 22 ¼ inches
Romare Bearden Foundation

Fig. 29
The Train, 1974
Collage on paper,
15 ¼ × 19 ½ inches

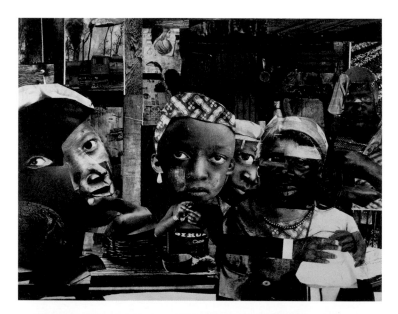

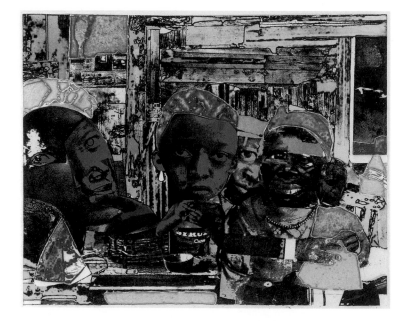

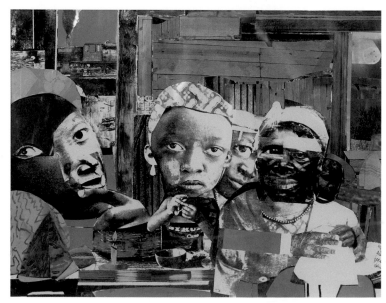

reproduction of his own art as he works on a collage (possibly *Firebirds*) with what could be the 1973 M. Bunch Washington book on Bearden open on the table to his left, apparently showing the piquette *Junction*, 1971.[43] A second image, the 1979 lithograph *Pilate,* is propped against the wall in front of the artist.[44] The copy and/or the photocopy thus become agents for change, providing the means for progressing "through cumulative destructions and new beginnings." They present a familiar place from which to reinvent, expand, and transform meaning, with all of the nuances of past associations playing a part. "No star is lost at all."[45]

Repetition establishes the baseline from which variation and improvisation can occur. Bearden apparently used the 1964 Projections and/or related collages as a starting point for a number of his collagraphs of the early 1970s.[46] His print production includes examples of compositional reinvention based on a Projection (and thus its source collage), with works such as *Mysteries* (fig. 26), for example, reinvented as a collagraph (fig. 27), and again as the etching *The Train* (fig. 28). The desire to explore numerous possible variations is reflected in the many unique hand-colored proofs made from *The Train* matrices.[47] In 1974 Bearden executed another collage version of *The Train* (fig. 29), in which repurposed photostatic elements again play a pivotal role in carrying the image and the narrative from one composition to the next. Collectively, these works are improvisations realized in distinctly different media but with a shared theme and structure. In them, Bearden both acknowledges and celebrates the repetition. His oeuvre is replete with variant compositions in which structure, themes, and motifs are subject to reinterpretation and reinvention. Bearden's use of the hand-drawn, observational copy, tracing, and the Photostat for compositional reinvention merits a more thorough review than can be given here, but a limited discussion nevertheless provides insight into the essential function of studied repetition in Bearden's aesthetic.[48]

Sarah Kennel has provided numerous comparisons of Bearden's compositions to their art historical sources, including watercolors from the mid-1940s based on compositions by Duccio and Dirk Bouts. But as Kennel points out, "these images are not copies per se, but rather free or loose transpositions of existing compositions into new visual idioms."[49] Bearden's earliest studies of world art included active engagement with the Old Masters through observation and copying. He also freely used photoreproduction as one means of exploring and reinventing compositional structures employed by other artists, from Pieter de Hooch to the eighteenth-century Japanese Ukiyo-e artist Toshusai Sharaku.[50] Bearden described the important role of the Photostat in his study on numerous occasions, including comments he made to Henri Ghent in 1968: "Usually my procedure would be to get a reproduction of the paintings of these masters and have them enlarged by photostat and copy the painting from the photostat instead of going to the museum."[51]

Bearden owned a negative Photostat image of the de Hooch painting *Figures Drinking in a Courtyard* (fig. 30).[52] The *Falling Star* compositions clearly pay homage to this interior, with its flattened spatial structure built upon strong vertical and horizontal rectangular forms and yielding a prevailing sense of stillness and mystery through a stereoscopic layering of open windows and doors, offering views that are simultaneously revealed and concealed. A strong diagonal cutting across the bottom third of the composition further unifies and flattens, echoing the diagonals of the floor tiles in the de Hooch and forming a visual connection between the floor and workbasket (the counterpoint to de Hooch's copper kettle) in the foreground. The diagonal thrust in *Falling Star* extends from the bottom corner of the woman's dress to the opposite wall of the outer room, via the back wall of the room beyond the doorway.[53] The archetypal female figure in full profile is a reprisal of de Hooch, too, as can be seen in *A Dutch Courtyard* (fig. 31, and pls. 97–98).

Bearden used compositional structure as one means of establishing connections, of securing a place on the historical continuum. In his 1969 article "Rectangular Structure in My Montage Paintings," he wrote, "And in 'Two Women in a Courtyard' I try to show that the courtyard was as important to American southern life, as indeed it was in the Holland of De Hooch, Terborch and Vermeer."[54] Thus, as an integral part of Bearden's practice early on, the Photostat laid the groundwork for the call and recall strategy that would define his art.

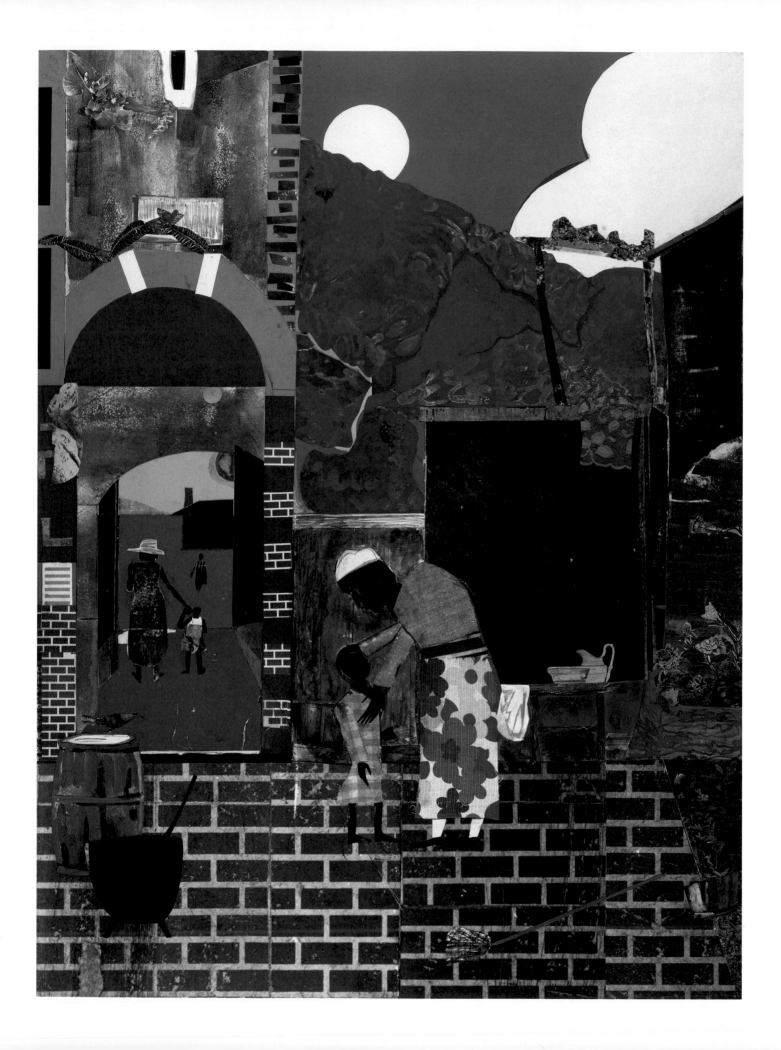

Pl. 97

Southern Courtyard, 1976
Collage on paper:
photomechanically printed paper
cut outs, colored paper, paint,
graphite, and fabric, 48 × 36 inches

Pl. 98

Back Home, 1978
Watercolor on paper,
9 ½ × 7 ½ inches

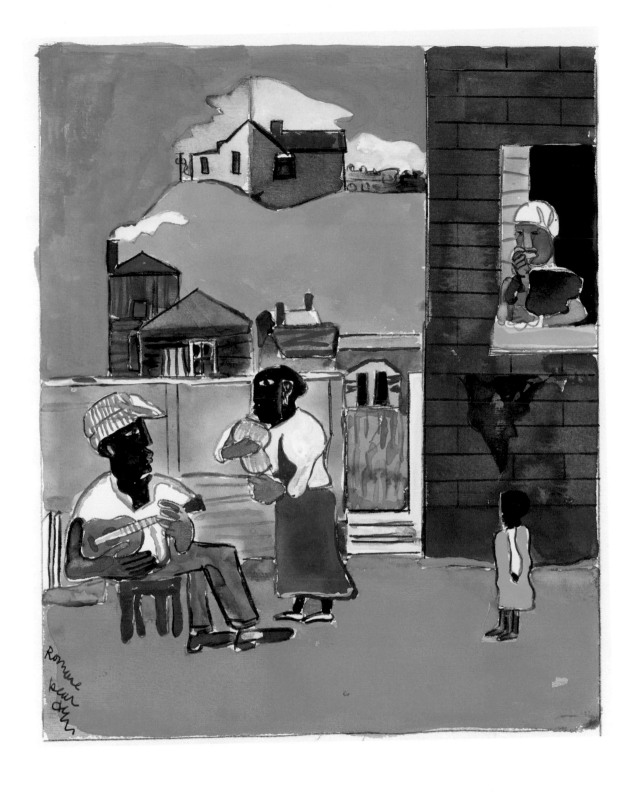

In the 1960s, Bearden used the Photostatic process to simultaneously enlarge and unify the surfaces of his collages, creating the groundbreaking *Projections,* first shown by Cordier and Ekstrom Gallery in 1964.[55] For Bearden, the Photostat was important for its ability to facilitate a shift in scale. But the plasticity of the repetition that this process could provide, especially as later combined with collage, also served the organization and extension of structure and theme, carrying both from one composition to another, as in the *Carolina Interior* and related *Mecklenburg Morning* collages. Bearden embraced repetition as a device that facilitated improvisation, and in the recall of previous iterations, the layering of meaning.[56]

But the photocopy was only one approach in a larger strategy of repetition. Bearden's compositional improvisation certainly did not require it, as indicated by the lithograph *Quilting Time,* 1981 (fig. 32), which offers another close variation in a different medium on the two-windowed compositional structure used in *Carolina Interior* and the circa 1979 version of the *Mecklenburg Morning* collages. In the 1980s, while discussing with Joy Peters his methodology for making monotypes, Bearden mentioned—in the context of the speed with which the medium necessitated that he work—that he occasionally made a preparatory drawing, "usually something like an instrument I had to remember what it looked like."[57] The preparatory drawing served as an on-the-spot visual aid—in other words, something he could copy. Bearden may well have employed a similar methodology to create at least some of his colla-

graphic plates, such as the *Mysteries* collagraph (fig. 27), in which relative speed and fluidity were of paramount importance to delivering the glue lines.

Bearden indicated to his biographer Myron Schwartzman that he might also hand trace an image as a starting point: "If I wanted to do something very precise—if I wanted to copy that little collage over there—I'd probably do it in gouache; trace it and do it in gouache."[58] Tracing, obviously, worked as another strategy for facilitating the deliberate reuse of a compositional structure. This method has precedents in general printmaking practice, where transfer paper has been commonly used for transferring an image to plate. Bearden employed transfer paper, as Kleineman had noted,[59] and he also traced through transparent Mylar to create plates, as can be seen in the photographic series (figs. 33–34) by Lucia Woods made during the production of the lithograph *Come Sunday* (fig. 35). This image was based on an earlier collage titled *Carolina Morning*, 1974 (pl. 99), for the group portfolio *1776 USA*, published by Contemporary Artists for the nation's bicentennial celebration.[60]

In the whole of Bearden's oeuvre, then, the importance of the relationship between related collages, prints, and works in other media is not how closely they may or may not duplicate one another. Rather, it is the insight revealed by the themes and structures he chose to revisit and the manner in which he reinvented them. Each composition is rooted in associations and connections with earlier ones, sometimes recalling works by other artists, such as

 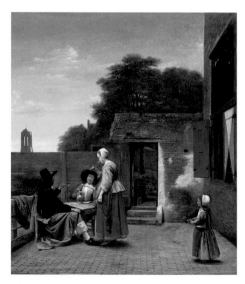

Fig. 30
Negative Photostat of Pieter de Hooch's Figures Drinking in a Courtyard, date unknown
Romare Bearden Foundation

Fig. 31
Pieter de Hooch
A Dutch Courtyard, 1658–60
Oil on canvas, 27 ⅜ × 23 ⅝ inches
National Gallery of Art, Washington, Andrew W. Mellon Collection 1937.1.56

de Hooch. But most importantly, they are invested with the power and richness of Bearden's own variations.

The elements of Bearden's visual lexicon—including the frequently discussed trains, birds (Bearden called them "journeying things"[61]), roosters, cats, and moons, as well as the less-often mentioned candles, quilts, workbaskets, doorways, and windows (the last two of which are ubiquitous on his city streets as well as in his rural and urban interiors), among many others—are continuously recast, delivering new and different nuances of meaning with each reincarnation. Bearden's motifs become richer with each new juxtaposition, association, and reference, and additional layers of meaning are constructed with each re-telling and re-statement.[62] Over time compositions figuratively overlay and interlock, and the aesthetic experience is enriched through the process of viewing one work in the context of others.[63] Bearden used call and recall to accumulate meaning and add new facets, to create a rich conjunction of "the past interwoven in the present," to borrow a phrase he used in a letter to Mary Schmidt Campbell.[64] Meaning is perpetually enhanced through context and association, so that it is never fixed, but always in flux.

Call and response requires that the viewer contribute to context. In discussing critical reaction to his *Projections*, Bearden told Henri Ghent that three reviewers "each in his own way, saw qualities in it or brought something to it that I had not thought of myself."[65] A decade later, Bearden stated:

The best kind of painting or sculpture is when the viewer has to finish it, you know, when he is allowed some entrance into your work, as if you invite somebody into your house and make them welcome so they can find their own proper place. In Chinese painting of the classical eras, there is always an open corner where you can enter, and this is why I try not to make things too specific, because I want the viewers to enter the work on their own terms.[66]

Bearden fully embraced the role of the viewer in enhancing meaning in his work. He expanded on the idea in the documentary film *Visual Jazz*: "When the onlooker looks at a painting what he might see there might even be more valid than what I put there. I think a painting should be approached as if the onlooker had to complete some part of it."[67]

Call and response, rooted in African culture and celebrated in the African American church, "often operates like a challenge, to see how large a difference you can produce in your audience's perceptions with as little change as possible in the form being repeated."[68] The connection between a collage and its companion Projection, or the interrelationship of the *Falling Star* collage, print, and watercolor, can be viewed in these terms. The jazz act of improvisation manifests itself in the ways in which Bearden lay down color (paint or collage), line, and form to shape a composition. But shaped as it is by

Fig. 32
Quilting Time, 1981
Lithograph, 18 × 23 ⅛ inches
Romare Bearden Foundation

Fig. 33
Lucia Woods
Romare Bearden, Narkiewicz Studio,
New York City, 1974
Photography © Lucia Woods, 1974

Fig. 34
Lucia Woods
Paul Narkiewicz and Romare Bearden,
Narkiewicz Studio, New York City, 1974
Photography © Lucia Woods, 1974

his autobiography, it is perhaps even more importantly asserted in the way he lay down narratives through his entire body of work—through repetition tempered by variation, self-reference interwoven with connections to art, literature, storytelling, myth, and music.

It is precisely by looking at Bearden's process—the lists on the walls; the Photostats of Old Master works and the images based on them; the reinvention of collages as Projections via the Photostatic process; the repurposing of Photostats in subsequent works; the revisiting of his own previous compositional structures, themes, and motifs with the resulting enlargement of meaning that occurs through a layering of associated literary, mythic, or cultural references—that we can gain a clearer understanding of what improvisation looks like in Bearden's art. His art is no more jazz than it is Chinese painting, for example, but one cannot dismiss the relationship the artist himself saw between his work and these disparate art forms.

As with jazz music, the layering of themes in Bearden's art provides multiple points of entry for the viewer, multiple references, and multiple places to connect. Bearden's art does not force a choice between improvisation as process or narrative. His legacy is the creation of visual statements that transcend the individual experience while respecting it, drawing affinities through multiple disciplines and time periods, and the attendant linking of cultural and historical associations. Understanding the ways in which repetition plays out in Bearden's work is critical to understanding his significance in twentieth-century American art. His art involves a full, complex structure of reinvention based on interlocking relationships between multiple references (art historical, literary, mythological, and more) and materials. He broke new ground in his search for cross-cultural, multidisciplinary inclusivity within the modernist context, putting a few cracks in the glass ceiling of the art historical canon.

Bearden said it best: "What I have tried to do is set down a world, and have asked the viewer to enter it so he can envision those things that I have seen and felt. A work of art can always keep growing. You can always add something to it each time you see it. Because, you see, it is imbued with a life of its own."[69]

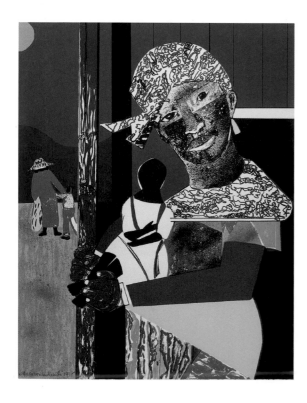

Fig. 35
Come Sunday, 1976
Lithograph, 27 ¾ × 21 ½ inches
Romare Bearden Foundation

Pl. 99

Carolina Morning, 1974
Mixed media collage on board,
30 × 22 inches

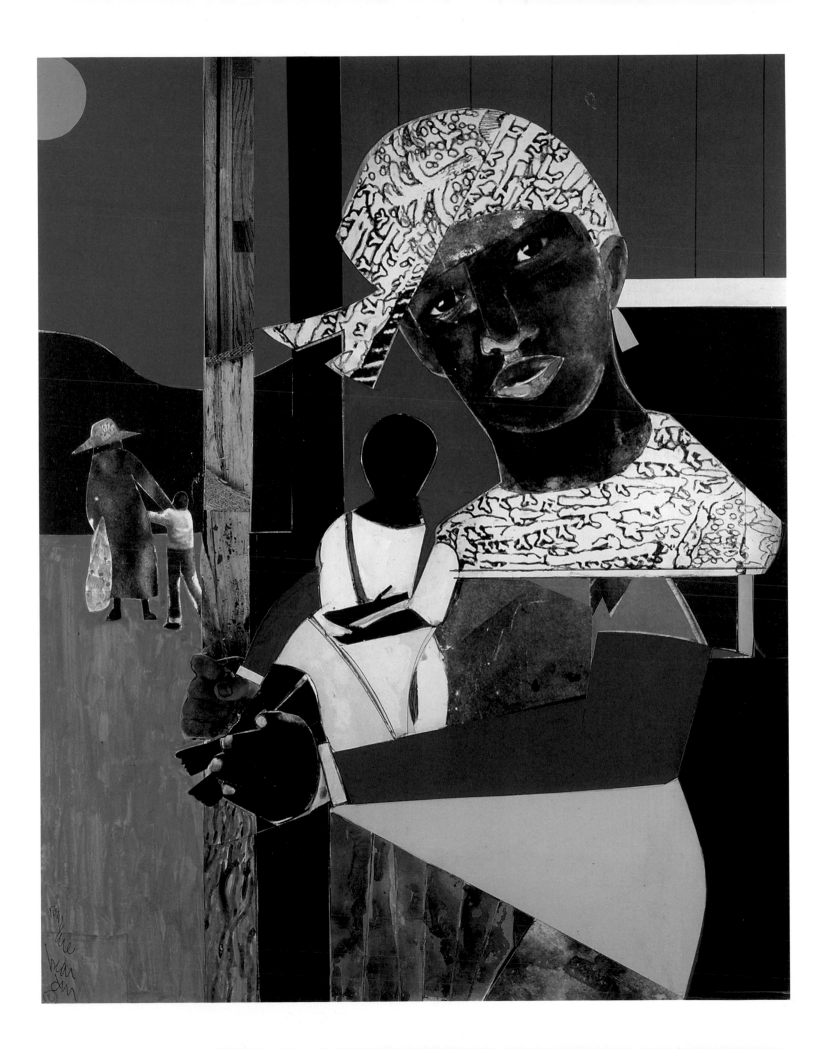

Notes

1 Bearden, "Rectangular Structure in My Montage Paintings," *Leonardo* 2, no. 1 (January 1969): 12.

2 Ruth Fine, quoted in Paul Trachtman, "Romare Bearden: Man of Many Parts," *Smithsonian* (February 2004), http://www.smithsonianmag.com/arts-culture/romare.html (accessed 30 April 2011).

3 The collage, undated, was probably executed in 1979. See Ruth Fine, *The Art of Romare Bearden* (Washington: National Gallery of Art, 2003), 105.

4 This essay was developed from an entry on the *Falling Star* print, written for *Collection Highlights: Telfair Museum of Art*, ed. Hollis Koons McCullough (Savannah, GA: Telfair Museum of Art, 2005). I thank the Telfair for permission to excerpt it.

5 At the time of the National Gallery of Art's 2003 exhibition *The Art of Romare Bearden*, this watercolor was in a private collection in Massachusetts.

6 For Bearden, the proofing process was critical; he typically annotated multiple proofs. See Mary Lee Corlett, "Impressions and Improvisations: A Look at the Prints of Romare Bearden," in *From Process to Print: Graphic Works by Romare Bearden* (Petaluma, CA: Pomegranate, 2010).

7 Mary Schmidt Campbell has noted, "Quilts and quilt-like patterns recur in his works and, from time to time, form not only a compositional basis but an iconographic source as well." See Campbell, "Romare Bearden: A Creative Mythology" (Ph.D. diss., Syracuse University, New York, 1982), 266. Numerous examples of patterns are found as quilts, articles of clothing, and wallpapers. See also Patricia Hills, "Cultural Legacies and the Transformation of the Cubist Collage Aesthetic by Romare Bearden, Jacob Lawrence, and Other African-American Artists," in Ruth Fine and Jacqueline Francis, eds. *Romare Bearden, American Modernist*, Studies in the History of Art: Center for Advanced Study in the Visual Arts. Symposium Papers 48 (Washington: National Gallery of Art, 2011), 221–47. Hills notes falling star imagery in a late nineteenth-century quilt by African American quiltmaker Harriet Powers, citing Powers's reference to the fear inspired by the massive meteor shower of 13 November 1833, in Fine and Francis, 228, 245 n29. I thank the Center for Advanced Study in the Visual Arts for making this volume available prior to publication.

8 See Bearden, "Reminiscences," in Huston Paschal, *Riffs and Takes: Music in the Art of Romare Bearden* (Raleigh: North Carolina Museum of Art, 1988), n.p.

9 Harry T. Burleigh, *The Spirituals of Harry T. Burleigh: Low Voice* (Miami, FL: Belwin Mills, 1984), 30-33.

10 Written with Larry Douglas and Fred Norman, ©1954, Laerteas Music Co., New York.

11 It's twilight in my heart / music, Marvin Lagunoff; words, Rommie Bearden. [1954] [1] leaf of ms. music; LC control no: 94703655. http://lccn.loc.gov/94703655. Call number: M1630.2.L.

12 John Donne, *The Complete Poetry and Selected Prose*, ed. John Hayward (New York: Random House, 1936). I thank Diedra Harris-Kelley at the Romare Bearden Foundation for confirming the presence of the book in Bearden's library (telephone conversation, 15 March 2004). Star references can be found in a myriad of other literary [e.g., John Milton, *Paradise Lost* (falling star) or William Shakespeare, *King Richard II* (shooting star)] and biblical [e.g., Matt. 24:29 or Rev. 6:13] sources, many of which were surely known to Bearden, whose utilization of literary sources in his art is well documented. Biblical references appear in Bearden's oeuvre in the 1940s. See Kymberly N. Pinder, "Deep Waters: Rebirth, Transcendence, and Abstraction in Romare Bearden's Passion of Christ," in Fine and Francis, *Romare Bearden, American Modernist*, 143–65. For a discussion of literary influences on Bearden's work prior to the 1960s, see Campbell, "Romare Bearden: A Creative Mythology," 123–81. Regarding Bearden's depictions of women, see Campbell, *Mysteries: Women in the Art of Romare Bearden* (Syracuse, NY: Everson Museum of Art of Syracuse and Onondaga County, 1975).

13 Nora Niedzielski-Eichner, "Integrating Modernism: The Migration Paintings of Aaron Douglas, Jacob Lawrence, and Romare Bearden" (Ph.D. diss., Stanford University, 2009), 203.

14 Niedzielski-Eichner, "Integrating Modernism," 204. Niedzielski-Eichner summarizes the tenets of New Criticism and identifies its relationship to Bearden's Projections.

15 Romare Bearden, interview by Avis Berman, 31 July 1980, Romare Bearden Papers, 1937–1982, Archives of American Art, Smithsonian Institution, http://www.aaa.si.edu/collections/oralhistories/transcripts/bearde80.htm (accessed 30 April 2011). Julia Markus reported a similar statement in "Romare Bearden's Art Does Go Home Again—To Conquer," *Smithsonian* 11 (March 1981): 74.

16 Romare Bearden, interview by Henri Ghent, 29 June 1968, Romare Bearden Papers, 1937–1982, Archives of American Art, Smithsonian Institution, http://www.aaa.si.edu/collections/oralhistories/transcripts/bearde68.htm (accessed 30 April 2011).

17 Fine notes that Bearden's variant versions of his life story may reflect his belief that the story is a vehicle for expressing higher truths. See Fine, "Nurtured and Necessary: Mothers of Invention," in Fine and Francis, *Romare Bearden, American Modernist*, 183.

18 Bearden, quoted in Avis Berman, "Romare Bearden: 'I Paint Out of the Tradition of the Blues,'" *ArtNews* 79 (December 1980): 64–65. Bearden told numerous versions of this story; see for example Calvin Tomkins, "Profiles: Romare Bearden: Putting Something over Something Else," *New Yorker* 53 (28 November 1977): 58.

19 For an urban landscape with the same sort of dichotomy, see *Profile/Part II, The Thirties: Midtown Sunset*, 1981, reproduced in Fine, *The Art of Romare Bearden*, 110.

20 Bearden, quoted in Tomkins, "Profiles," 76–77.

21 Bearden's title also brings to mind Carl Sandburg's poem "Summer Stars," in *Smoke and Steel* (New York: Harcourt, Brace and Howe, 1920), http://www.poets.org/viewmedia.php/prmMID/21696# (accessed 30 April 2011).

22 Hills records artist Whitefield Lovell's description of the Southern folk practice of painting windowsills indigo to guard against the entry of evil spirits. Interestingly, the doorjambs in Bearden's *Falling Star* compositions are indigo. See Hills, "Cultural Legacies and the Transformation of the Cubist Collage," 230–31, 238.

23 Reproduced in Fine, *The Art of Romare Bearden*, 60 (fig. 29), along with the collagraph matrix (fig. 30).

24 Reproduced in *From Process to Print*, 70.

25 For Elizabeth Barrett Browning's poem, see http://www.poets.org/viewmedia.php/prmMID/15384 (accessed 30 April 2011). Examples of the candle motif, like the shooting star, are abundant in literature.

26 Berman, "Romare Bearden," *ARTnews*, 60.

27 Bearden to Campbell, 22 September 1973, in Campbell, "Romare Bearden: A Creative Mythology," 564.

28 Campbell, "Romare Bearden: Rites and Riffs," *Art in America* 69 (December 1981): 135.

29 Kobena Mercer observes, "As we begin to notice the frequency with which Bearden employs window frames and door frames in 'playing' with the postcubist possibilities of the pictorial 'box,' we can observe a dialectical spacing in which outside and inside are not fixed by the timeless laws of geometry, but interact in a multiplanar domain that reveals the contingent ambiguity of social borders and cultural boundaries." See Mercer, "Romare Bearden's Critical Modernism: Visual Dialogues in the Diaspora Imagination," in *Romare Bearden in the Modernist Tradition* (New York: Romare Bearden Foundation, 2010), 13.

30 The latter two works are reproduced in Myron Schwartzman, *Romare Bearden: His Life and Art* (New York: Harry N. Abrams, 1990), 60 and 93, respectively. For more on the urban/rural and other dualities in Bearden's life and art, see Bridget R. Cooks, "Romare Bearden: On View," in Fine and Francis, *Romare Bearden, American Modernist,* 207–19.

31 See Fine, *The Art of Romare Bearden*, 100, cat. nos. 102, 103, 104.

32 Ibid., 99.

33 See Fine, "Nurtured and Necessary: Mothers of Invention," 181–98, for additional discussion of Bearden's compositional use of the Photostat and photocopy.

34 Albert Murray, "The Visual Equivalent of the Blues," in *Romare Bearden: 1970–1980* (Charlotte, NC: Mint Museum of Art, 1980), 27.

35 Bearden, quoted in Murray, "The Visual Equivalent," 23.

36 James Snead, "On Repetition in Black Cul-

ture," *Black American Literature Forum* 15, no. 4, *Black Textual Strategies, Volume 1: Theory* (Winter 1981): 150. Pattern breaks in quiltmaking might be seen in terms of improvisation and the "cut." See Hills, "Cultural Legacies and the Transformation of the Cubist Collage Aesthetic," 228. Hills provides a brief discussion of the Robert Farris Thompson essay in Eli Leon, *Who'd a Thought It: Improvisation in African-American Quiltmaking* (San Francisco: San Francisco Craft and Folk Museum, 1988), 245 n35, which included an observation made by Thompson's friend Fu-Kiau Bunseki, that, "Every time there is a break in pattern, that is the rebirth of [ancestral] power in you."

37 See Huston Paschal, *Riffs and Takes*; Edward F. Weeks, *Romare Bearden: Jazz* (Birmingham, AL: Birmingham Museum of Art, 1982); Robert G. O'Meally, Brent Hayes Edwards, and Farah Jasmine Griffin, eds., *Uptown Conversation: The New Jazz Studies* (New York: Columbia University Press, 2004); Graham Lock and David Murray, eds., *The Hearing Eye: Jazz & Blues Influences in African American Visual Art* (New York: Oxford University Press, 2009); and *Romare Bearden in the Modernist Tradition*.

38 Snead, 151.

39 In 1963–64, Bearden used the photostatic process to enlarge a number of his collage images, the result of which he termed Projections. See Gail Gelburd and Thelma Golden, with Albert Murray, *Romare Bearden in Black-and-White: Photomontage Projections, 1964* (New York: Whitney Museum of American Art, 1997), 78–79.

40 Christie's, New York, *Contemporary Art, Part II*, sale 8170, 4 May 1995, lot 190.

41 Fine, *The Art of Romare Bearden*, 99–100. I thank Miranda Lash and Taylor Murrow for confirming the presence of Photostatic elements in *Jazz—Kansas City*.

42 Bearden noted that early in his career, in addition to using Photostats as study aids for copying the Old Masters, he also used color reproductions of works of art. See "Rectangular Structure," 12.

43 M. Bunch Washington, *The Art of Romare Bearden: The Prevalence of Ritual* (New York: Harry N. Abrams, 1973), 212–13.

44 *Pilate* is reproduced in http://www.udel.edu/museums/jones/archive/archive_pages/artist_pages/bearden.html (accessed 30 April 2011).

45 The title of this essay derives from the seventh poem in A. E. Housman's collection *More Poems* (1936), which begins: "Stars, I have seen them fall,/But when they drop and die/No star is lost at all/From all the star-sown sky." I thank Charles Ritchie for calling this poem to my attention. See http://www.kalliope.org/digt.pl?longdid=housman2002020507 (accessed 30 April 2011).

46 See *From Process to Print*, 61. *The Guitar Player (Saturday Night)* is a variation (detail, with some elements in reverse of the Photostat) of *Train Whistle Blues No. 1*, the latter of which is reproduced in M.

Bunch Washington, *The Art of Romare Bearden*, 63. See also the collagraphs *The Street* and *Watching the Good Trains Go By,* reproduced in *From Process to Print*, 62, 63. The 1964 collage/Projection counterparts are reproduced in Fine, *The Art of Romare Bearden*, on pages 36 and 34, respectively.

47 See *From Process to Print*, 44–49, for images of these proofs. The methodology used to create the plates for *The Train* etching, which involved cutting apart and reconfiguring multiple kodaliths (stencils), was in itself an improvisational use of repeatable photographic elements. See *From Process to Print*, 15–16, and Pamela Ford and Diedra Harris-Kelley, "Interview with Mohammad Omer Khalil," in *From Process to Print*, 112–13.

48 Fine offers additional discussion of the role of various forms of the copy in Bearden's art and includes a short description of the mechanics of the photostatic process in "Nurtured and Necessary," 187-88. She also makes specific mention of the various Photostats and photocopies that remained in Bearden's studio effects, 190.

49 Sarah Kennel, "Bearden's Musée Imaginaire," in Fine, *The Art of Romare Bearden*, 143.

50 See Fine, *The Art of Romare Bearden*, 22–23.

51 Bearden, interview by Ghent.

52 See Fine, *The Art of Romare Bearden*, 22. The painting is oil on canvas, private collection.

53 Bearden discussed the compositional devices of the "Little Dutch Masters," including de Hooch, in "Rectangular Structure," 11–19, and Bearden and Carl Holty, *The Painter's Mind: A Study of the Relations of Structure and Space in Painting* (1969; repr. New York: Garland Publishing, 1981), 24.

54 Bearden, "Rectangular Structure," 17.

55 As Bearden told Ghent, "I was talking to a painter and he suggested that I have these enlarged photostatically. He said he had a letter from a photostatic company saying they do large enlargements of art works. And I might take my things there and see what could be done. And I did. I did four or five." See interview by Ghent. That painter was Reginald Gammon; see Tomkins, "Profiles," 70.

56 As Fine summarized: "This use of a range of photographic duplication methods to develop variations of an image at different sizes over many years is a central component of Bearden's creative methodology." See *The Art of Romare Bearden*, 99.

57 Bearden, quoted in Joy Peters, "Romare Bearden: Jazz Intervals," *Art Papers* 7 (January–February 1983): 11.

58 Bearden, quoted in Schwartzman, *Romare Bearden: His Life and Art*, 191. Fine also discusses Bearden's use of tracing as a methodology. See Fine, "Nurtured and Necessary: Mothers of Invention," in *Romare Bearden, American Modernist*, 196.

59 *Collection Highlights: Telfair Museum of Art*, 246.

60 See also *From Process to Print*, 23–24.

61 Bearden, quoted in Tomkins, "Profiles," 74. When asked what the birds and trains symbolized in his art, Bearden stated, "Well, they can bring you to a place and also take you away. That was the image of one particular culture and the image of another." Quoted in Barbaralee Diamonstein, *Inside New York's Art World* (New York: Rizzoli, 1979), 36. With rare specificity, Bearden wrote about his Projection *The Baptism*: "In this picture, the train represents the encroachment of another culture." See "Rectangular Structure," 15.

62 Dick Russell has observed, "the trains in Bearden's pictures evoke not only the old guitar and harmonica folk blues, but Ellington's "Daybreak Express" and the locomotive themes in Murray's novels." See *Black Genius and the American Experience* (New York: Carroll & Graf, 1998), 79.

63 Robert G. O'Meally has called Bearden the "master of layering," and provides analogies in literature and jazz. See "Layering and Unlayering: Jazz, Literature, and Bearden's Collage Art," in *Romare Bearden in the Modernist Tradition*, 95–102.

64 Bearden, quoted in Campbell, "Romare Bearden: A Creative Mythology," 565.

65 Bearden, interview by Ghent.

66 Bearden, quoted in Diamonstein, *Inside New York's Art World*, 37.

67 Bearden, quoted in *Romare Bearden: Visual Jazz* (Chappaqua, NY: L&S Video, 1995). VHS.

68 Niedzielski-Eichner, "Integrating Modernism," 172.

69 Bearden, quoted in *Romare Bearden: Visual Jazz*, 1995.

AFTERWORD

Myron Schwartzman

Paper-cutting rhythm, snips of blue foil
Falling onto water-colored paper,
colored people into place. Eye divines
arrangement, hands slide shifting paper shapes.
Panes of color learned from stained-glass windows
Pauses spacing rests from Fatha Hines.

Elizabeth Alexander[1]

Above the worktable in Romare Bearden's Queens studio was this quotation from William Wordsworth's preface to the *Lyrical Ballads* (1800): "He is the rock of defence for human nature; an upholder and preserver, carrying every-where with him relationship and love."[2] Why did Bearden select this quotation, and what did he understand by the words "upholder and preserver"?

Bearden's struggle to become the artist who could proudly display that quotation was the result of a lifelong journey. It was a heroic affirmation. Like Wordsworth, Bearden broke with past definitions of heroism, invent-ing a new vocabulary in painting no less powerful than Wordsworth's had been in poetry. Bearden was the Wordsworthian "man speaking to men." He had found an authentic, sincere voice.

This authenticity did not come easily for Bearden. His early childhood in Charlotte was filled with "journey-ing things"— trains, birds, clouds, even the way of life that had come to seem so fragile and even dangerous that Romare's parents, Bessye and Howard, took him North to attend school in Manhattan's San Juan Hill, and in Harlem. Paradise had lasted only a few years.[3]

From the perspective of Bearden's centennial, it is clear that Charlotte and Mecklenburg County became part of his innermost core as an artist, once he found himself. Before that, he had exhibited at Caresse Croshy's G Place Gallery in Washington DC, as a United States Army sergeant; at Samuel Kootz's midtown Manhattan gallery as an up-and-coming young black artist; and even as a member of the American Society of Composers, Authors, and Publishers (A.S.C.A.P.) and a composer of popular tunes, until he crashed emotionally in the early 1950s. Marriage to Nanette Rohan, cessation of cigarette smoking, relocation from Harlem to a Soho apartment and studio at 357 Canal Street, and most of all, accept-ance of his worth as a man and an artist, enabled Bearden to reinvent himself.

Bearden carried the topography of Charlotte with him during four decades (in Harlem, Pittsburgh, Boston, and Paris), much as James Joyce carried a cerebral map of 1904 Dublin through London, Rome, Trieste, Paris, and Zurich. Something similar is true of William Faulkner, Eudora Welty, and Albert Murray, who traveled (and wrote) *South to a Very Old Place* (1971).

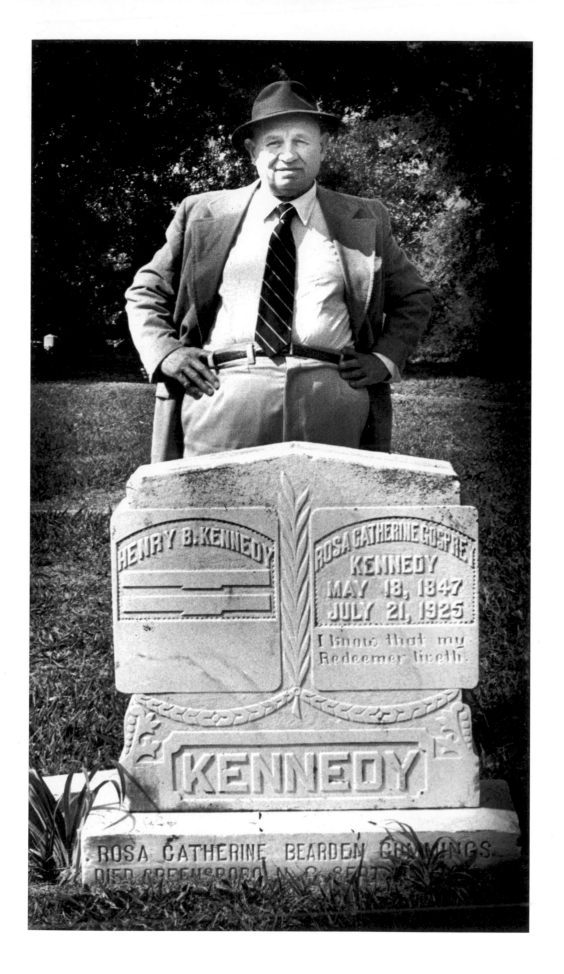

Fig. 36
Romare Bearden with the grave of Rosa Catherine Gosprey Kennedy, Pinewood Cemetery, Charlotte, North Carolina, October, 1980
Photography courtesy of *The Charlotte Observer*

Bearden's memories of Charlotte and Mecklenburg could not have been complete at the time he was brought to New York City and schooled at P.S. 5. However, just as Wordsworth famously defined poetry as generated by powerful "emotion recollected in tranquility," it is likely that Bearden's work had its origins in his large, close-knit family rooted in a corner house with gardens, flowers, and birds near a train trestle.[4]

Nor were Bearden's recollections anything like photographs. Maudell Sleet (see pls. 47 and 50), Mr. Grimes (pl. 100), and Madeleine Jones (see pl. 46) were archetypal, as much a part of the South configured in Bearden's art as the very process of collage he used to bring it to life. As actual, historical names, they do not exist: they do not appear on any census, record of births or deaths, or baptismal record. These people were engaged in the rituals of everyday Southern life—planting, harvesting, gathering, and creating music.

Bearden was of two minds about the past. Trained as a mathematician, he was rigorously analytical. Yet with the lyricism of an artist drawn to Wordsworth, there were the memories, the ghosts that made themselves known if he allowed them to enter his paintings. "One day," he said, "these people came walking into my work and seemed to know just where to go within the painting."[5] To explain what triggered the memories, Bearden pointed to a postcard reproduction of Johannes Vermeer's *The Concert* (1658–1660), on his studio wall. "I'll say to myself, 'Well, I saw something like this; I've been in places like this, with

the same kind of stillness, and the light coming in from this source.'"[6]

Let us return for a moment to the street at the corner of Graham and Second. Look southward about five hundred feet and you will see an iron railroad bridge running diagonally across South Graham Street. If you tore away the concrete, you might well locate the foundations of Henry B. Kennedy's home. In Charlotte, this is true of almost the entire Second and Third Wards, and much of the old First Ward.

The generations, too, are layered almost geologically, like strata.

In 1980, Bearden stood in Pinewood Cemetery, near the graves of most of his family (fig. 36). "It's all down under the earth here—that's Charlotte," he told *Charlotte Observer* art critic Richard Maschal. It was a quick visit. As he stood near the graves of his Aunt Anna and his Uncle Harry, he learned of the existence of a cousin, Elizabeth, who had died at eighteen months. Asked if he had any thought of his own mortality, Bearden answered, "No, just to living." The thought is not much different from Leopold Bloom's, upon leaving Glasnevin Cemetery in the "Hades" episode of Joyce's *Ulysses*: not this inning.

Homer's *Odyssey*, which Joyce celebrated by seeming to "freeze" a single day—16 June 1904—has as its theme Telemachus's search for Odysseus, the son for the father. The Odyssean theme appealed to Bearden. He painted variations of both the *Iliad* and the *Odyssey*. Instead of the son's search for the father, Bearden's own Odyssean voyage was more like a young boy's search for the world of his great-grandfather, a man who held Romare in his arms, on his knee and, that he might see farther, on his shoulder.

Pl. 100

Mr. Grimes and His Sundown Guitar, 1985
Watercolor and collage on paper on card, 6 × 9 inches

Notes

1 Elizabeth Alexander, "Bearden at Work," from "Omni-Albert Murray," in *The Venus Hottentot* (Charlottesville: University Press of Virginia, 1990).

2 William Wordsworth, "Preface to Lyrical Ballads," in *The Norton Anthology of English Literature*, gen. ed. M.H. Abrams, (New York: W.W. Norton, 1979), 248.

3 The reasons for the Beardens' relocation to New York City were not as simple as skin color and race. They also had to do with the limits of possibility. It is true that because Romare had light skin and golden locks, and because his father's skin was dark, it was a mistake for Bessye to leave the child in a carriage under the care of his father. Years later, race incited a confrontation between Howard and the police, leading to his arrest, incarceration, and abrupt departure from Charlotte.
In an April 1985 conversation between the author, Dan Morrill (Charlotte-Mecklenburg Historic Landmarks Commission), and Richard Maschal (then art critic, the *Charlotte Observer*), Maschal remarked, "I have a feeling [that] in the internal dynamics of the Bearden family, his great-grandfather would have wanted him to stay in Charlotte. I have a feeling it's probably Bessye that's the reason why they left, because she would have realized that her field of activity here would have been severely restricted just to domestic pursuits.... You see, Anna Alston Bearden works for a while, teaches music, I think. She was educated. Maybe to do that kind of thing, to become a school teacher, maybe.... Yeah, I'm sure that [Bessye] understood, obviously, what the whole game was, for herself and for her son."
As far as Morrill was concerned, "Charlotte was the city it was fundamentally because of railroads; and excellent rail connections make the city. After the Civil War, the old port towns on the coast went into decline. It was inland towns with excellent rail connections that gained a sense of economic and strategic location. Taking into account the location of Bearden's great-grandparents' house, it was [situated] where the old line ran over to Columbia—trains whistled to trains, trains were a constant part of life. Sometimes I feel like I'm in a layer cake: when you go down in Charlotte, even today, topographically, you go to the trains. You are aware of the trains. The trains are still here!"

4 In April 1985, Maschal and I stood on the site of the house on Graham Street where Bearden was born. It had been paved over for a parking lot. "The land was higher," Maschal said. "The house stood right on this corner—big porch in front; I think a side yard. He talks about his great grandmother's tiger lily, right?" Looking toward a train trestle nearby, Maschal commented that another trestle had replaced the original. "You can see how close the trains were to him," he said. "I mean trains were passing here all the time. His great-grandfather worked for the train company.... Long ago, he did tell me that he could remember people walking along the tracks; when they wanted to get up to Trade Street, they walked along the tracks.... You've got to think yourself back into what it was like when he was here. This would have been a thriving area; houses jammed next to each other, yards in the back, chickens in the yards, cows even. Because these were rural people, with rural roots, and they brought that with them into the city. This *was* the city."

5 Bearden, quoted in Myron Schwartzman, *Romare Bearden: His Life and Art* (New York: Harry N. Abrams, 1990), 24.

6 Bearden, quoted in ibid., 38.

CONTRIBUTORS

Mary Lee Corlett is a Research Associate in the Department of Special Projects in Modern Art, National Gallery of Art, Washington. With more than twenty years in the museum field, Corlett previously held research positions in the Department of Modern Prints and Drawings at the National Gallery and in the print departments of the Smithsonian American Art Museum and the National Portrait Gallery. A contributor to *The Art of Romare Bearden* (2003) and author of *From Process to Print: Graphic Works by Romare Bearden* (2010), Corlett has also written on numerous other contemporary American artists, including Roy Lichtenstein, Jackson Pollock, and Robert Stackhouse.

Jae Emerling is Assistant Professor of Modern and Contemporary Art at the University of North Carolina, Charlotte. He holds a Ph.D. in art history from the University of California, Los Angeles, and a B.A. from Wesleyan University, Connecticut. Emerling is the recipient of numerous grants and fellowships. His research focuses on the intersection between modern and contemporary art and critical theory. Emerling is the author of *Theory for Art History* (2005) and *Photography: Theory and History* (2011). His work has also appeared in *X-TRA: Contemporary Art Quarterly*, the *Journal of Visual Culture*, and the *Journal of Art Historiography*.

Ruth Fine is Curator of Special Projects in Modern Art, National Gallery of Art, Washington. Fine organized the 2003 Romare Bearden retrospective, *The Art of Romare Bearden*, and has written extensively on the artist's work, including as co-editor of *Romare Bearden, American Modernist*, published in 2011 by the National Gallery of Art. Fine's exhibitions and publications have also examined work by Mel Bochner, Helen Frankenthaler, Jasper Johns, Roy Lichtenstein, John Marin, and Georgia O'Keeffe, among others. She sits on the boards of the Terra Foundation for American Art, the Richard Diebenkorn Foundation, and the Roy Lichtenstein Foundation.

Glenda Elizabeth Gilmore is the Peter V. and C. Vann Woodward Professor of History, African American Studies, and American Studies at Yale University. Gilmore is the author of *Gender and Jim Crow: Women and the Politics of White Supremacy in North Carolina, 1896–1920* (1996) and *Defying Dixie: The Radical Roots of Civil Rights, 1919–1950* (2008). Gilmore is currently working on *A Homeland of His Imagination: Romare Bearden's Southern Odyssey in Time and Space*, a study of four generations of the Bearden family to be published by the University of North Carolina Press.

Carla M. Hanzal is Curator of Contemporary Art at The Mint Museum. Hanzal has previously held positions as Chief Curator at the Contemporary Art Center of Virginia, and Deputy Director and Director of Exhibitions at the International Sculpture Center. Hanzal organized the exhibition *Romare Bearden: Southern Recollections*. She has curated exhibitions and written catalogues on numerous contemporary artists, including José Bedia, Whitfield Lovell, Elizabeth Turk, Robert Lazzarini, and Janet Biggs. She is a recipient of an arts administration fellowship from the National Endowment for the Arts.

Leslie King-Hammond is the Graduate Dean Emeritus, Maryland Institute College of Art, and Founding Director of the Center for Race and Culture in Baltimore, Maryland. She is currently the Chair of the Board of the Reginald F. Lewis Museum of Maryland African American History and Culture in Baltimore. King-Hammond has written extensively on African American artists; her most recent publication, *Hughie Lee-Smith* (2010), comprises the eighth volume of The David C. Driskell Series of African American Art.

Myron Schwartzman is Professor Emeritus of Journalism at Baruch College of The City University of New York. He is the author of *Romare Bearden: His Life and Art* (1990), the standard biography of Bearden. He is privileged to have known Bearden from 1978 to his passing in 1988, and met with Bearden very regularly from 1982 to 1988. His biography, the product of research in New York City; Charlotte, North Carolina; Washington, D.C.; Pittsburgh; and St. Martin, has been cited in virtually every work on Bearden since its publication. Schwartzman is also the author of *Celebrating the Victory* (2000), a young people's book on Bearden.

CHRONOLOGICAL LIST OF WORKS IN THE EXHIBITION

While every attempt has been made to determine the exact media used in each of the works included in this exhibition, the complexities involved in Bearden's work often impede such a listing. Thus the media cited here is, in some cases, not entirely comprehensive, and should not be considered a complete inventory of materials.

*Indicates that the work of art was shown only at The Mint Museum venue of the exhibition

Dimensions are in inches; height precedes width

All art by Romare Bearden is © Romare Bearden Foundation/ Licensed by VAGA, New York, New York

Cotton Workers, circa 1936–44
Gouache on paper on board, 31 × 43 ⅝ inches
University of California, Berkeley Art Museum and Pacific Film Archive; Gift of Richard Buxbaum in Memory of Dr. Henry and Hermine Buxbaum
(pl. 27)

Untitled (Harvesting Tobacco), circa 1940
Gouache on paperboard, 43 × 30 inches
Courtesy of Michael Rosenfeld Gallery, LLC, New York, New York
(pl. 69)

The Family, circa 1941
Gouache with ink and graphite on brown paper, 29 ⅛ × 41 ¼ inches
From the Earle Hyman Collection in memory of Rolf Simes, promised gift to the National Gallery of Art
(pl. 28)

Untitled (Husband and Wife), circa 1941
Tempera on paper, 20 × 27 inches
Susan and David Goode; Courtesy of Michael Rosenfeld Gallery, LLC, New York, New York
(pl. 70)

The Visitation, 1941
Gouache with ink and graphite on brown paper, 30 ⅝ × 46 ¼ inches
Estate of Nanette Bearden, Courtesy of DC Moore Gallery, New York
(pl. 71)

Folk Musicians, 1942
Gouache with ink and graphite on brown paper, 35 ½ × 45 ½ inches
Curtis Galleries, Minneapolis, Minnesota
(pl. 55)

Presage, 1944
Gouache with ink and graphite on brown paper, 48 × 32 inches
The Walter O. Evans Collection of African American Art
(pl. 72)

Gathering, circa 1964
Collage on paperboard, 8 ⅜ × 5 ⅝ inches
Lowrance and Brucie Harry
(pl. 51)

Evening, 9:10, 461 Lenox Avenue, 1964
Collage of various papers with paint, ink, and graphite on cardboard, 8 ⅜ × 11 inches
Van Every/Smith Galleries, Davidson College
(pl. 32)

Mysteries, 1964
Photostat on fiberboard, 28 ½ × 36 ¼ inches
Romare Bearden Foundation, Courtesy of DC Moore Gallery, New York
(pl. 59)

Prevalence of Ritual: Conjur Woman, 1964
Collage of various papers with foil, ink, and graphite on cardboard, 9 ¼ × 7 ¼ inches
Private Collection, California. Lent in memory of Sheldon Ross
(pl. 68)

Prevalence of Ritual: Conjur Woman as an Angel, 1964
Collage of various papers with paint and ink on cardboard, 9 ³⁄₁₆ × 6 ⁷⁄₁₆ inches
John Axelrod, Boston, Massachusetts; Courtesy of Michael Rosenfeld Gallery, LLC, New York, New York
(pl. 67)

Prevalence of Ritual: Tidings, 1964
Collage of various papers with graphite on cardboard, 7 ¾ × 10 ½ inches
Private Collection, Courtesy of Kim Heirston Art Advisory LLC and ACA Galleries, New York
(pl. 35)

Prevalence of Ritual: Tidings, 1964
Photostat on fiberboard, 27 ¼ × 37 ½ inches
Romare Bearden Foundation, Courtesy of DC Moore Gallery, New York
(pl. 65)

Train Whistle Blues No. 1, 1964
Photostat on fiberboard, 29 × 37 ½ inches
Estate of Nanette Bearden, Courtesy of DC Moore Gallery, New York
(pl. 2)

Train Whistle Blues: II, 1964
Collage of various papers with paint and graphite on cardboard, 11 × 14 ⅜ inches
The Davidson's
(pl. 3)

Watching the Good Trains Go By, 1964
Collage of various papers with ink on cardboard, 13 ¾ × 16 ⅞ inches
Courtesy Columbus Museum of Art, Ohio. Museum Purchase, Derby Fund, from the Phillip J. and Suzanne Schiller Collection of American Social Commentary Art 1930–1970
(pl. 39)

Farmhouse Interior, 1966
Collage and mixed media on board, 9 ⅜ × 12 ⅜ inches
Private Collection, California. Lent in memory of Sheldon Ross
(pl. 36)

Untitled (Melon Season), circa 1967
Collage of papers with ink on gessoed cardstock mounted to board, 11 ½ × 8 ½ inches
Questroyal Fine Art, LLC, New York, New York
(pl. 79)

Early Morning, 1967
Collage of various papers with paint on board, 44 × 56 inches
Howard University Gallery of Art, Washington, DC
(pl. 93)

Fish Fry, 1967
Paper collage on board, 30 × 40 inches
Courtesy of Michael Rosenfeld Gallery, LLC,
New York, New York
(pl. 83)

**Melon Season*, 1967
Paper collage on canvas, 56 × 44 inches
Neuberger Museum of Art, Purchase College,
State University of New York, gift of Roy R.
Neuberger
(pl. 78)

Return of the Prodigal Son, 1967
Mixed media and collage on canvas, 50 ¼ × 60
inches
Collection Albright-Knox Art Gallery, Buffalo,
New York. Gift of Mr. and Mrs. Armand J.
Castellani, 1981. 1981:39
(pl. 43)

**Three Folk Musicians*, 1967
Collage of various papers with paint and graphite
on canvas, 50 ⅛ × 60 inches
Private Collection
(pl. 54)

Three Men, 1966–67
Collage of various papers with paint and graphite
on canvas, 58 × 42 inches
Manoogian Collection
(pl. 33)

**Eastern Barn*, 1968
Collage of paper on board, 55 ½ × 44 inches
Whitney Museum of American Art, New York;
Purchase 69.14
(pl. 19)

**House in Cotton Field*, 1968
Collage of various papers on fiberboard,
30 × 40 inches
Courtesy of DC Moore Gallery, New York,
New York
(pl. 17)

Soul Three, 1968
Paper and fabric collage on board,
44 × 55 ½ inches
Dallas Museum of Art, General Acquisitions
Fund and Roberta Coke Camp Fund
(pl. 57)

Conversation Piece, 1969
Collage, fabric, and graphite on paper,
17 ½ × 20 inches
Weatherspoon Art Museum, The University
of North Carolina at Greensboro, Museum
purchase with funds from the Dillard Paper
Company for the Dillard Collection, 1975
(pl. 18)

**The Woodshed*, 1969
Cut and pasted printed and colored papers,
Photostats, cloth, graphite, and sprayed ink on
Masonite, 40 ½ × 50 ½ inches
The Metropolitan Museum of Art, New York.
George A. Hearn Fund, 1970.1990.19
(pl. 58)

Mississippi Monday, 1970
Mixed media collage on panel, 11 ½ × 14 ¾ inches
Private Collection; Courtesy of Michael
Rosenfeld Gallery, LLC, New York, New York
(pl. 4)

**She-Ba*, 1970
Collage on board, 48 × 35 ⅞ inches
Wadsworth Atheneum Museum of Art, Hartford,
Connecticut. The Ella Gallup Sumner and Mary
Catlin Sumner Collection Fund
(pl. 80)

Before the Dark, 1971
Collage on board, 23 ¾ × 18 inches
Munson-Williams-Proctor Arts Institute,
Museum of Art, Utica, New York. 72.8
(pl. 84)

Family, 1971
Paint, photographs, paper, and fabric on board,
22 ½ × 25 ¾ inches
Collection of Kemper Museum of Contemporary
Art, Kansas City, Missouri. Bebe and Crosby
Kemper Collection, Gift of the William T. Kemper
Charitable Trust, 1999.13
(pl. 29)

Late Afternoon, 1971
Collage on cardboard, 18 × 24 inches
Montclair Art Museum, Montclair, New Jersey.
Museum purchase; funds provided by The
William Lightfoot Schulz Foundation. 1979.6
(pl. 60)

Mother and Child, 1971
Oil and ink on paper, cutouts collaged and
mounted onto Masonite panel, 11 × 7 ⅞ inches
T. Michael Todd
(pl. 75)

Sun and Candle, 1971
Collage of various papers with paint, ink,
graphite, and surface abrasion on fiberboard,
10 ½ × 12 ⅞ inches
Tougaloo College Collections, Tougaloo College,
Mississippi
(pl. 92)

A Very Blue Fish Day on Mobile Bay, 1971
Mixed media collage on Masonite, 18 × 24 inches
Private Collection, New York; Courtesy of
Michael Rosenfeld Gallery, LLC, New York,
New York
(pl. 16)

Untitled (Girl in a Pond), 1972
Collage of various papers with paint and surface
abrasion on fiberboard, 17 ½ × 7 ¾ inches
Judy and Patrick Diamond
(pl. 88)

Tidings from the *Prevalence of Ritual* series, 1973
Paper and polymer on composition board,
16 × 25 inches
Collection of The Mint Museum, Charlotte, North
Carolina. Gift of Bank of America. 2002.68.1
(pl. 34)

Carolina Morning, 1974
Mixed media collage on board, 30 × 22 inches
In Memory of Elaine Lebenbom and
Dr. Miriam Mansour
(pl. 99)

Of the Blues: Carolina Shout, 1974
Collage and acrylic and lacquer on board,
27 ½ × 51 inches
Collection of The Mint Museum, Charlotte,
North Carolina. Museum Purchase: National
Endowment for the Arts Matching Fund and
Charlotte Debutante Club Fund. 1975.8
(pl. 38)

*Of the Blues: Mecklenburg County,
Saturday Night*, 1974
Mixed media collage on Masonite,
50 × 44 inches
Courtesy of Michael Rosenfeld Gallery,
LLC, New York, New York
(pl. 37 not in exhibition)

**Of the Blues: New Orleans, Ragging Home*, 1974
Collage of plain, printed, and painted papers,
with acrylic, lacquer, graphite, and marker
mounted on Masonite panel, 36 ⅛ × 48 inches
North Carolina Museum of Art, Raleigh, Museum
purchase with funds from the State of North
Carolina and various donors, by exchange
(pl. 14)

Sunset Limited, 1974
Mixed media collage on Masonite,
14 × 20 inches
Courtesy of Michael Rosenfeld Gallery, LLC,
New York, New York
(pl. 64)

The Train, 1974
Collage on paper, 15 ¼ × 19 ½ inches
Collection of The Mint Museum, Charlotte, North
Carolina. Made possible through a Gift from
Bank of America. 2002.68.2
(pl. 40)

Carolina Reunion, 1975
Collage and watercolor on paper,
21 ½ × 15 ¼ inches
Susan and David Goode; Courtesy of Michael
Rosenfeld Gallery, LLC, New York, New York
(pl. 22)

Carolina Sunrise, 1975
Collage on board, 15 × 20 inches
The Walter O. Evans Collection of African
American Art
(pl. 85)

**Farewell in New Orleans*, 1975
Cut paper, newsprint, and glossy magazine paper
on board, 14 ¼ × 18 ¼ inches
Lent by The David and Alfred Smart Museum of
Art, The University of Chicago; Gift of Elisabeth
and William Landes in honor of the 30th
Anniversary of the Smart Museum
Courtesy: ACA Galleries, New York
(pl. 15)

Mecklenburg Family, circa 1976
Collage and mixed media on board,
17 ¾ × 26 ¾ inches
Private Collection, New York City
(pl. 30)

New Orleans: Storyville Entrance, 1976
Monotype with graphite on paper,
29 ½ × 41 inches
Estate of Nanette Bearden, Courtesy of DC
Moore Gallery, New York
(pl. 12)

**Southern Courtyard*, 1976
Collage on paper: photomechanically printed
paper cut outs, colored paper, paint, graphite,
and fabric, 48 × 36 inches
Brooklyn Museum; Gift of The Beatrice and
Samuel A. Seaver Foundation, 2004.30.1
(pl. 97)

Mother and Child, circa 1976–77
Collage on canvas mounted on Masonite,
48 × 36 inches
Courtesy: ACA Galleries, New York
(pl. 5)

Back Porch Serenade, 1977
Collage with color inks and pencil on Masonite,
6 × 9 inches
Collection of The Mint Museum, Charlotte, North
Carolina. Partial Gift from the collection of Lyn
and E. T. Williams. Museum Purchase with funds
provided by the Romare Bearden Society, John
and Stacy Sumner Jesso, Richard "Stick" and
Teresa Williams, Yele Aluko MD and Shirley
Houston Aluko MD, Tom and Phyllis Baldwin,
Dr. Kim Blanding and Family, Dee Dixon, The
Charlotte Chapter of The Links, Inc., Dr. Keia
Hewitt, Ken and Toi Lay, Patti Tracey and Chris
Hudson, Elizabeth A. Apple, Dr. Karen Breach-
Washington and Mr. Harry Washington, Rubie
R. Britt-Height and Daughters, Ron and Nicole
Freeman, John and Vernell Harvey, Drs. Roger
and Natasha Denny, Keva and Juanita Walton,
and Dr. Spurgeon and Sterlin Webber, III. 2011.2
(pl. 56)

Jazz: Kansas City, 1977
Collage and paint on board, 18 ¼ × 27 inches
New Orleans Museum of Art; Museum Purchase,
the Robert P. Gordy and Carrie Heiderich
Funds. 96.28
(pl. 96)

Madeleine Jones' Wonderful Garden, 1977
Collage of various papers with ink, graphite,
and surface abrasion on fiberboard,
13 × 15 ½ inches
Constance and Frederick Brown, Belmont,
Massachusetts
(pl. 46)

New Orleans Joys (Storyville), 1977
Oil on paper, 29 ¼ × 40 ½ inches
Private Collection, Omaha, Nebraska
(pl. 13)

Back Home, 1978
Watercolor on paper, 9 ½ × 7 ½ inches
Collection of Dr. Raleigh and Thelmetia Bynum,
Charlotte, North Carolina
(pl. 98)

Baptism, 1978
Collage and watercolor on paper,
4 ½ × 9 ¼ inches
The Walter O. Evans Collection of African
American Art
(pl. 73)

The Baptism, 1978
Watercolor, gouache, and graphite on paper,
21 × 26 inches
Collection of The Mint Museum, Charlotte, North
Carolina. Museum Purchase: Funds provided
by the Charlotte Garden Club, the YAMS, the
Collector's Circle, and Exchange Funds from the
Gift of Harry and Mary Dalton. 2005.86.1
(pl. 74)

**Evening: Off Shelby Road*, 1978
Collage, watercolor, and ink on board,
17 ½ × 13 ½ inches
Cameron Art Museum, Wilmington, North
Carolina: Purchased with funds from the Claude
Howell Endowment for the Purchase of North
Carolina Art, 2002.8
(pl. 7)

*Profile/Part I, The Twenties: Mecklenburg
County, Conjur Woman and the Virgin*, 1978
Collage of various papers with ink on fiberboard,
14 × 20 inches
Studio Museum in Harlem; Museum Purchase
97.9.13
(pl. 87)

*Profile/Part I, The Twenties: Mecklenburg
County, Early Carolina Morning*, 1978
Collage on board, 29 × 41 inches
Dr. and Mrs. Clinton N. Levin
(pl. 45)

*Profile/Part I, The Twenties: Mecklenburg
County, Maudell Sleet's Magic Garden*, 1978
Collage on board, 10 ⅛ × 7 inches
Linda and Pearson C. Cummin III, Greenwich,
Connecticut
(pl. 47)

*Profile/Part I, The Twenties: Mecklenburg
County, Morning*, 1978
Collage on board, 10 ¾ × 7 inches
Glen and Lynn Tobias
(pl. 63)

*Profile/Part I, The Twenties: Mecklenburg
County, Railroad Shack Sporting House*, 1978
Collage of various papers with fabric, paint, ink,
graphite, and bleached areas on fiberboard,
11 ⅛ × 16 ½ inches
Paul and Karen Izenberg
(pl. 11)

*Profile/Part I, The Twenties: Mecklenburg
County, Sunset Limited*, 1978
Collage on board, 15 ½ × 20 ¼ inches
Ute and Gerhard Stebich
(pl. 53)

The Tin Roof, 1978
Collage and watercolor on paper,
6 ¼ × 9 ½ inches
The Walter O. Evans Collection of African
American Art
(pl. 61)

Mecklenburg County, Lamp at Midnight,
circa 1979
Mixed media collage on board,
17 ¾ × 13 ½ inches
Georgia Museum of Art, University of Georgia;
museum purchase with funds provided by the
Friends of the Museum on the occasion of the
museum's 50th anniversary. GMOA 1998.21
(pl. 21)

Mecklenburg Morning, circa 1979
Collage of various papers with paint, ink, and
graphite on fiberboard, 7 × 15 inches
The Walter O. Evans Collection of African
American Art
(pl. 95)

Bayou Fever—The Buzzard and the Snake, 1979
Gouache and watercolor on paper,
9 × 6 inches
Estate of Nanette Bearden, Courtesy of DC
Moore Gallery, New York
(pl. 86)

Early Carolina Morning, 1979
Collage on board, 16 × 23 ⅞ inches
Private Collection; Courtesy of Michael
Rosenfeld Gallery, LLC, New York, New York
(pl. 48)

Falling Star, 1979
Collage with paint, ink, and graphite on
fiberboard, 14 × 18 inches
Private Collection
(pl. 90)

Memories: Mecklenburg County, 1979
Collage on board, 31 × 40 inches
Private Collection; Courtesy: ACA Galleries,
New York
(pl. 52)

Continuity, 1980
Collage and mixed media on board,
14 × 17 inches
Private Collection, New York City
(pl. 66)

Blue Nude, 1981
Collage and mixed media on board,
14 × 18 inches
Jancy and Gilbert Patrick
(pl. 89)

Morning Train to Durham, 1981
Mixed media collage on composite board,
18 × 13 ¾ inches
Courtesy of Michael Rosenfeld Gallery, LLC,
New York, New York
(pl. 10)

**Autumn of the Red Hat*, 1982
Collage and watercolor on board,
30 ½ × 39 ⅝ inches
Virginia Museum of Fine Arts, Richmond. The
National Endowment for the Arts Fund for
American Art. 95.17
(pl. 1)

Evening of the Gray Cat, 1982
Collage on board, 30 × 40 inches
Collection of The Mint Museum, Charlotte, North
Carolina. Made possible through a Gift from
Bank of America. 2002.68.3
(pl. 6)

Mecklenburg Early Evening, 1982
Collage and mixed media on board,
17 ½ × 23 ½ inches
Private Collection, New York City
(pl. 9)

A Summer Star, 1982
Collage on board, 30 × 40 inches
The Walter O. Evans Collection of African
American Art
(pl. 91)

Mecklenburg Autumn: The China Lamp
(a.k.a. *The Dressmaker*), 1983
Mixed media collage on board, 40 × 31 inches
Courtesy of Michael Rosenfeld Gallery, LLC,
New York, New York
(pl. 77)

Mecklenburg Autumn Morning, 1983
Collage on board, 40 × 30 inches
Glen and Lynn Tobias
(pl. 81)

*Mecklenburg Autumn: October—Toward
Paw's Creek*, 1983
Collage of various papers with paint, ink,
graphite, and bleached areas on fiberboard,
30 × 40 inches
Romare Bearden Foundation, Courtesy of DC
Moore Gallery, New York
(pl. 23)

*Mecklenburg Autumn: September—
Sky and Meadow*, 1983
Oil and collage on board, 32 × 44 inches
Estate of Nanette Bearden, Courtesy of DC
Moore Gallery, New York
(pl. 24)

Sunrise, 1983
Collage and watercolor on board,
10 ¼ × 14 inches
Herb Jackson and Laura Grosch, Davidson,
North Carolina
(pl. 8)

**Carolina Autumn*, 1984
Collage on board, 12 × 16 inches
Private Collection, South Carolina
(pl. 25)

Return of the Prodigal Son, 1984
Collage on board, 12 × 8 ½ inches
Collection of Don and Patricia Deutsch
(pl. 44)

Sunset Express, 1984
Collage on board, 12 ⅝ × 14 inches
Asheville Art Museum Collection, 1985.04.1.29
(pl. 41)

**Evening Church*, 1985
Collage on board, 14 × 11 ⅝ inches
The Charlotte Observer
(pl. 49)

Evening Guitar, 1985
Collage on board, 12 ½ × 15 inches
Collection of The Mint Museum, Charlotte, North
Carolina. Made possible through a Gift from
Bank of America. 2002.68.4
(pl. 62)

Mr. Grimes and His Sundown Guitar, 1985
Watercolor and collage on paper on card,
6 × 9 inches
T. Michael Todd
(pl. 100)

**Summer (Maudell Sleet's July Garden)*, 1985
Collage of various papers with paint, ink,
graphite, and bleached areas on fiberboard,
11 ⅞ × 13 ½ inches
Private Collection, South Carolina
(pl. 50)

Sunday Morning, 1985
Mixed media collage on board, 11 ⅛ × 7 inches
Collection of Linda and Pearson C. Cummin III,
Greenwich, Connecticut
(pl. 76)

**Winter (Time of the Hawk)*, 1985
Collage of various papers with paint, ink, and
graphite on fiberboard, 10 ¾ × 13 ¾ inches
Private Collection, South Carolina
(pl. 26)

Before Dawn on Shelby Road, 1986
Paper, fabric, print, ink, and graphite on board,
16 × 20 inches
Lucinda W. Bunnen and Kendrick N. Reusch Jr.
(pl. 94)

Family, 1986
Collage on wood, 28 × 20 inches
Smithsonian American Art Museum,
Washington, DC. Transfer from the General
Services Administration, Art-in-Architecture
Program
(pl. 31)

Evening Limited to Memphis, 1987
Collage on board, 14 × 18 inches
Hickory Museum of Art, Hickory, North Carolina
(pl. 20)

Gospel Morning, 1987
Collage of watercolor, paper, and fabric on board,
28 × 31 ¼ inches
American Masters Collection I, Managed by
The Collectors Fund, Kansas City, Missouri
(pl. 82)

Moonlight Prelude, 1987
Collage and watercolor on mahogany board,
20 × 28 inches
Collection of Emily and Zach Smith
(pl. 42)

SELECTED BIBLIOGRAPHY

Compiled by Amber Smith

*This bibliography includes only publications dated 2003 to the present, building upon the comprehensive bibliography included in Ruth Fine's *The Art of Romare Bearden* (Washington, DC: National Gallery of Art, 2003).

Exhibition Catalogues

Bradley, Jacqueline, Clarence Otis, Franklin Sirmans, and E.L. McKinnon. *Crossing the Line: African American Artists in the Jacqueline Bradley and Clarence Otis, Jr. Collection*. Winter Park, FL: Cornell Fine Arts Museum, 2007. [group exhibition, 19 January–20 May 2007].

Bronx Museum of the Arts. *Collection ReMixed*. Bronx, NY: Bronx Museum of the Arts, 2005. [group exhibition, 3 February–29 March 2005].

Corlett, Mary Lee. *From Process to Print: Graphic Works by Romare Bearden*. Petaluma, CA: Pomegranate Communications, 2009. [solo exhibition organized by the Romare Bearden Foundation, 1 October 2009–3 January 2010, traveling through 2012].

Fine, Ruth, and Mary Lee Corlett. *The Art of Romare Bearden*. Washington, DC: National Gallery of Art, 2003. [retrospective exhibition, September 2003–April 2005].

Foster, Carter E., Jeffrey D. Grove, Patrick S. Cable, and Cathleen Chaffee. *Drawing Modern: Works from the Agnes Gund Collection*. Cleveland: Cleveland Museum of Art, 2003. [group exhibition, 26 October 2003–1 January 2004].

Hills, Patricia, and Melissa Renn. *Syncopated Rhythms: 20th-Century African American Art from the George and Joyce Wein Collection*. Boston: Boston University Art Gallery, 2005. [group exhibition, 18 November 2005–22 January 2006].

Kelley, Robin D. G. *African-American Art: 20th-Century Masterworks, X*. New York: Michael Rosenfeld Gallery, 2003. [group exhibition, 17 January–8 March 2003].

Mint Museum of Art. *Passing*. Charlotte, NC: Mint Museum of Art, 2003. [group exhibition of six artists inspired by Romare Bearden's artwork, 5 July–7 September 2003].

O'Meally, Robert G. *Romare Bearden: A Black Odyssey*. New York: DC Moore Gallery, 2007. [solo exhibition, 13 November 2007–5 January 2008].

Powell, Richard J., Margaret Ellen Di Giulio, Alicia Garcia, Victoria Trout, and Christine Wang. *Conjuring Bearden*. Durham, NC: Nasher Museum of Art at Duke University, 2006. [solo exhibition, 4 March 2006–16 July 2006].

Riehlman, Franklin, Sharon F. Patton, and David Lebenbom. *Romare Bearden & Sheldon Ross: Artist & Dealer*. New York: Romare Bearden Foundation, 2004. [solo exhibition, Franklin Riehlman Fine Art, and Megan Moynihan Fine Art, New York, 14 October–6 November 2004].

Romare Bearden, from the Studio and Archive: and A Painter's Mind: Selections from the Library of Romare Bearden. New York: Schomburg Center for Research in Black Culture, 2004. [solo exhibition, 3 November 2003–7 January 2004].

Rosenfeld, Michael, Jonathan P. Binstock, and Lowery Stokes Sims. *African American Art: 200 Years*. New York: Michael Rosenfeld Gallery, 2008. [group exhibition, 10 January–15 March 2008].

Michael Rosenfeld Gallery. *Building Community: The African American Scene*. New York: Michael Rosenfeld Gallery, 2006. [group exhibition, 13 January–11 March 2006].

Michael Rosenfeld Gallery. *Romare Bearden: Fractured Tales, Intimate Collages*. New York: Michael Rosenfeld Gallery, 2006. [solo exhibition, 8 September–28 October 2006].

Shoemaker, Innis H., and Jennifer T. Criss. *Adventures in Modern Art: The Charles K. Williams II Collection*. Philadelphia: Philadelphia Museum of Art, 2009. [group exhibition, 12 July–13 September 2009].

Sims, Lowery Stokes. *Challenge of the Modern: African-American Artists, 1925–1945*. New York: Studio Museum in Harlem, 2003. [group exhibition, 23 January–30 March 2009].

Books

Amaki, Amalia K., ed. *A Century of African American Art: The Paul R. Jones Collection*. New Brunswick, NJ: Rutgers University Press, 2004.

Bernier, Celeste-Marie. *African American Visual Arts: From Slavery to the Present*. Chapel Hill: University of North Carolina Press, 2009.

Bryer, Jackson R., and Mary C. Hartig, eds. *Conversations with August Wilson*. Literary Conversations Series. Jackson: University Press of Mississippi, 2006.

Goings, Russell L., and Romare Bearden. *The Children of Children Keep Coming: An Epic Griotsong*. New York: Pocket Books, 2009.

Greenberg, Jan, and Romare Bearden. *Romare Bearden: Collage of Memories*. New York: Harry N. Abrams, 2003. [juvenile].

Hayes, Dwayne. *Authors and Artists for Young Adults*. Vol. 67. Detroit: Thomson Gale, 2005. [juvenile].

Kaplan, Louis. *American Exposures: Photography and Community in the Twentieth Century*. Minneapolis: University of Minnesota Press, 2005.

Kohl, Mary Ann F., and Kim Solga. *Great American Artists for Kids: Hands-on Art Experiences in the Styles of Great American Masters*. Bellingham, WA: Bright Ring Publishing, 2008. [juvenile].

Lock, Graham, and David Murray, eds. *The Hearing Eye: Jazz and Blues Influences in African American Visual Art*. New York: Oxford University Press, 2009.

Mamigonian, Beatriz G., and Karen Racine, eds. *The Human Tradition in the Black Atlantic, 1500–2000*. Lanham, MD: Rowman & Littlefield, 2010.

Mercer, Kobena. *Cosmopolitan Modernisms*. London: Institute of International Visual Arts, 2005.

O'Meally, Robert G., Brent Hayes Edwards, and Farah Jasmine Griffin. *Uptown Conversation: The New Jazz Studies*. New York: Columbia University Press, 2004.

Price, Sally, and Richard Price. *Romare Bearden: The Caribbean Dimension*. Philadelphia: University of Pennsylvania Press, 2006.

Rolling, James Haywood. *Come Look with Me: Discovering African American Art for Children*. New York: Lickle Publishing, 2005. [juvenile].

Steiner, Mary Ann, ed. *Handbook of the Collection*. Saint Louis: Saint Louis Art Museum, 2004.

Stewart, Frank. *Romare Bearden*. San Francisco: Pomegranate, 2004.

Tweedy, Ellie. *Romare Bearden in the Modernist Tradition: Essays from the Romare Bearden Foundation Symposium, Chicago, 2007*. New York: Romare Bearden Foundation, 2008.

Veneciano, Jorge Daniel, and Thomas White. *New Acquisitions 2008: African-American Masters Collection*. Lincoln, NE: Sheldon Museum of Art, 2009.

Wintz, Cary D. *Harlem Speaks: A Living History of the Harlem Renaissance*. Naperville, IL: Sourcebooks, 2007.

Theses and Dissertations

Fortin, Robin C. "Romare Bearden: How the Civil Rights Movement Impacted His Career." Master's thesis, University of Missouri, Kansas City, 2010.

Greene, Nikki A. "The Rhythm of Glue, Grease, and Grime: Indexicality in the Works of Romare Bearden, David Hammons, and Renee Stout." PhD diss., University of Delaware, 2009.

Hansen, Sara J. "Thinking Outside the Frame: How Museum Curators Shape the Viewer's Experience of Art." Master's thesis, University of North Dakota, 2004.

Lawrence, Amy. "Romare Bearden, August Wilson, and the Blues: A Tradition of Aesthetics and an Aesthetics of Tradition in August Wilson's *Joe Turner's Come and Gone* and *The Piano Lesson*." Bachelor's thesis, Reed College, 2008.

Niedzielski-Eichner, Nora. "Integrating Modernism: The Migration Paintings of Aaron Douglas, Jacob Lawrence, and Romare Bearden." PhD diss., Stanford University, 2009.

Articles and Reviews

Achenbaum, Emily S. "Touch of Art, History for New Parks: Uptown Additions to Honor Artist Bearden, Second Ward's Past." *Charlotte Observer* (Charlotte, NC), 4 October 2007.

Amaki, Amalia. "Romare Bearden and the Fine Art of Activism." *Crisis* 110, no. 5 (2003): 44.

Bardeen, Tara. "20 African-Americans Your Students Should Meet." *Instructor* 117, no. 4 (2008): 34–36, 38.

Bell, Nichole Monroe. "Across the Region: The Latest from Mecklenburg, the Region, and the State." *Charlotte Observer* (Charlotte, NC), 14 December 2008.

Cassano, Denise M. "Romare Bearden Memory Collages." *Arts and Activities* 142, no. 2 (2007): 34–35.

Cole, Julie. "Romare Bearden." *Southern Accents* 26, no. 5 (2003): 106.

Danto, Arthur C. "An Artist Beyond Category." *Nation* 279, no. 19 (2004): 29.

Dawson, Jessica. "Bearden's Contemporaries, Shining in his Shadow." *Washington Post*, 25 September 2003.

Fine, Ruth. "The Art of Romare Bearden." *World & I* 19, no. 2 (2004): 82.

———. "Expanding the Mainstream: Romare Bearden Revisited." *Proceedings of the American Philosophical Society Held at Philadelphia for Promoting Useful Knowledge* 149, no. 1 (2005): 40–55.

———. "Looking at Art—A Game of Hopscotch: Small in Scale and Intimate in Feeling, Romare Bearden's Collage Immortalizes a Game Played on a Harlem Sidewalk." *ARTnews* 102, no. 8 (2003): 90–92.

Francis, Jacqueline. "Essay Reviews: Romare Bearden: The Caribbean Dimension by Sally Price and Richard Price." *Journal of Latin American and Caribbean Anthropology* 13, no. 1 (2008): 263–65.

Goode, Stephen. "Romare Bearden Revealed." *Insight on the News* 19, no. 26 (2003): 39.

Grant, Daniel. "Demand for Bearden: 'Very Strong.'" *ARTnews* 103, no. 1 (2004): 67.

Greenwood, Emily. "A Tale of Two O's: Odysseus and Oedipus in the Black Atlantic." *New West Indian Guide* 83, nos. 3–4 (2009): 281–89.

Herrera, Camilla A. "Romare Bearden Show is the Best of the City and Country." *Advocate* (Stamford, CT), 21 January 2007.

Johnson, Mark M. "From Process to Print: Graphic Works by Romare Bearden." *Arts & Activities* 147, no. 1 (2010): 19–21.

———. "Modern Masters from the Smithsonian American Art Museum." *Arts & Activities* 145, no. 5 (2009): 30–32.

Lamm, Kimberly. "Visuality and Black Masculinity in Ralph Ellison's *Invisible Man* and Romare Bearden's Photomontages." *Callaloo* 26, no. 3 (2003): 813–35.

Linn, Melissa. "Digitally Romare." *Arts & Activities* 139, no. 1 (2006): 32.

Maschal, Richard. "2011 Will Be the Year for Artist Romare Bearden." *Charlotte Observer* (Charlotte, NC), 18 May 2010.

———. "Bearden Invokes Latest Triumph with 'Conjuring.'" *Charlotte Observer* (Charlotte, NC), 3 March 2006.

———. "Bearden's Vision Went Beyond What He Saw." *Charlotte Observer* (Charlotte, NC), 6 March 2005.

———. "The Bearden We Didn't Know." *Charlotte Observer* (Charlotte, NC), 7 July 2003.

———. "Fun, Stunning Works Will Catch Young Eyes." *Charlotte Observer* (Charlotte, NC), 8 July 2007.

———. "Melberg's Latest Bearden Tribute is Rare, Indeed." *Charlotte Observer* (Charlotte, NC), 11 May 2007.

———. "Mint Gets Serious About Showcasing a Charlotte Native." *Charlotte Observer* (Charlotte, NC), 24 June 2005.

———. "Name Third Ward Park for Romare Bearden—Artist Took Much of His Inspiration from Mecklenburg Themes." *Charlotte Observer* (Charlotte, NC), 20 March 2005.

Mason, LaTonya. "Buzzing About Bearden." *Pride* (March–April 2010): 36–37.

"Mysterious Muse." *Chronicle of Higher Education* 52, no. 42 (2006): B15.

Plagens, Peter. "Arts and Entertainment—Art: Romare Bearden, Who Turned the Everyday into the Profound." *Newsweek*, 22 September 2003.

Powell, Lew. "Bearden Returns—In Flesh—Plus: 'We Came Down Here For Wind and Sand, and We Have Got Them.'" *Charlotte Observer* (Charlotte, NC), 5 October 2007.

Pruitt, Sharon Yvette. "Bearden's Country Still." *International Review of African American Art* 19 (2003): 49–51.

"Romare Bearden Revisited." *Jerald Melberg Gallery Newsletter* 3, no. 3 (2002).

Romero, Joseph M. "Romare Bearden's Imprint: Twenty-Seven of His Works Go on Display in Pennsylvania." *Humanities* 27, no. 2 (2006): 42–43. [review of exhibition at Hoyt Institute of Fine Art, New Castle, PA].

Rossi, Lisa. "Time Off/Exhibit." *Wall Street Journal*, 24 February 2007.

Shuler, Deardra. "Romare Bearden: The Man and His Art." *New York Amsterdam News*, 21 October 2004, 21.

Seawright, Sandy. "Remembering Romare: Celebrate Birthday with Art." *Charlotte Post* (Charlotte, NC), 1 September 2005.

——. "Bearden, Oubré Highlight Mint Museum Art Exhibit." *Charlotte Post* (Charlotte, NC), 7 July 2006. [review of *What's New—2005* at the Mint Museum of Art].

Smith, Roberta. "Visions of Life, Built From Bits and Pieces." *New York Times*, 2 April 2011.

Southgate, M. Therese. "New Orleans: Ragging Home." *JAMA: Journal of the American Medical Association* 289, no. 19 (2003): 2464.

Stern, Fred. "The Road to Glory: The Surprising Story of Romare Bearden." *World & I* 20, no. 9 (2005): 3.

Sullivan, Karen. "Three Finalists for Bearden Park Art." *Charlotte Observer* (Charlotte, NC), 25 April 2010.

Swope, Darcy M. "Ready-to-Use Resources—ClipCards—Inspired by Romare Bearden." *School Arts* 108, no. 8 (2009): 9.

Thomas, Mary. "Romare Bearden's Impact Focal Point of Symposium: Art News." *Pittsburgh Post-Gazette*, 24 March 2010.

Trachtman, Paul. "Romare Bearden: Man of Many Parts." *Smithsonian* 34 (2004): 60–67.

Turner, Elisa. "Living with Art—Sentimental Education: Walter Evans Began Buying Art by Romare Bearden, Jacob Lawrence, and Elizabeth Catlett to Support His Friends and Help His Daughters Understand Their Heritage," *ARTnews* 107, no. 8 (2008): 108.

Van Clief-Stefanon, Lyrae. "*Reclining Nude*, c. 1977, Romare Bearden." *Callaloo* 30, no. 4 (2008): 1031–32.

Walkup, Nancy. "Teaching Art with Music: Collages Inspired by the Art and Music of Romare Bearden." *School Arts: The Art Education Magazine for Teachers* 104, no. 6 (2005): 48.

Washburn, Mark. "TV Documentary Tracks Artist's Roots—Latest Steve Crump Production Focuses on Charlotte Influences." *Charlotte Observer* (Charlotte, NC), 19 February 2003.

White, Renee Minus. "Romare Bearden's Art at DC Moore Gallery." *New York Amsterdam News*, 15 November 2007.

Yezzi, David. "A Great Day (and Night) in Harlem." *Wall Street Journal*, 15 May 2010.

Multimedia

Carter, Richard, et al. *The Art of Romare Bearden: A Resource for Teachers*. Washington, DC: National Gallery of Art, 2003. Kit.

Chanda, Jacqueline, and Kristen Pederson Marstaller. *Harcourt Art Everywhere*. Orlando: Harcourt School Publishers, 2006. Kit. [juvenile].

Crump, Steve. *Romare Bearden: Charlotte Collaborations*. Charlotte, NC: WTVI, 2003. VHS. [profile of Romare Bearden, emphasizing his connections to Charlotte, North Carolina].

Davis, Roger, et al. *Seven American Artists: An Homage*. Wilmington, NC: Roger Davis, 2004. Compact disc.

Freeman, Linda, and David K. Irving. *I Can Fly, Part Two. Kids and Painting*. Chappaqua, NY: L & S Video, 2006. DVD. [juvenile].

Freeman, Linda, and David K. Irving. *I Can Fly, Part Four, Kids and African American Art*. Chappaqua, NY: L & S Video, 2004. VHS. [juvenile].

Greene, Denise A. *I'll Make Me a World: Not a Rhyme Time, 1963–1986*. Alexandria, VA: PBS Video, 2005. DVD.

Irving, David K. *Romare Bearden: Visual Jazz*. Chappaqua, NY: L&S Video, 2006. DVD.

Marsalis, Branford Quartet, et al. *Romare Bearden Revealed*. Cambridge, MA: Marsalis Music/Rounder Records, 2003. Compact disc. [jazz arrangements inspired by the life and artwork of Romare Bearden].

Meltzer, Milton, and Alvin Yudkoff. *Five*. Washington, DC: National Archives, 2010. DVD. [profiles five African American artists: Romare Bearden, Betty Blayton, Barbara Chase-Riboud, Richard Hunt, Milton Meltzer, Charles White].

The Metropolitan Museum of Art and Lisa Gail Collins. *Art by African-American Artists: Selections from the 20th Century: A Resource for Educators*. New York: Metropolitan Museum of Art, 2003. Kit. [juvenile].

Mint Museum of Art. *Romare Bearden Resource Trunk*. Charlotte, NC: Mint Museum of Art, 2004. Kit. [teacher resources for the classroom including images, lesson plans, and activities].

National Gallery of Art. *20th-Century American Art*. Washington, DC: National Gallery of Art, 2003. DVD.

"Romare Bearden: Let's Walk the Block." The Metropolitan Museum of Art, 2000–11, http://wwww.metmuseum.org/explore/the_block/index_flash.html (accessed 1 February 2011).

Stephens, Pamela Geiger. *Dropping in on Romare Bearden*. Glenview, IL: Crystal Productions, 2007. DVD. [juvenile].

"Welcome to the Romare Bearden Foundation." The Romare Bearden Foundation, 2009, http://www.beardenfoundation.org.index2.shtml (accessed 1 February 2011).

Fig. 37 (next page)
Frank Stewart
Romare Bearden at The Mint Museum, Charlotte, North Carolina, 1980
Photography © Frank Stewart/Black Light Productions